ART OF THE WORLD

NON-EUROPEAN SCULPTURES
THE HISTORICAL, SOCIOLOGICAL,
AND RELIGIOUS BACKGROUNDS

THE ART OF ETRURIA
AND EARLY ROME

G. A. MANSUELLI

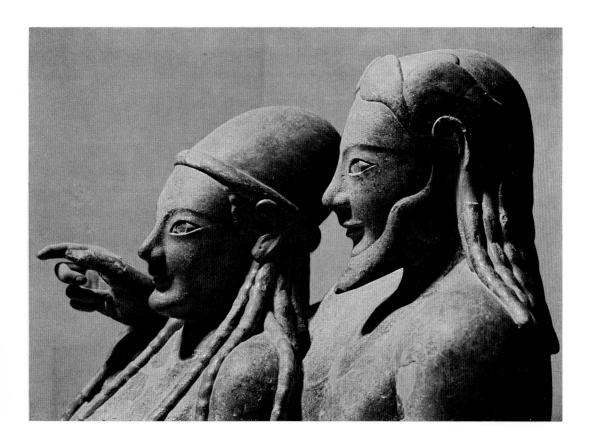

CROWN PUBLISHERS, INC., NEW YORK

Translated by C. E. Ellis

Title-page: Married couple. Terracotte sarcophagus from Caere.
About 550–525. Villa Giulia, Rome.
Height 1.40 m. Cf.p. 97

FIRST PUBLISHED IN THE UNITED STATES, 1965

© 1964 BY HOLLE VERLAG G.M.B.H. BADEN-BADEN, GERMANY

PRINTED IN HOLLAND

LIBRARY OF CONGRESS CARD CATALOGUE NUMBER: 65–24336

The author wishes to thank those colleagues who have kindly permitted the reproduction of the photographs needed to illustrate this book: Prof. Luciano Laurenzi, Director of the Civic Museum, Bologna, and Dr. Rosanna Pincelli, Inspector of the same Museum; Dr. Umberto Ciotti, Director of the Umbrian Archaeological Museum; Prof. Carlo Pietrangeli, Director of the Capitoline Museums; Dr. Vincenzo Tusa, Superintendent of Antiquities at Palermo. I am grateful in particular for the friendly assistance of Prof. Giacomo Caputo, Superintendent of Antiquities for Etruria, and Dr. Mario Moretti, Superintendent of Antiquities for Southern Etruria (Rome II), since the greater part of our reproductions is of material in museums under their jurisdiction; moreover they have both supplied reproductions of works of art only recently discovered. All the plates were produced by the staff of Foto Scala of Florence, to whom I also wish to express my warm thanks, as also to Messrs. Heinz Prüstel and Hannes Pixa who drew the figures. The black-and-white photographs are mostly from the archives of the Superintendency of Antiquities of Emilia and of the Institute of Archaeology of the University of Pavia.

TRANSLATOR'S NOTE

The translation of names of places, persons, tombs and works of art presents special problems in a book such as this. A hypothetical case is not at all inconceivable where forms existed in one or more dialects of Greek, in earlier or later Etruscan, in classical Latin, late Latin, traditional Italian, and modern Italian of the Fascist period. There may in addition be one or more special English traditional forms.

There are in fact examples of most of these in the translated text and appendices of this book. In general I have tried to use the classical Latin form, except where there was a well-known English one, — thus, 'Veii', but 'Rome'. I have also tried to respect the original text, where for instance an Etruscan name is used by the author, — thus 'Turms' rather than 'Mercury'. In the transliteration of Greek names — itself in a state of confusion in English works about the Greek world — I confess I have used the form that happened to be known to me. When Italian forms have been used, it has been because there was no known ancient equivalent, or because identification with an Etruscan, Latin or Greek name was not certain, or because the identification was not common knowledge, or where it was more important for the reader to know where a work of art can now be seen, or where it was felt that the Italian place-name would be far better known. (Admittedly, one is often reduced to guess-work. 'Fiesole' may be better known than 'Fæsulæ'; but the student of Livy will know 'Clusium' and perhaps not 'Chiusi', while those who have travelled in Italy may know the latter and not the former; and equally strong claims might be made for 'Præneste' and 'Palestrina'.)

It is worth making the point that many topographical identifications — as between Greek, Etruscan, Latin and Italian names — even though presented as matters of fact in past works, are dubious, at the best, and sometimes clearly wrong.

The names of the tombs and works of art appear in both Italian and English. In some cases it would have been misleading to translate the traditional Italian names because it would amount to a false description (some of the Italian names having been given by finders who misinterpreted what they had uncovered), or because several different names have been given to the tomb or work of art in English books. A large number of alternative forms are cross-referenced in the Appendices ('The Etruscan Towns' and the Index); and elsewhere the translator has tried to be consistent in his inconsistency.

LIST OF PLATES

ACKNOWLEDGMENTS

The following museums kindly allowed
reproduction of the plates on the pages listed
below:
Museo Civico, Bologna 34, 36, 123, 127, 137,
 139, 163
Museo dell'Accademia Etrusca, Cortona 90, 129
Museo Archeologico, Florence 49, 52, 58, 60, 91,
 93, 103, 131, 133, 147, 152, 153, 167, 169, 171,
 175, 176

Galleria Nazionale Estense, Modena 95
Museo Archeologico, Perugia 62, 96
Villa Giulia, Rome 3, 43, 56, 64, 72, 75, 88, 99,
 117, 118, 119, 135, 141, 157
Museo Capitolino, Rome 121, 173
Museo dei Conservatori, Rome 54, 76
Museo Archeologico, Tarquinia 145
Museo Etrusco Gregoriano, Vatican City 44
Museo Guarnacci, Volterra 174

The blocks for the colour plates were kindly supplied by Foto Scala, Florence.

LIST OF FIGURES

MAP

CONTENTS

INTRODUCTION

In the last few decades, the large body of literature devoted to the argument treated in this book has often been specialized in interest, with the emphasis on publishing samples of certain classes of monuments, defining the characteristics of particular localities, and on the further pursuit of particular subjects. It is right that it should have been so, because what has happened in the study of Etruscan art is that the consideration of the whole has been founded on insufficient research data. Of particular value therefore have been those researches aimed at bringing out, in particular, within the general field of 'Etruscan art', and in its chronological succession, the characteristic features of the single centres and their relationship one to another; we have thus moved towards formulating a picture based on historical fact, an Etruscan artistic phenomenon which is the result of a complex whole of separate phenomena which are in part parallel and interacting — a picture not greatly differing from that which mediaeval and Renaissance art historians have drawn of Tuscan art prior to Florence becoming the guiding even if not the absolute centre.

At the same time, the concept of Etruscan art as something geographically and culturally circumscribed has been outmoded, our field of vision now extending to the entire Italic area, still firmly acknowledging, however, the individual and dominant character of Etruscan art.

I have tried to give an account of these and other problems and aspects in the course of this book; not wanting it to have too personal a flavour, I have added a chapter reviewing the principal works on the subject.

My difficulty has been to balance different needs, which lead to contradicting demands in the actual making of the book: to keep in focus, within the chronological framework, the general problems and common features, whilst not dismissing the local ones. I hope that I have done so with sufficient clarity, even though in some cases, so as not to break off the discussion of certain subjects, I have thought it opportune not to follow a strictly chronological sequence. A systematic framework is given in any case by the chronological tables in the appendix. The arrangement of the material is for obvious reasons fairly 'traditional', but I thought it fitting to make some minor changes. Thus, I have taken the Veii terracotta groups out of the 'Archaism' section, because they no longer possessed the interest, in respect of decoration, found in the Archaic, and are immune from the prevailing Ionic influence which had characterized the plastic art of the 6th century. Their isolation, and the force of their impact, are something new, which broke with tradition, which until the end of the 6th century had been fairly constant in respect of the local effects of what was imported from outside. Moreover the very difficulty of

attributing exact dates — in the absolute sense, or relative to one another — persuaded me that in discussing the problems it was better to follow whither logic led.

When we consider the situation as a whole in the ancient world, the Etruscans were only a small people, and occupied only a part of the Italian peninsula. But the civilization of this small people grows in importance when we consider it its effects, the complexity of its formation, the extent of its external relations, the efficacy of its influence in civilizing (and not only civilizing) the other peoples of ancient Italy. This verdict — which recognizes Etruscan civilization's full historic importance — must never be overlooked by any student of antiquity taking up any of the major themes it offers for his consideration.

Bologna, 1962.

I. THE ETRUSCANS AND THE
ANCIENT WORLD

'The might of the Etruscans, before the Romans rose to power, stretched widely over land and sea. How great their power was, on the Upper and Lower Seas by which Italy is girded round like an island, their very names are witness, for the Italic peoples have called one the Tuscan, from the common designation of the race, and the other the Adriatic, from Hadria, a colony of the Etruscans (Tuscans); and the Greeks call the same seas the Tyrrhenian and the Adriatic. In the lands that run down to either sea they established in each twelve cities; first on this side of the Apennines, towards the Lower Sea, and later, across the Apennines, they sent forth as many colonies as there were original capitals, taking over all districts across the Po... as far as the Alps.' Thus Livy described the Etruscans at their moment of maximum expansion (v, 33, 7–10); he had previously said (I, 2–5): '...Such the power of Etruria that she filled not only the land but also the sea with her fame throughout the length of Italy, from the Alps to the Sicilian Straits.'

The Etruscans and the Romans were for long opponents, and the growth of the power of Rome gradually destroyed old Etruria, reducing its cities, one by one, economically and politically. Yet there is scarcely a voice in Roman literature that does not speak of Etruria with the greatest respect; Virgil made the majority of the Etruscans allies of Aeneas. Etruria, in the tradition of the ancients, appears as a nation serving as guide in religion and civil affairs, as a teacher of civilization to the Italic peoples, and particularly to the Romans, who to Etruscan teachings attributed much of what was most ancient and sacred in their moral and institutional beliefs. In Roman scholarship of the 1st century B.C., whether in poetry or historical writings, Etruria is presented as the source of many of their noble titles; and the very vagueness of the chronology, the atmosphere of mystery which even in antiquity surrounded this people, often led to its being viewed as with an aura of the legendary about it, so that the fecund contribution of the Italiote world and culture, which on Etruria and Latium alike often acted contemporaneously, was forgotten. And even though a nationalistic spirit was later to strike out the temporary subjection of Latium to the Etruscans from the official records, and though the 'great Rome of the Tarquins' (as it was put by a great Italian scholar, Giorgio Pasquali, no longer with us) disappeared as such from the history of Rome as reconstructed *a posteriori* by the annalists, that continuous drinking at the Etruscan well was tacit admission of the continuance of contacts of immemorial age.

The 'Etruscan empire' such as the ancients thought of, stretching from the Tyrrhenian to the Adriatic, the first great continuous political structure of ancient Italy, was a fiction: we cannot really speak of the power of the 'Etrus-

cans', but only of that of the various Etruscan cities, which became of first rank neither in alliance, nor always at the same time, with the Etruscan nation politically disunited as it was. The conquest of the Po valley, if conquest it was, and if it was in fact consolidated in the dodecapolis system (a system of which the ancients themselves knew only four components), which seems very doubtful, it certainly was not in the nature of a great national undertaking (as neither was the earlier expansion south of the Tiber and in Campanian territory), but they were both of them undertakings of certain cities of Etruria proper, that is, of those established north of the Tiber, and as far as the Arno. The absence of political unity, amply evidenced by non-co-operation in difficult circumstances — no other Etruscan city moved a finger to help Veii against the Romans, nor in support of Clusium against the Gauls — is also reflected in the different artistic complexion of the separate centres, judging from the material we can see and consider, so that the picture we have is one of a civilization composed of independent entities, of cities with characters clearly their own.

The religious element served to some extent as a catalyst of national unity above and beyond the separatist tendency. We do not know exactly which centres adhered, in the earliest times, to the national sanctuary of the *fanum Voltumnae*, nor how cities seceded or acceded later. An undeniably common basis in religion, parallel with and matching the linguistic unity, did not prevent variants and local flavours, also in connection with the acceptance of Hellenic elements.

This, taken as a whole, is a demonstrated and accepted fact; we are less well informed about the internal politico-social structure, which however appears to have been a fairly uniform aristocratic system, markedly conservative, in which democratic movements were the exception, represented by historical writers as episodes of shameful abuse. The view of religion, formalistic and ritualistic, which largely controlled the life and organization of the town, was expressed particularly in funerary art, in a clear insistent doctrine of survival after death, in forms which correspond much more closely to proto-historic and oriental ways of feeling than to classical and Italic ones.

The problem debated since the times of the ancients, and that which has always seemed the most current and pressing one — whether to 'logographic' literature echoed by Herodotus or to modern historical critics — is that of the place of origin of the Etruscans. Many different theories have been put forward, deterministic and one-sided, and challenged as often as advanced. It seems pointless to take up the problem again here, it being one in any case with which readers, at all levels of culture, are well acquainted. In fact, Etruscan civilization takes on a physiognomy of its own by using the means of artistic expression offered by the orientalizing style, thereby showing affinity with a movement of Mediterranean-wide importance; but it also shows that it is constructed on the fundamental principle of urban life, synchronous in this respect with the general phenomenon of colonizing currents which dotted the Euro-African coasts of the central and western Mediterranean with city units. It might

therefore seem logical, following the 'oriental' theory, to see the 'origin' of the Etruscans as a part of this phenomenon. But the Etruscan cities, far from being coastal centres of the colonial, that is, Graeco-Phoenician type, seem to be offshoots of forces building up from the interior, from their very location on heights at a distance from the coast, or for the correspondence between coastal zones and hinterland, or for the topographical coincidence almost always found between Etruscan cities and populations having the look of the Villanovan culture.

Pallottino's interpretation of the 'ethnic formation' of the Etruscan nation, however, is valuable in turning our attention in a fresh direction, towards an historical point of view, and as a determining factor to further developments. The problem shifts, in fact, as far as the chronological starting-point is concerned, from the beginning of the Iron Age II to the beginning of the First, and the Villanovan civilization, in all respects, is by it taken over and assimilated. Etrurian civilization, therefore, seems to us an Italic phenomenon, modified in its outward and visible forms – moral and artistic – by a complex of Mediterranean influences. This came about, in varying degrees of intensity, and at different times, both in the Tyrrhenian and interior parts of Tuscany, universally believed in ancient times to be the motherland of the Etruscans, and north of the Apennines, at Bologna. The history of a so-called Etruscan Po valley takes on a fresh importance too, a decisive one, in my opinion, for the problem as a whole, since even the double expansion of the Villanovan culture north of the Apennines, at Bologna and Verucchio, appears as a consequence of pressures from central Italy characterized at first by action in unison with the eastern side of the country, and then following different paths in later developments.

In order to discuss these various aspects we must also get rid of the unhistorical chronology with its classifications (which have of late seemed to become ossified by their very completeness, carried to extremes) inherited from 19th century scholars. These rapid notes justify our including the Villanovan decorative treatment as part of the chronological sequence of Etruscan art, which has in fact been done before, but rather from the topographic than the historical point of view. If Villanovans and Etruscans can be seen as separate entities, it would be justifiable to regard their artistic production as two separate developments also, but the fact that a figurative art gradually came to replace the Villanovan geometric style is not of itself a discriminating factor: as in other situations and fields, influences and contributions from outside have encouraged a civilization not figurative in origin to refine its concepts in a figurative direction. I therefore think that special emphasis must be laid, in a chiefly historical outline such as this, on the phenomenon noted above, that is of the organization into cities, in its various aspects, before we concern ourselves with the expression through images of the worlds of religion and symbols, on which were active the same influences as were exercised in art. If our knowledge of the political organization and institutional history of the Etruscans were complete, we could measure their relationships with the civilization of other

Beginnings of Etruscan civilization

Villanovan civilization

From the Villanovan geometric style to figurative art

Mediterranean city-states, better than through their figurative arts, which cannot be given the rank of a determining factor merely because it is the only well-known one. The aristocratic constitution, as far as our knowledge goes, presents an archaic aspect that places the genesis of the various components of the Etruscan nation very far back indeed.

HISTORY

Expansion

The alphabet

The centres of population of the Etruscans are distributed in an area cutting across the peninsula, setting them in almost contemporaneous contact with various other ethnic and cultural elements, extremely diverse in level and nature. To the south they came into contact, direct as well as indirect, with the Greek cities, particularly Cumae, whence they took the alphabet, adapting it to the phonetic needs of a people speaking another language; of the Italic civilizations the Etruscan was the first to receive and use writing, to pass beyond the pre-historic or proto-historic stage. In central Italy, Etruria had on one side, with frontiers not yet precisely known, peoples of other cultures, partly still backward, like the mountain-dwelling Samnites, whom Etruscan penetration in Campania was cutting off from the Greek cities on the coast;

Political boundaries

then the Latins, now developing their own forms of political organization and for whom reaction to Etruscan supremacy took the form, in the specific case of Rome, of an aristocratic revolution against the monarchy; and the Umbrians, who, from a very early date seem to have been deeply imbued with Etruscan civilization. To the north of the lower Arno and beyond the Apennines the peoples with whom the Etruscans came into contact were in a practically prehistoric state and closely linked, as in the case of the Veneti, with the transalpine civilizations. Beyond the Arno stretched the great Ligurian area, lacking either clear cultural characteristics or a well-defined political structure. Etruria thus served as a bridge between the south and north, the Mediterranean and the main mass of the continent. Moreover, whilst on the Tyrrhenian side cultural forms were Mediterranean in type, on the Adriatic there was an ancient inheritance of Oriental contacts, evidenced in the twofold tradition of a Trojan settlement at Padua and one from Colchis at Pola, and documented by the thread of orientalizing influence coming from Apulia to Picenum and by the forms taken by the Nesazio civilization.

Connections with Carthage

Such broad horizons were still further extended by the connections with Carthage, with which Etruria — or rather some cities of Etruria — shared sea-power in the Tyrrhenian.

Not all such contacts took place at the same time, according to the traditional chronology, borne out, moreover, by the archaeological evidence, if we refer to the 'facies' of Etruscan culture as revealed by reliable research. After success at Alalia, which, notwithstanding the uncertain result of the naval battle, checked the fortunes of the Greeks in the northern Mediterranean, to the advantage of the Carthaginian and Etruscan coalition, there came less than a quarter of a century later the setback at Cumae when both the Cumaeans and Latins took arms against them. There followed the evacuation of the Campanian positions, when a power-vacuum was created above Cumae later to cause the fall of the glorious old Chalcidian colony, like others on the Cam-

The setback at Cumae

panian and Lucanian coast, at the hands of the Italic mountain peoples, yet not before the Etruscans repeated, in 474, this time by sea, an attack on Cumae, which was helped, successfully, by the Tyrant of Syracuse, Hieron. The struggle, which must have had a mainly economic basis, was celebrated by the Greeks as completing those over the 'barbarians' which the Athenians and Spartans had won over the Persians at Salamis, and Gelon over the Carthaginians at Himera; yet one can scarcely speak of a common Etrusco-Carthaginian front, it being impossible to discover which of the Etruscans took part in the battle of Cumae. Tradition speaks of an anti-Hellenic and pro-Punic policy and then of a pro-Hellenic one, which can only be explained by supposing different relationships between this and that group of Etruscans and this and that group of Greek cities.

Non-consistent foreign policy

The Etruscans' reverses in the lower Tyrrhenian seem to have coincided in time — judging from the archaeological evidence — with the period of maximum development beyond the Apennines, even though Livy's story of the Gauls settling in the Po valley places the first military defeat suffered by the Etruscans on the Ticino at the beginning of the 6th century, presupposing therefore Etruscan influence already firmly established beyond the Po. Later a supposed coinciding in time — clearly fictitious — is claimed between the fall of Veii, after a long siege, at the hands of Camillus, and the fall of *Melpum*, an Etruscan advance-post north of the Po. In consequence of the simultaneous — even though independent — expansion of two growing powers, the Roman in the south and the Gallic in the north, ancient Etruria would appear to have begun to decline at the northern and southern extremities of its sphere of influence. In reality this decline had begun at the time of the first failure under the walls of Cumae, but the very lack of political cohesion meant that the after effects were neither widespread nor immediately disastrous. Military pressure on a massive scale, like that of the Celts, and a systematic and unremitting policy, like that of the Romans, and especially the latter, invested one by one the constituent parts of the Etruscan nation. It was certainly easy to understand that the threat from Rome was the more serious, and this induced the Etruscans of Clusium to divert the Senones' expedition to Rome at the beginning of the 4th century, and other Etruscans later to make common cause with the same Senones and Rome's Italic opponents in an attempt to stem their growing power, an attempt that came to nought in the battle of Sentinum. Various Etruscan cities, for long thereafter, maintained an ambiguous role, helping indeed the Gallic incursions. The consequences of the Battle of Vadimonis (Lake Bassano) affected the Etruscans no less than the Gauls. The need to adjust to the changed situation led in the end to the Etruscans, as early as the 3rd century, becoming the Romans' collaborators and giving them their support in their enterprises of most moment, and taking their place in the organization which was Romanized Italy. From that moment, Etruria had fulfilled her historic destiny, unfolded through the course of many long centuries.

Roman and Gallic expansions

High productivity and far-reaching trading connections, among the most striking phenomena of the ancient world, were characteristic of the economic

ECONOMIC LIFE

life of the Etruscan cities. By exploiting the deposits of the most important mining district of Italy many Etruscan cities were able to achieve an extraordinarily high economic level, evidently obtaining a monopoly in the manufacture of and trade in metal objects and, particularly, arms. Technological development and, apparently, labour organization caused Etruscan metal work to dominate practically unchallenged the markets of northern and central Italy for a very long period, and in those of the more anciently peopled neighbouring states, as also of the Celtic tribes of later settlement. The solid Italic basis of home trade facilitated that on a longer range, even on a European scale. It is not to be supposed that Etruscan merchants themselves took their products abroad, but rather that trade was carried on — as is evidenced in various parts of Europe — from canton to canton, in both directions, exporting and importing. Nor, we can be sure, were metal products — which have survived and exist as evidence — the only ones, but agricultural products too must have formed an important part of the total volume of exports; the legend of Aruns of Clusium (Chiusi), who fooled the Gauls with the gift of wine and figs, though childish in the form in which it has come down to us, is evidently founded on fact. The struggle to prevent Greek expansion in the northern Mediterranean, that is, resistance to Phocaean consolidation, was essentially an economic war to counter the functioning of Marseilles as an outlet for an important section of the European economy. In this respect Etruscan and Punic interests were at one.

Moreover, the fact that there existed no Greek settlements north of Cumae up to the mouth of the Rhone and that the Phocaeans tried to establish themselves in Corsica, an island which of itself had little to offer, amply shows that the Tyrrhenian coast was entirely under the sway of the Etruscans, who would not have tolerated others getting a foothold. Yet, the situation was not one to stop the flow of the highly esteemed Hellenic products of industry and art found most plentifully in the Etruscan towns, nor to prevent the latter handling them on their way to the hinterland. Etruria was one of the biggest markets for Attic pottery, with this peculiarity, however, that importation through the Tyrrhenian ports during the Archaic and sub-Archaic Age, remarkable in respect of both number and quality, contracted later, in the 5th century, whilst it grew in a notable manner in the upper Adratic and its Cispadane hinterland in a few short decades. This phenomenon is certainly indicative of a situation, or a number of highly complex situations, interdependent one on another in their effects, not causes. One, political and economic, was in the western Mediterranean, where the growth of the power of Doric Syracuse stemmed the economic expansion of Attic Greece, whilst the to-and-fro conflict between the Syracusans and Carthaginians did not in general provide suitable conditions for the pursuit of trade. The other situation was one affecting continental Europe, that is, the shift of power within the Celtic area from Burgundy to the Middle Rhine, which, in the course of things, led to a new route being sought by both sides, that through the Alps, around the end of the 6th and the beginning of the 5th centuries. With such

concomitants the part played by Etruria is clearly seen, holding a power developed and established in the centre of ancient Italy, an intermediary between Mediterranean and continental Europe, on the central axes of both, balancing the other politico-economic forces currently and analogously operating. The separatism which was in the case in point the direct result of the contemporaneous yet practically independent foundation of the single cities, and their inability for ideological reasons and practical causes to develop and bring up-to-date their own internal structure, caused them to fall to the Romans, the only people which succeeded in forming a unitary state and in harmonizing within it the needs of its separate components so as to create a workable instrument.

Intermediary between Mediterranean and continental Europe

Economic causes for decline

The part played by Etruria, we repeat, was not so much a political as an economic and civilizing one, and it is well to clarify what is meant by this last term. No other people of ancient Italy modelled its own institutional organization on the Etruscan pattern: the Romans themselves took elements which were fundamentally external ones, formal and practical rather than substantial, and more in the field of religion than strictly political; in the north the Veneti remained entirely resistant to penetration; later the Gauls took external elements, ones affecting material culture, artistic and manufactured objects, preserving meanwhile their own culture entire. It will be necessary to explore more thoroughly than hitherto the Umbrian and Picenian cultures, the first being in direct, and the second in indirect contact with the Etruscans. It appears that the central Italian people, not Etruscan by race or speech, that became most thoroughly Etruscanized were the Faliscans, also politically allied for a certain time with Etruria. The language did not spread beyond the territory of the Etruscan towns; for their alphabet, however, all the Italic peoples were indebted to Etruria, save those bordering on the Italiote Greek-speaking lands. In Campania, as in the north, where there were Samnitico-Lucanian and Celtic cultures, the Etruscan cultural heritage disappeared in a relatively short time; what the Etruscans left, as envisaged by various scholars in a number of successive studies, is best seen as the Etruscan contribution to the Romano-Italic cultural *koiné*, which was being formed and taking shape from at least the 3rd century. Roman civilization itself seems more deeply permeated by Greek influences and then Hellenistic ones, under the all-concealing mask of which are to be found and identified the forms and phenomena of what survived from the Etruscans.

ETRUSCAN INFLUENCE

Romans

Veneti
Gauls

Umbrians and Picenians

Faliscans

Rome

What ancient Etruria meant and achieved are things to be considered against a particular historical background, supplemented by the geographical facts, the situation, that is, of the 7th to the 4th centuries. We have as students of art history our own particular point of view, and the civilization of the Etruscans presents itself to us as the only one in ancient Italy which was able in a grandiose manner and an amazingly rich variety of forms to give expression to a whole range of figurative ideas, which would not have been capable of formulation had it not been for the continuous stream of ideas coming out of Greece and without constant recourse to the Greek artistic language. This

THE SIGNIFICANCE OF ANCIENT ETRURIA

however does not mean returning to the old proposition according to which Etruscan art was nothing but a provincial, deteriorated manifestation of Hellenic art. It was something individual, because when it was confronted by outside influences and stimuli it was capable not merely of a mechanical repetition, but could lay bare what it felt, and give expression to what it needed to say, to the world of its own imaginings, both quite different in the manner of their birth and growth from those of the Greeks. As compared with the Greek, the Etruscan civilization had not on call an equally full complement of the means of self-manifestation: its characteristic was primarily the need for immediacy, the visual effect. It had no real patrimony of literary production and lacked imagination and poetic creative power, as also speculative reasoning, and perhaps also — as compared with Roman civilization — a positive way of thinking out its law. Conditioned morally by its religious dogmatism and formalism of rites, in practice it sought after the beautiful as an expression of wealth rather than as an expression of an intimate aesthetic need which springs indeed from an organically rational way of looking at things. This is the real point and here stand the intrinsic limits within which we must objectively base our judgment on the art of the Etruscans.

II. JUDGMENTS ON ETRUSCAN ART;
ITS HISTORY AND THE
DIVISION INTO PERIODS

The ancient world's historical writers acknowledged the Etruscans to be φιλότεχνοι, lovers of art, but were intuitively aware that their art had its limitations. In architecture the Etruscans were mentioned for purely technical and type-defining detail, and, in respect of their religious architecture, for the close correspondence between architectural practice and religious ritual. To painting there are no references of significance, of the plastic arts bronze and terracotta works only are mentioned. For their *signa*, that is, bronze statues, Pliny uses the same adjective *Tuscanicus* introduced into literary and artistic terminology by Vitruvius; the statuettes, *Tyrrhena sigilla*, as Horace called them, were sought after by collectors. The literary and artistic texts which we have, mostly inspired by the classicist view which Roman culture accepted from late Hellenism, seized on the impossibility of measuring Etruscan art by the classical yardstick. Strabo established a connection between Etruscan and Egyptian art and, later, Quintilian stressed Etruscan archaism, when he pondered upon the statues of Kallon and Hegesias, *duriora et Tuscanicis proxima*. Etruscan art — for a certain current of Roman scholarly opinion — was therefore a term to serve as a touchstone, and the subject was thus approached on lines entirely opposed to those which are now thought fundamental for modern writing on art history. All of which means, perhaps, only that the ancients' one-sidedness, as it closed their eyes to almost all else than the classic period of Greek art, so it took into account in Etruscan art only the archaic, out of a nostalgic feeling for the ancestral traditions of their motherland which made them look back with special interest to the rude art of Italic antiquity, an attitude (of which Pliny made himself the spokesman) that has nothing to do with critical judgments.

The problem of Etruscan art was not effectively taken up again until the last century. A first movement, in the 18th century, had led to the Etruscans being seen as essentially original creators, whence the polemics on the origin of the pottery found in cemeteries. 'Etruscheria' was more particularly a Tuscan phenomenon, because of the impulse given in the Grand Duchy to archaeological research and collecting Etruscan antiquities, but it was not all vain erudition and uncritical spinning of fancies, in that the pioneer work of Luigi Lanzi was based upon it. Discussion on painted pottery was given immediacy by E. Gerhard in his classic *Report on Vulci*, while the new direction given by Winckelmann had turned studies exclusively towards the 'central' role of classical Greece in the art of antiquity. Thus, for a time, Etruscan art lost its interest, whilst that in ethnic, linguistic and antiquarian aspects grew, and art was mentioned only as something imitative, of marginal, secondary importance compared with art in the Greek world, so much so that J. Martha, when he

published the first history of Etruscan art in 1889, denied that it had had even the power to come into being, conceding to artistic phenomena in the Etruscan area no more than the role of copies. Such reservations had widespread repercussions, not so much because of Martha's influence as because they were generally shared: for want of a fitting critical yardstick those works in which an above average quality was divined were attributed to Greece or Greek artists; and the Etruscan heritage was credited, in the main, not with its more characteristic but with its less valuable legacies. Again a more or less implicit adherence to the 'oriental origin' thesis led to the inclusion of Etruscan art, in textbook classifications, rather with the later artistic phenomena of Anatolia or of the Middle East. That Etruscan should repeatedly recall Greek art followed naturally from analogies of theme, from the Etruscan area's adopting Greece's heritage of myth and legend; the collection of analogic iconographic motifs took the place of evaluation and led judgement astray. Such attitudes were unhistorical, doubtless, but it would be equally unhistorical to wonder at them or to persist overmuch in attacking them.

What is really remarkable is their stubborn survival after the fundamental research of Wickhoff and Riegl opened the way (one made easier by philosophical theories on the one hand, and, on the other, be it not forgotten, by revolutionary and *avant-garde* positions taken up by modern art) to an understanding of the artistic facts beyond the reach of the classical yardstick and outside the limits of classical comparison, and therefore towards formulating acritical judgement, one which, not born simply of a comparison, is inherent in the work of art, not dependent on something outside it. Wickhoff and Riegl reached their conclusions working on Roman art, which delayed, almost of necessity, the broadening of the scope of their methodical exposés, at the very time that the decisive import of Etruscan influence in the formation of Roman art was being widely asserted — asserted, however, as yet, as an intuition, uncritically, and lacking documentation.

The assertion of the decisive role of Etruscan influence on Roman art led to over-estimations and aberrations, for which in the last analysis the ancients themselves were to blame, in their stressing, as we have already mentioned, the civilizing influence exercised by Etruria on Rome. The conclusion having been arrived at, analysis followed, and, elsewhere, with accident of circumstance and non-scientific considerations helping, there was formulated a thesis of an 'Italic originality', in which Etruscan civilization's clearly-marked individual character risked being lost sight of within the ambit of an Italic *koiné* (Anti); this thesis had its repercussions later in the historical field too. To consider art, at base, as only an aspect of that 'Etruscan problem' (a solution to which was continually sought after discussing *ad infinitum* theories about where the Etruscans came from), prejudiced from the outset the critical evaluation of the works and the reconstruction of that art's history, at least in its critically important phases.

A moment of cardinal importance for the history of Etruscan art was without doubt the discovery of the fictile statues of Portonaccio, at Veii; the im-

possibility of classifying these in accordance with traditional views and methods, after some initial hesitation, was fairly quickly understood. It was possible from chronological evidence to attribute these, the one and only exception, to a named artist, Vulca of Veii, and to a celebrated school known to literary tradition (Giglioli). Critical judgement on this artistic phenomenon was also helped by closer study of his particular characteristics and the broadening of research to cover other artistic centres and specially by the increased knowledge obtained of Greek art itself before and after classicism, of the 'geometric' style and the 'High Archaic' in particular, and of Hellenism, and of the irradiating influence from Greece on the surrounding territories from east to farthest west. In other words, Etruscan art found its proper place more easily when seen as part of a more universal picture than the Italic one alone, of which other aspects could also now be more fully appreciated, that of Campanian and Central Italic art in particular: with the discovery of the 'Warrior of Capestrano' comparison, historical and qualitative, between 'Italic' and 'Etruscan' production was easier.

Vulca of Veii

It soon came about that the traditional attitude was starkly confronted by the attribution to Etruscan art of distinctive original features in its powers of expression (Anti; Della Seta) sketching even (Anti) an 'Italic cycle' marked by an Etruscan and a Roman period, whose characteristics were illusionism, anti-naturalism, and a formal primitivism capable of expressing what is individual and immediate, which gave the basis for continuously fruitful developments down to modern times. On the other hand, Greek art remained the yardstick for comparisons as to quality, and it was in fact affirmed that it was legitimate to consider Etruscan art as something on its own, not necessarily linked to the Italic area. A traditional attitude of this sort (Ducati) remained firmly entrenched in its positions, while other tendencies led logically to the problem of Etruscan art being broadened to take in what could be called the dialectical antithesis, classical/anti-classical, and then organic/non-organic. Against this background there now appeared the attempt at interpreting the differentiating characteristics of the Etrusco-Italic and the Hellenic worlds by supposing the existence of an immanent essence (*Struktur*), from which there would be the twin development of plastico-dynamic and geometrico-cubist (v. Kaschnitz-Weinberg). Others have sought the reasons for particular aspects of Etruscan art in the continuance of the archaic geometric in the Etrusco-Italic geometric style (Levi), or — in the case of the oriental origin theory — also in the continuance of the oriental style (Mühlestein: more scientifically, Gjerstad).

Modern views on discoveries

The latter attitudes, there is no doubt, were closer to reality; there was more thorough research into the nature and qualities of existing documents, extended sometimes to details and taking in local peculiarities as illustrating cultural traditions and convergence of influences from outside (Bianchi Bandinelli, Magi, Pallottino, E. Paribeni), with comparison with historical events (Banti) and assessments of individual characteristics (Rijs), and also, of late, the study of attitudes about form, subject and even techniques (Dohrn). Certain it is that generalizations or theoretical assertions of an absolute nature come into

collision with a many-faceted reality whose aspects were often contradictory, and within which some positive conclusions have been arrived at by an analysis inside the local frame and above all studying, case by case, the subjective reactions, the single personalities, so as to arrive at actual 'values' and evaluative criteria based on the work of art, on its intrinsic qualities and its historical position (Bianchi Bandinelli). That does nothing to stop our seeing Etruscan artistic phenomena within the Italic whole, provided in this too we consider one by one the separate moments in a story which is by its nature episodic and, both inside and outside of the historical centres of the Etruscans (Pallottino), resolving the dialectical dualism of 'classic/non-classic' in the actual historical facts of cultural material transmitted and extant, and in the comparison of how the different Italic consequences stand one to another, — the reactions, that is, of the local environments, as a culture, to the pressures from outside which from time to time occasioned them.

This compressed outline could of course take into account only the main elements of the conclusions and methods of treatment of the authors cited; the position is in fact much more complicated, since some of them have in varying degrees come round to the views of others, but a detailed analysis would make this chapter excessively long.

'ETRUSCOLOGY AS A SUBJECT IN ITS OWN RIGHT A certain unity has always been evident in examining the various aspects of Etruscan civilization and history, which have indeed become a subject existing in its own right, 'Etruscology'. But it cannot be said that this has greatly helped us to understand the artistic aspect, and particularly so because of the one-sidedness and prejudice inherent in the attitude whereby the 'origin' of the Etruscan nation was still defined as the appearance of a people on the shores of the Tyrrhenian with an already developed civilisation. The artistic aspect then either remained something apart from the historical perspective, or lent itself to manifest contradictions, as among the proponents of the 'oriental origin' theory, who, after being led to establish a net distinction between the Villanovan and Etruscan civilizations, were then, in art history, forced to include the Villanovan chapter in the Etruscan book. It therefore seems evident that only a presentation on historical lines, overriding those prejudices, and

'Auto-formation concept' broadening, at its very base, the 'auto-formation concept' (Pallottino), could restore the historico-artistic aspect to its logical place in the problem as a whole with a direct and telling effect in a reconstructed history of art, considered broadly as something not separable from the history of civilization. Moreover, a weakening in hitherto rigid attitudes has been evident in the last few decades, even though some scholars have disclaimed any interest in the 'prehistoric' works of art earlier than the 'orientalizing tendency', and, with the stress laid on the 'peripheric art' concept, thus placed Etruscan artistic culture amongst the phenomena resulting from the spread of Greek influence westwards and into the European continental hinterland.

WHAT THE WORKS CONSIST OF As is not the case with Greek art, the study of Etruscan art is based entirely on originals; the scholar's difficulties of identification, collation and evaluation of copies, does not apply. But it must be constantly borne in mind *what* originals

we are concerned with. Etruscan art, like Greek, has been in great part lost, and, for the reason previously given, there are even greater gaps in the documentation. The religious statues are lost, the *signa tuscanica* are lost, save for occasional examples and fragments; what remain are works mostly in the decorative field, even in the highest sense of the Veii *acroteria*. And this is the case also of the pictured funerary cycles — these also remaining the only direct examples known to us of wall-paintings from the 6th to the 4th centuries — on sarcophagi and funerary memorials.

There are small-scale works without number, those commonly called 'skilled craft products', — bronzes, utensils, goldsmiths' work, *búccheri*, painted pottery, engravings, intaglios, mirrors, small urns, — a sort of immense connecting tissue, indicative of the current state of taste, joining together the main ganglia of works of higher aim and greater interest. All this material might be set aside if we could make the same claims for the Etruscan civilization as for the Greek, of an art dependent on a few major personalities, arbiters of taste and prompters of each fresh mood, that is, of an art which moving from preconceptions about quality sets the *nobilia opera* on a different plane from the day-to-day production — whatever heights that may reach — of skilled trades and even from architectural decoration. The sense of the 'finished', the ἀκρίβεια, being unknown to the Etruscan world, means that such a classification cannot be applied, and it is therefore proper for us to extend our interest to a wider range of artefacts, whatever category they fall in; the odd departure, and features showing an attitude or a tendency, can be garnered unexpectedly when the area is very large, leaving out of account of course the mass of industrial copies. All this suggests the need for the greatest care and calls for an alert critical discrimination, imposing on us the duty, not letting ourselves be led astray by first impressions or by tempting externals, of examining, case by case, thoroughly, the quality of the several works, often disconnected, either because they contemporaneously reflect different influences, or because they seem to us incomplete.

Levels of quality

Etruscan art progressed in a somewhat different manner from Greek art; in the one case, systematic development and innovations to meet special needs, creative impetus exactly balanced by logically disciplined execution, — an organic conception; in the other, inconsequentiality, improvization, an asyntactic way of looking at externals, anacoluthic sequences. We are dealing, it seems, with two incomparables, and so indeed they may be, according to the way in which we confront them. There is certainly no sense in wondering at the gap between an Etruscan work and the Zeus of Phidias, if our comparison is made (it need hardly be said) assuming the second as the ultimate in perfection and the measuring rod of quality, — a literary man's attitude, not an historian's. To consider Etruscan art alongside Greek must be on quite another basis. The first without the second could never have been, of course, but the Etruscans' receiving was not a mere copying operation, nor an attempt to come up to the Greek level, both inconceivable, but rather a lesson received and re-experienced in an individual way, a reception that implies a selection.

Greek art and Etruscan art

That fact remains, and indeed acquires a fuller significance, even though in the selection process are lost those very values which we think of as distinctive in the Greek artistic vision, but which, in antiquity, outside the narrow bounds of Greek culture, were in fact incommunicable and unrepeatable.

Etruscan creativeness

We are dealing then not with a mere reflex or provincial phenomenon, as has been affirmed in some quarters, but with conscious, active formation, and — up to a certain point — progressive enrichment of the cultural inheritance which became part of the fabric at the very moment of acquisition, though more or less so according to the continuity, greater or less, of the influences received. Etruscan creative power is in effect a conditioned one; it was unable to renew itself, of itself, when the opportunities and possibilities of refreshment grew less or altogether disappeared, but capable of starting up again, with a noticeable delay, when contacts were re-established. Faced with, as we cannot speak of a particular model in this sense, a flow of stimuli, Etruscan art reacts not by copying, but by re-experiencing on its own account whatever was congenial to it, that is to say, adapting what it learnt to its own need, the need to achieve with ease an immediate effect, the need for ready 'legibility' (and I do not mean legible in the sense of ease of interpretation) with no effort on the part of the reason. It would perhaps not be entirely out of place to suggest the equation, — Etruscan art stands to Greek as Plautine comedy to Menandrean, — the results were quite different even if undeniably conditioned by the same premisses. The relationship to Greek art is thus re-assessed in accordance with the real facts of the case and in the same way the 'originality' — or better the 'autonomy' — of Etruscan art is reduced to its proper proportions. 'Autonomy' rather than 'originality', I repeat, because Etruscan art lacked that poetic phantasy, that ability to create for itself its own figurative-narrative tradition whether mythological or historical, and only in episodic forms, without leaning on Greek iconography, whence the large-scale acceptance of Hellenic mythology in art, prevalently by way of decoration, but later allegorically, or at any rate given fresh meaning. The bringing in of Etruscan figures, such as Vanth or Charu or the Lasae, in scenes from Greek mythology, is a fact which has nothing to do with the history of art, like the Etruscan interpretation and the substitution of Etruscan names for the original ones of the Greek pantheon and the heroes of Greek sagas. Insistence on the need to clarify the relationship with Greek art is justified by the fact that the relationship went on through Etruscan art's entire history, even for much of the orientalizing period, and has legitimately determined the division of that history into periods.

Relations with Greece in various periods

I here do no more than merely mention certain points — with the intention of throwing further light on them in the following chapters — which are now commonly accepted as fundamental, that is that the 'archaicizing' style could be more widely accepted in that it was reducible to external features, whereas from the time of the 'severe style' onwards the Etruscan mentality no longer found it possible to keep to an organic style of composition. This is shown in the Etruscans' lack of interest in anatomy as the expression of syntactic relation-

ships. It seemed to rediscover its lost ability when it was confronted by the 'baroque' style and by the freedom offered by Hellenism, which developed that common language, which archaism had earlier presented, but in Etruscan art there was no awareness that Hellenism had its roots deep in classical Greece and drew therefrom its manifold forms of expression. Thus Etruscan art remained insensitive to late Hellenism's turning back to classicism, neo-archaism, and academism, all of them particular Greek intellectual standpoints.

For the Hellenistic age, indeed, there is little sense in speaking of 'Etruscan art' except in the purely topographical sense — of activities, that is, taking place in Etruscan localities. Etruria's ancient position as the only centre of artistic creation in non-Greek Italy could no longer be maintained, and together with the political levelling of the Etruscan cities within the Roman organization there was the development of other art centres in central and southern Italy. Now at last the Roman catalyst did really bring the Italic *koiné* into being. But at the same time, we must consider another fact; if Etruscan art *ab antiquo* had been city art, just as Etruscan history had been a history of cities, now the various centres which were still artistically active, and which had taken the place of the older ones, began to differ one from another. The urns, for instance, of Volterra and Chiusi have less of that 'family likeness', that common denominator, which in the archaic period, and as late as the 4th century, imposed on them a oneness of complexion over and above any local features they might possess. In other words, what was at one time called the end, the last working out of Etruscan art (more exactly its dissolving, its absorption into the Romano-Italic *koiné*) has two different aspects, which are, indeed, in appearance contradictory. On one hand, the dissolution of the typically Etruscan physiognomy, and on the other, its closing up, its cutting itself off, in a sense, from interregional contacts. This can be easily explained by the difference in degree and speed of the Romanization process, of denationalization, in the ancient Etruscan centres.

'A geographical expression'

A problem which is not to be overlooked is the Etruscans' limited creativeness in architecture; I shall return to this again, but think it necessary to mention it here, because it is a very special characteristic of what was without any doubt a vital urban culture and one which in this respect was to develop quite differently from Greek and other ancient civilizations, which were, in the main, civilizations producing architecture. The interest in Etruscan architecture shown by the ancients is above all, I repeat, a technical and religious one; the Etruscans, moreover, gave no sign of an inner compulsion to express themselves in durable form through architecture, and Etruscan monuments were denied survival by the easily cleaving nature of their material and consequent fragility of their decorative apparatus. Nor, it seems, apart from town planning for ritual or practical purposes, did they follow out architectural schemes extending to more than the single building. Defence works and city gates are of late, sometimes, indeed, of very late date, and there are few remains of temples which can be certainly dated as earlier than the middle of the 5th century. They sought imperishibility only for their tombs, which were mostly under-

Limited architectural creativeness

ground or given an external mark of recognition in the pre-historic tradition by the tumulus or by the architectural fronts of rock tombs. Public buildings or even private residences of much interest are not so far known to us.

The cardinal problem of Etruscan art, however posed, having always been its external relationships, it is clear that there will be consequences from the way we divide up its history, which is somewhat different from setting down exact dates in a chronological scheme. The chronology has undergone notable changes, partly under the influence of the fixed dates of late pre-history and the Iron Age, and set in doubt too by the lack of those concrete details which serve as evidence in date fixing. The point is worth making, therefore, that it is often easier to establish a relative date-order of artefacts from internal evidence. The lack of continuity in Etruscan art does not always allow us to understand the delay in influences making themselves felt, the periods of stagnation and the retreat to positions formerly held, which are not infrequent features of its story. Attributing in some cases a later date, a general practice today, though it has led to some doubts and even exaggerations (such as the fairly recent attempt to re-date some series of handicraft products as late as the middle of the Roman Imperial period), has given us at least a fresh measure of the importance of certain examples which had been spoken of on insufficient evidence as 'anticipations' and 'forerunners'. The latter, in some cases, may be admitted to exist, but they lose their value from the very first because of their accidental character, that is, their being found unsystematically and therefore their not being capable of serving as starting-points for reasoned conclusions; they are suggestive hints, not achievements, in the true sense of the word.

Division into periods There has been, in essentials, a large measure of agreement in the division into periods in its several versions, which vary only in so far as they have been made for different purposes; this is true at least for the distinction made between the orientalizing period and the Archaic under the prevailing Ionico-Attic influence, which does not however at all exclude connections with the Peloponnese, already visible in the orientalizing production, with certain features and forms continuing in a long 'sub-archaic' phase, which dies out as the Etruscans acquired, at a late date, classical formulas, which however are not found in all forms of artistic expression, but are prevalent in figurative art. With the 3rd century begins the period of Hellenistic influences, soon to coincide with that broadening of the horizon already mentioned and for which the term 'Etruscan art' begins to take on only a limited sense. With a mass of phenomena of such proportions as the universal spread of the Roman way of life, it is pointless to speak, as used to be the case in evolutionist judgements, of an 'end' of Etruscan art: the new political state of affairs naturally influenced profoundly the state of art, making it unhistorical to apply then a system of evaluation possible only for Etruria in the archaic age.

One last feature remains to be examined, that, not of the *survival* but of the *handing on* of the legacy of Etruscan artistic experience, of what that has meant and what contributed outside its own environment. The thesis of the survival

of attitudes, of forms, of ways of seeing things, through long periods of time and, as it were, by subterranean, arcane avenues, whereby some have thought they could recognize survivals right into the Middle Ages, does not stand up to critical examination nor offer a worthwhile basis for discussion. Here too we must understand and distinguish clearly: the moment of the Etruscan states' greatest power imposed Etruscan ways of life outside their own historical territories; Latium and the Faliscan territory, though speaking other languages than Etruscan, share with Etruria a common language in figurative art, throughout the archaic period and after, so that no objections have ever been made to including their artistic production in the wider field of Etruscan art. But even in Campania the position is different and Campanian 'Etruschism' fails to take on a face of its own amidst the reawakening of local tendencies and the contemporary flow of Greek influences coming from the Ionic, or directly through the more northerly colonies, from Poseidonia to Cumae, from which last came the political pressure at the end of the 5th century to separate the Latins from the Etruscan sphere of influence. Elsewhere, and specially on the Adriatic side of central Italy, it is not always easy to distinguish what is pure export from what may be interpreted as a local development of Etruscan experiences and here again account must always be taken of the opening up of relations with the Greek lands, whether directly or by the Italiote agency.

If it is in the south of Etruria that the artistic flowering is more intense and more sharply defined, during the orientalizing period and Archaism, that does not mean that central and northern Tuscany were not from an equally ancient date practically Etruscanized, even if with a physiognomy all their own. It was from the centre, mainly, that there went out all that stream of influences, still only in part documented, which introduced Etruscan forms into western Umbria and Perugia, which, for the whole of the 5th and 4th centuries appears from its importations to be in the area receiving products from Chiusi and Volterra. The middle part of the Arno valley is documented by the monuments of Arezzo and from Florentine territory, where the discovery of the tumuli of Quintus shows that local artistic activity was contemporaneous with that of the more richly flowering centres of the south. North of the Apennines, where there were features to which I shall return at greater length later, there occurred in the 5th century, and particularly at Bologna, a head-on encounter between Etrusco-Central Italian pressures and Greek ones arriving via the Adriatic. The area of the Felsinean civilization is a restricted one, and when we reach the plain of the upper Po we find what seem only importations, even if very ancient ones, which did not lead to local forms of artistic creation, and this because the wave of Etruscan expansion soon met that of the Celts. Nor do I think that artistic creation in the Etruscan Po valley served as an absolutely vital element in the art, mainly decorative, of the Veneti, nor for the vast area in which are found the objects which we provisionally define as the 'Art of the Situlae'. I should say that the northern centres of Etruscan civilization had it as their main function to act as intermediaries, though not the only ones,

because contacts via the Adriatic are always to be taken into the greatest account, and the medium of the Balkans and developing tendencies from central Europe cannot be ruled out either. It is in any case certain that the 'function of intermediaries' above referred to must be dated very early, accepting the orientalizing basis of the 'Art of the Situlae'. It would be much riskier, for the present, to accept Etruscan influence in the upper western Mediterranean, for which a claim has been made, to explain theriomorphic characteristics (which in any case are not very old) in southern Gallic art, as deriving from Etruscan daemonology.

In essentials I consider that it is still possible, within certain time limits, that is, not beyond the beginning of the 3rd century, to speak of an Etruscan art, which is individual, yet not cut off from nor independent of the other aspects of the Italic world, but a tangible expression of the only civilization in the Italic area that was capable of constructing machinery of government and of establishing itself as a political force reaching out into a vast sphere of influence, even if I do not believe in an Etruscan 'Empire' as an organic unity, a putting out of context of the later Roman reality.

As for a true and proper survival, other than what I have already been able to say, it is best to write off at once any possibility of direct influence on artistic manifestations, in the Roman period, in the northern part of the valley of the Po. In other fringe areas the distinction which came into being in Roman times between 'cultivated' or 'aulic' — that is 'Hellenicized' — art on the one hand and 'popular' art on the other, allowing the latter no chance to find expression in major undertakings, now the exclusive apanage of the former, exempts us from pursuing the theme in our study of the art of the Etruscans.

III. THE VILLANOVAN GEOMETRIC
STYLE

The geometric style of decoration, reaching maturity in the Bronze Age, takes GEOMETRIC DECORATION its origin from the decorative tradition of pre-history, which in many areas goes back to Neolithic times, to 'zonate' and 'comb-pattern' pottery, and which is sometimes associated with attempts at fictile plastic art; it constitutes a true and proper *koiné* found throughout continental Europe and a great part of the Mediterranean. Development did not come about at the same time in all the several areas, nor were the results achieved equal. Only between the 9th and 8th centuries, in the pottery of the *Dipylon*, was a fully consistent stylistic vision achieved, through which Greek rationalism gave form to the need it felt for wholeness and beauty of proportion, and, instead of guesswork, used a logical, fixed yardstick of proportional relationships. The Villanovan geometric style, though it has some parallel features with the *Dipylon* pottery, was not influenced directly. It does not get beyond guesswork in *Prehistoric way of feeling* judging proportion, is still tied to the pre-historic way of feeling, of rule-of-thumb measurements, in short, those of the artisan, even when pottery manu- FIG. I facture outstrips family needs and becomes industrialized and mass-produced. Not infrequently, however, one can observe a clear striving after the harmonious whole, maturing with time, though not developing steadily and logically, but with returns to the past, fresh starts, and corrections, the succession of which it is instructive to follow. One often sees a clear understanding of the purpose of decoration, which only now and then so obscures the shape as to hinder perception; more often it serves to stress elements which stand out, such as — in vases — the rim, the neck, or the surface with the greatest area. FIG. I Neither does it often happen that attempts at figured work cover the entire FIG. 8 body of the object, being more frequently limited to accessories, such as handles and holders, without the functional shape being subordinated to the

FIG. I – *Painted cinerary urn from Falerii. Museo Archeologico, Florence*

33

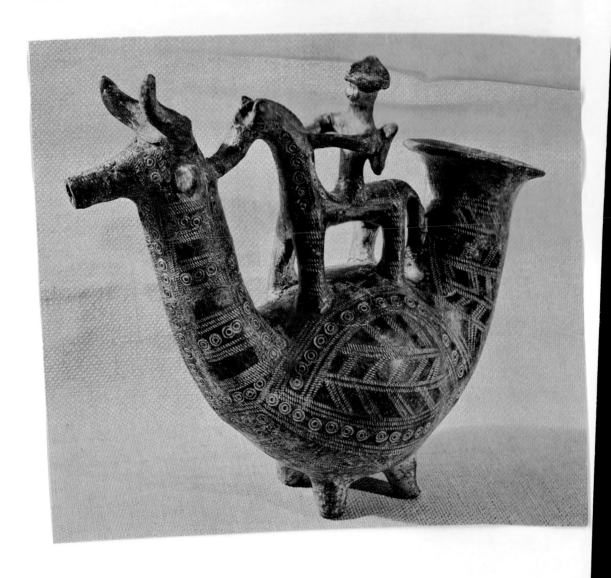

PLATE I – *Askós* in fictile with impressed decoration. Villanovan III. From Benacci Tomb 525, Bologna. *Museo Civico, Bologna. Height 17.7 cm. Cf. p. 35*

34

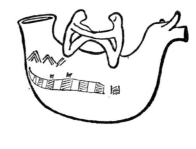

FIGS. 2, 3 – *Askoi from Tarquinia (Monterozzi Necropolis). Museo Nazionale, Tarquinia*

figurative element as in Iranic animalistic art, or functional elements in the body of the object itself taking figurative forms as in Celtic art. The most frequent examples, those of fibulae with decorated bows, do not however predominate, while cases of decoration almost completely covering the object, like the fictile *askos* from the Benacci necropolis at Bologna, are very much the exception.

FIGS. 2, 3

PLATE P. 34

Labour organization

Production was for long of two kinds, one being pottery worked in the home and the other craftsman-produced bronzes, the first supplying the particular needs of human groups which were mainly immobile, the second associated with travel further afield occasioned by metal-working, especially where the need for raw materials meant distant visits. Every craft organization — and thus that too of the Villanovan civilization — has its own special kinds of production and, in a certain sense, its special 'language', or perhaps better 'terminology'. Later, when trade connections are established, pottery takes shapes and motifs from metal-work, and finally the latter from the former too.

FIG. 5

Attitude to colour

The Villanovan potters were not generally great lovers of colour; it cannot be taken as showing a sensitiveness for colour that they used white to mark — with lime, or by the ancient technique of inserting shell fragments — the linear parts of their decoration. Rather rarely and late, one finds the geometrical figures painted red on backgrounds naturally light-coloured or artificially whitened. The metallic additions to the terracotta, in bronze or tin, spring from the inclination to add richness to the article, as is also the case with the amber, bone and glass paste insets in fibulae and other bronze ornaments. The practice of thus setting different materials side by side, in their natural state, gradually brought an interest in colour, even though this was not subordinated to a search for coordinated effects and though the bronze which we see with its green patina had in origin a colour not greatly differing from that of amber. It was rather the metal surfaces — which must have been polished — that stressed with their brightness the search for a magnificence meant to strike the eye, in a civilization which only in late times and by way of exception possessed and worked the precious metals. Our having lost the

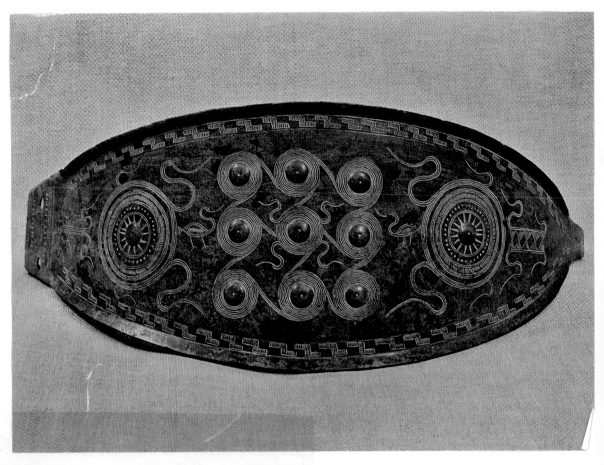

PLATE 2 – Girdle in cast bronze with engraved decoration. Villanovan III. From Benacci Tomb 543A, Bologna. *Museo Civico, Bologna. Length 47.7 cm. Cf. p. 37*

fabrics, and articles in leather or perishable organic materials, will not allow us to make a considered judgment on the Villanovan civilization's colour sense, nor can we base opinion on the tone, generally severe and gloomy, of brownish and blackish pottery alone. The striving after a showy magnificence would lead us to expect a love of bright colours, but there is for us only evidence for the restricted range of yellow, white and blue, of the glass pastes imported from the south and the Orient.

Geometric patterns

FIG. 4

The styles in use were not exclusively geometric: to meander motifs, stripes, wolf's teeth, triangles and rectangular panels were soon added curved linear patterns, chief of which being the conventionalized 'sun-boat', used on a continent-wide scale and persisting over a long period. Schematization often leading to the heraldic bird theme, and typified by fondness for repetition and sym-

36

metric arrangement, does not appear to be of local origin, but to have been adopted just as it was, as in other parts of the continent. It accounts for the tendency to express all zoomorphic elements in schematized form, for instance ducklings, which are likewise reduced to the purely linear, serpentine formula, horses, both as protomes and in full, which occur again and again, and the bull 'promotes' of which the Coste del Marano bronze cup marks a chronologically important point of reference.

The gradual increase in the variety of patterns and the introduction of figurative elements in increasing neglect of the formula, as in the Bolognese decoration of the Villanovan IV period (Arnoaldi), are no part of a gradual, local, autonomous development, but the result of influences and importations from outside. This is equal to saying that the Villanovan civilization had no feeling for the figurative, using figures only to the extent that they could give expression to a decorative or, more often, a symbolic element, without falling into obscurity. The simple plastic sketch of the horse-rider on the Benacci *askós* offers an instructive example of this. The aim-determined character of Villanovan figurative expression could not go further within its limited needs. Its feeling for decoration was essentially geometric and kept within the realm of the linear. It did not set itself the problem of plastic form; the little geese, horses and even human figures are not greatly different in engraving, press-work or when presented independently in plastic forms. In no case is proportional relationship rigidly observed, many concessions being made, on the contrary, to 'expressionistic' emphasizing of certain elements, that end up by isolating themselves completely in the shape of the protome (horses, birds, human heads). There is thus no grouping but a purely paratactic one, in series, without the slightest hint of narrative association, which the Greek geometric style on the contrary did achieve. When figurative elements were arranged in paratactic series, the Villanovan style was already restricted to the northern area, influenced by the orientalizing style which, on the Tyrrhenian side of the Apennines, had entirely supplanted the ancient manner of expression, though not entirely turning its back on tradition.

Patterns which might be called pre-orientalizing, but which in their exclusive use of curved lines contrast in part with the straight line Geometric, were, in fact, common in Villanovan art from remote times: such is the theme of the 'solar disc' in a beautiful belt from Bologna, contemporaneous with and resembling another from Tarquinia for example.

Amid the variety of aspects of the Villanovan civilization, and in others coeval or related, elements may be noted which we shall later find in a developed

Introduction of figurative elements

PLATE P. 34

FIGS. 2, 3

Pre-orientalizing patterns

PLATE P. 36

Development of Villanovan elements

FIG. 4 form, such as the interpretation of the cinerary urn as a house, in the hut urns, that are so often found in the Alban Hills and at Tarquinia, Vetulonia and in Faliscan territory, or else as an aniconic representation of the deceased; also the cinerary urns covered with bronze helmets (Tarquinia, Veii) or with imitation helmets in terracotta (Verucchio), or else surrounded by the girdle (Verucchio). But, apart from these elements and the abundance of non-geometric motifs in late Villanovan art in the north, at Verucchio and Bologna, where even the Villanova form of the stele reappears in the Etruscan period — this however being only a local phenomenon — one cannot say that the Villanovan experience laid the foundations of Etruscan art, or at least one cannot say it yet, in our present state of knowledge. What one *can* say is rather that elements of the Villanovan tradition are found side by side with new ones, coming from the orientalizing side. That is not of course a fact of decisive importance for the solution of the wider and more serious problem at which we have already hinted, of the relationship between the Villanovan and Etruscan cultures, in general, but rather one giving evidence of a fundamental characteristic, to which we shall return again and again in this book, that is, the need for a continuous flow of influences from outside which allowed Etruscan art to achieve an identity, and made it take the shape it did during the course of its history.

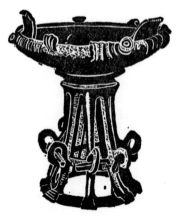

FIG. 5 – *Cup with feet, from Bologna (Benacci Necropolis, Tomb 487). Middle Villanovan period. Museo Civico, Bologna*

IV. THE ORIENTALIZING *KOINÉ*
AND THE BEGINNINGS OF
ETRUSCAN ART

Reference has been made above to the significance that the orientalizing
forms take on within the historical framework, not, that is, as support for the
'oriental origin' thesis, because — and this is no paradox — it would show
rather the contrary, but as proof of the completion of the formative process
of a civilization with particular characteristics, the city civilization of the
Etruscans. In the context of that phenomenon, we find the need for means
of artistic expression different from those of the ancient Villanovan tradition
and — though not entirely disassociated yet from that tradition — in tune
with the great, living world of the Mediterranean. The orientalizing style has
a common character, in spite of its multiform aspects and the gradual nature
of its advance, which covered the entire Mediterranean area, coming from
the East, on the same path as the great currents of colonization and not
without more or less profound effects even in the interior of the European
continent. It is the only *koiné* serving so vast an area and penetrating in
such a variety of directions before the Hellenistico-Roman one, in that the
decorative basis of this art, or the interpretation of its elements in terms of
decoration, made it comprehensible and acceptable in environments and at
cultural levels (amongst which, at first, the Italic ones too) which had no
narrative tradition of their own and did not feel any need for figurative
art.

About the spread in the West — and so in Etruria too — of orientalizing forms, *Greece and the*
the many thorough recent analyses have led us to have a different view from *Orient*
the traditional one; there is no doubt that we must limit the role of the Phoeni-
cians to that of diffusers, merchants carrying luxury goods, cloths, perfumes
and the products of the East, but incapable themselves of artistic creation.
Now the characteristics of the Etruscan orientalizing style show that it would
be only in part correct to think of a passive traffic, of simple transmitters, where
a majority of signs clearly show a sub-stratum of original elaboration, which
could only have been done by the Greeks. Rather than pick out those features
of oriental artistic experience which could conveniently be combined in pleasing
decorative contexts, the Greeks imposed a version of their own, based on their
experience of the geometric style, stressing syntactic coherence and systematic
logic even in matters of pure decoration. Moreover, the Greek world, from the
Trojan war, at any rate, was able to have direct contacts with Asia and
particularly with the Anatolian region, where Greek expansion met (and then,
in consequence, clashed) with forces from the interior of nearer Asia moving
towards the Mediterranean basin. Egypt played a lesser part, in respect of the
West, both in the volume of its exportations and in the diffusion of patterns
and in influencing details, and then not directly, but only in roundabout ways.

Commercial importations The great Ionic 'exploration' of the West, celebrated by Thucydides, partly explains this phenomenon, because what makes up Ionic influence did not operate, when we come to look at the chronological aspect, before the weighty influence, Corinthian in the first place, from the Peloponnese. Phoenician interest in the Tyrrhenian is without documentation earlier than the middle of the 6th century, at the time of the Battle of Alalia, when the Phoenicians of the West, that is, the Carthaginians, were an entity independent of Asia, living its own life; nor can we set a date against the naval battle between the victorious Ionians of Massalia and the Carthaginians. In Etruria, to keep to our main theme, the basis of development of the orientalizing style is to be found in the scale of commercial importation; it has various aspects. Whilst originals of Urartaic art are not lacking, as we have shown, account must be taken of Syrian influence and, already thrust directly into the Mediterranean, Cypriot, with manifold echoes of the Anatolian world, first on the Tyrrhenian side, then the northern Adriatic. That maritime commerce was the means by which the importations came is shown by the fact that the phenomenon occurred in great part in coastal towns and in skilled-craft circles, to meet the needs of a restricted society owing its fortune to the exploitation of economic resources, particularly metal — mining, and desirous of achieving a hedonistic ideal of life.

Aristocracy The orientalizing style is a sign of the birth of the hedonism of the Etruscan magnates, of an aristocracy founded on economic enterprises rather than on the profession of arms.

Figurative decorations Central Italy was now confronted for the first time with examples of figured narration: the gilded-silver goblets, showing Egyptian influence, from Caere ('Regolini-Galassi tomb'), Palestrina ('Bernardini tomb') and Pontecagnano are importations, presenting a complex alien to local taste. More in

FIG. 6
FIG. 7

accord with that taste were such elements as monsters and compounded animal forms, lions, sphinxes, decorative protomes, plant-form motifs, to be composed and assorted in a paratactic or syntactic fashion. Perhaps the expansion of the repertoire in the last Bolognese Villanovan style does more than any other example to make clear the character of this phenomenon whereby one style

FIG. 6 – *Vase in engraved silver from the Tomba del Duce at Vetulonia. 7th century. Museo Archeologico, Florence*

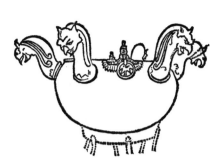

FIGS. 7, 8 – *Lebes in bronze from Vetulonia (Tomb of the Lebetes). 7th century. Museo Archeologico, Florence. Cinerary urn from Tarquinia (Poggio Selciatello Necropolis). Museo Archeologico, Florence*

is inserted within another. The nuances are certainly infinite in number, but, along with the great figurative themes of the bronze reliefs of Urartian complexion (the stands of *lebetes* in the 'Barberini tomb', for example) and the Egyptian-style figurative decoration in the instances already mentioned, and other more general ones, the decorative principle is mainly of geometric origin, an artistic viewpoint wherein perhaps we can see a union of the Villanovan tradition (the last signs of which it bears) and, most important of all, the superimposed Hellenic influence of zonate decoration.

The imitations in kneaded clay (*impasto*) which Etruscan craftsmen very promptly made of orientalizing vessels (*lebes* with stand, now in the Hermitage, Leningrad) show a ready acceptance by the local environment, but also its promptness and talent in re-statement. The Etruscan version is done with

Etruscan imitations

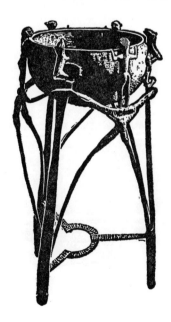

FIG. 9 – *Bronze tripod with lebes from Palestrina (Bernardini Tomb). About 650. Villa Giulia, Rome*

FIG. 10

FIG. 9

emphasis placed on the volumes of particular parts, with the curves exaggerated and the decorations made more striking. In terms of taste we might call it a 'baroque style', which very soon becomes a distinctive feature of much Etruscan work (bowl with sphinxes in the 'Barberini tomb'; Castelletto Ticino bowl). While this is going on, the traditional elements are maintained elsewhere: the small male figures around the *lebes* from the 'Bernardini Tomb' are the descendants of geometric plastic art, and so too the equestrian groups of Vetulonian tripods, still entirely Villanovan in character; the small figures on the wheeled tripod from Visentium; likewise again the linear motifs and little half circles on the shields of the 'Regolini-Galassi tomb' and of 'the Marsiliana', which have affinity in their composition with the fictile shields (used as lids for cinerary urns) of the Villanovan IV period at Bologna; and also the motifs, with a more or less marked 'plastic' treatment, of the throne with reliefs in sheet bronze from the Barberini tomb, in contrast with the refined vegetable- and animal-form stylized features given to the other almost contemporary throne of the 'Regolini-Galassi tomb', completely different in structure and form.

Types of figurative motifs

If we wished to list in categories the figurative and decorative motifs, reproduced a thousand times in metal reliefs, goldsmiths' work, intaglios, and then on *buccheri* too, we should find that they can really be reduced to a very small number; yet one never gets the impression of wearying monotony nor mechanical means of expression. What makes the Etruscan orientalizing style so very vital and attractive is the sense of full possession of decorative forms, felt as wholly congenial, the imaginative freedom with which figurative and decorative motifs combined in contexts of the most varied character, and the ability to express through those forms clearly differentiated nuances of taste.

GOLDSMITHS' WORK

Goldsmiths' work can be described as one of the most significant forms of Etruscan art in the orientalizing period, which was that of its birth; it is a

FIG. 10 – *Bronze lebes from Palestrina. 7th century B.C. Villa Giulia, Rome*

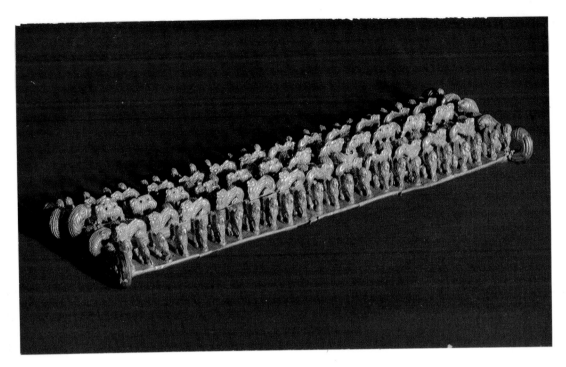

PLATE 3 – Plaque in sheet gold with reliefs and granulation. (A breastplate?) About 650 B.C. From the 'Barberini tomb' at Palestrina (Praeneste). *Villa Giulia, Rome. Length 24.3 cm. Cf. p. 43*

craft specialization, but also a pointer to particular aspects of taste. The contents of the 'tombs of gold' are also indicative of the state of Etruscan society, one in which, in the 7th to the 6th century, wealth and power were concentrated in the hands of a small ruling class. It was this aristocracy which enthusiastically encouraged the introduction of oriental products; thereafter this influence affected wider circles through the means of the local, the 'national' pottery, the *bucchero*.

Goldsmiths' work, in southern Etruria, tends towards emphasis, placed sometimes upon the size itself of gold jewellery like the breastplate or the disc fibula from the Regolini-Galassi tomb or the plaques (breastplates?) of the Barberini and Bernardini tombs. The Regolini breastplate is in relief, carried out with an almost miniaturistic technique, and with schematized stock figures, arranged in long, low 'zones'. The fibula in the same tomb combines relief (lions on the disc) with figures in the round (small lions on the bow) and in this last respect resembles the Bernardini and Barberini plaques, revealing an eclecticism of taste. In plaques coming from Praeneste, on the other hand, one finds a more coherently 'baroque' manner in the accentuation of the relief and superabundance of decoration that emphasizes volume. The persistent use of applied small figures in the round has also the explicit aim of multiplying

PLATE P. 43

PLATE P. 44

43

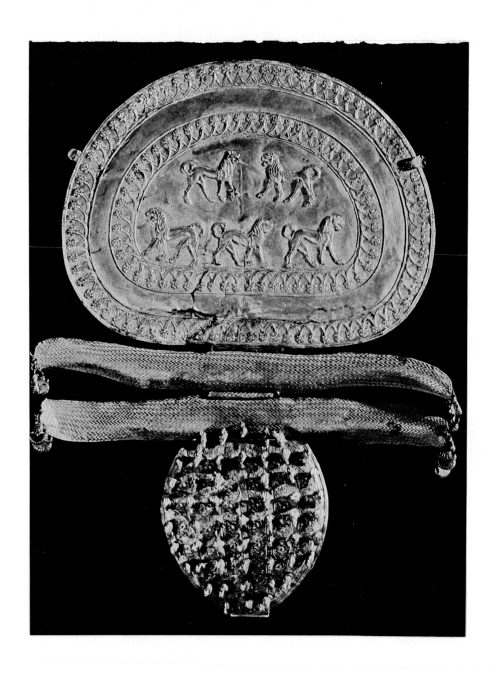

PLATE 4 – Fibula in sheet gold with reliefs and granulation. About 650 B.C. From the 'Regolini-Galassi tomb' at Caere (Cerveteri). *Museo Etrusco Gregoriano, Vatican City. Length 32 cm. Cf. p. 43*

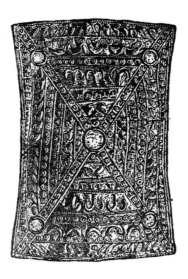

FIG. II – *Gold plaque from the 'Warrior's tomb' (Tar-quinia). 7th century. Antikensammlungen, Berlin*

the reflection of light, augmenting the natural gleam of something made in a precious metal. This striving after light-effects — it too a 'baroque' feature — is greatly furthered by the generous use of 'granulation', knurling, and applied embellishment used to mark out the lines of details, bring out functional elements, and to get colour-effects, — but always to multiply infinitely FIG. II the refraction of light. (There are similar effects in the gold plaque with decoration in relief from the 'Tomb of the Warrior' at Tarquinia.) Hence too the not infrequent samples, in orientalizing style, of fibulas with serpentine bow (Corsini fibula from the 'Marsiliana'; fibula from Vulci, in the British Museum). With granulation, filigree work, often combined with relief, as in the Vetulonia *armillae* (gold bracelets) from the Circolo dei Monili e delle Migliarine, aims at less ambitious effects and uses those of the *à jour* technique.

Just as baroque-like goldsmith work with applied motifs seems to be typical of southern Etruria, though it is far from the case to suppose there was only one centre of production, filigree seems typical of Vetulonia, along with granulation FIG. I2 added to form figures and decorative designs which stand out with heightened tones on the object's polished surface. Shapes however are strictly respected FIG. I3 in these procedures and fibulas in particular show their descent from Iron Age types. Light and colour effects, with less emphasis, are however equally sought after. Much Vetulonia goldsmiths' work was exported, as far as Bologna. At Vetulonia and elsewhere relief was much used, in the bows and fasteners of fibulas, in plaques, *armillae* (also at Tarquinia), and forehead ornaments; sometimes there are even amber insets (pendants from the 'Regolini-Galassi tomb'). Relief work made possible more rewarding results and what one might call 'mass-production'. The effect is basically, everywhere, in externals: the metal is very thin and the value of the gold slight, in articles of such lightness; the value to be attributed to workmanship is therefore greater than that

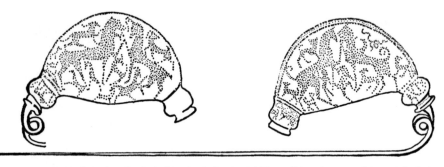

FIG. 12 – *Gold fibula from Vetulonia (Costiaccia Bombagini Necropolis). 7th century. Museo Archeologico, Florence*

of the material. Not infrequently there was recourse to gilt on silver and, in some cases, plating and the addition of embellishment on bronze to achieve the sober polychrome effects of the Villanovan tradition.

The part played by inventive imagination in producing these artistic craft-articles was in making a selection from and achieving variations with elements of an artistic repertoire which remained more or less unchanged; it lies in the art of composition, even if that was then subjected to a regular 'routine'. Craftsmen's originality of technique was equal to the situation: the Etruscans brought in particular granulation and 'pulviscule', i.e. application of gold dust, to a high pitch, as is borne out by their results, so that later their work-manship was well received even in localities having a Greek culture.

ARCHITECTURE Goldsmiths' and craftwork are the most widely-spread and striking forms and in them one can best trace in detail the gradual assimilation of the oriental-izing style; we have therefore given them precedence, in order of treatment, but this must not lead us to treat as if of secondary importance other aspects which are even more significant and tangible. The most significant phenomenon is really the appearance of monumental architecture. We do not so far know, admittedly, in what architectural forms the primitive urban civilization of the Etruscans took shape: civic groupings, private or religious or other public buildings have not so far come to light, nor have we other evidence from which to draw any conclusions. The tombs remain; these too are few, but they have characteristics such that they represent elements of the first importance in

FIG. 13 – *Gold fibula from a Vetulonia workshop, found at Bologna. 7th century. Museo Civico, Bologna, enlarged*

46

the history of the ancient architecture of non-Greek Italy. And it is indeed *Funerary*
symptomatic that the funerary monuments alone should have survived, *architecture*
destined to remain long as representative, almost exclusively, of what the
Etruscans were capable of in architecture. Their ruling class — and this subject
must be taken up again later — showed a continuing, almost obsessive concern
with the survival of the individual and the family after death, so as to give their
burial-places a permanence not possessed even by their religious buildings.
The funerary tumulus with which Etruscan architecture makes its beginnings
is foreign to the Italic pre-historic tradition; and yet it is fairly obvious that
we may exclude any connection with the tumuli of the pre-history of the
greater part of Europe. The problem has been posed inaccurately in that the
attempt has been made to use the appearance of chamber-tombs under tumuli *Tumulus tombs*
as 'proofs' for or against the theory of the oriental origin of the Etruscans. The
The adoption of this type and system can in fact be separated from the question of
'origin' and considered as one of the things introduced from without, as part
of the general phenomenon of the growth of the orientalizing style. With this
thesis moreover one could retain that conceptual link with religious and funera-
ry thought in the pre-orientalizing Italic area which A. Minto attempted to
bring out.

The first translation of the simple earth-and-stone tumulus into architectural APPX. PL. 3
shape, with a plinth of shaped stones which gives a defined geometrical
form to the sub-conic mass, repeats oriental experience, though we cannot
give precise times and places as sources of influence in this respect. The in-
teriors, except for the corridor type, of which the most ancient tomb known, *Corridor and square*
the Regolini-Galassi tumulus at Caere, is an example, have square or circular *chamber-tombs*
chambers, with pseudo cupolas and false vaults, given stability in the first case by
a central pillar. The technique is primitive, if we compare it with the unencum-
bered spaciousness of the 'Tomb of Atreus' at Mycenae. The localities in which
chamber-tombs under tumuli are found cover a great part of Etruria on the
Tyrrhenian side and inland as far as Chianti (Montecalvario) and the country
around Florence ('la Mula' and now 'la Montagnola' of Quinto Fiorentino), APPX. PL. 5
but we have to go as far as Melone del Sodo and Melone di Camucia in the
Cortona territory before we find more complex ground-plans and symmetrical
structures formally arranged around an axis or central element. We must not
overlook the fact that — venerable as their age may be — the earliest examples
of chamber-tombs under tumuli belong in great part to the history of building
techniques and not always to that of art; they represent, it is true, early stages
of experiences which are capable of being transformed into artistic ones, but
are often limited to a contingent need to solve a problem of statics.

This does not prevent our recognizing the reliable planning and conscien-
tious execution of a project, as Caputo has emphasized on the subject of the
Montagnola. He found there a feeling for space, stressed by the very presence
and upthrust of the pillar. Here we are on dangerous ground. There are, it is
true, some remarkable examples showing a sense of space though less so in
tombs with a circular plan than in square ones, where the false vault stands on

FIG. 14 – *Woman's head from a canopus. From Chiusi (Clusium). 7th century. Museo Archeologico, Florence*

pendentives (Populonia: 'Flabelli', 'Pseudocupola' and 'Colatoi' tombs; Volterra: the 'Colombaie' tomb). We cannot trace a development of this system in Etruria because even in the north and centre the general trend was later towards chamber-tombs (even ones under a tumulus) hewn out of the rock; this presents an architectural problem, but not a technical one. Å. Åkerström has pointed out that the tomb with constructed chamber prevails in central and northern Etruria, while in the south the common form is the rock-hewn tomb, the concept, the ideological basis is undoubtedly the same, though the method of construction is different. A. Minto, on the other hand, has found in the most ancient pseudocupola tombs at Populonia features still in the Villanovan tradition (le Granate), whereas the beginning and further development of orientalizing culture is found in the tombs of San Cerbone, with tumuli already built on plinths with a primitive projecting cornice, and, in one case, with a quadrangular bay. The chamber-tomb type and the pseudocupola technique therefore were already part of the Villanovan *facies*, and would appear to give us the first hint of the process of assimilation of orientalizing forms. Along with these constructed chamber-tombs there are others, elsewhere, which are partly underground (Lago dell' Accesa, near Massa Marittima). The dates of the Montagnola tomb furniture allow us to set back also

Date problem the date of the first pseudocupola tombs with a circular ground-plan. The earliest tombs with false vaulting and hypogea on a symmetrical and axial plan, which have been thought to show links with the planning of Etruscan houses, also go back to the 7th century.

FUNERARY PLASTIC ART If we wished to trace a line of development for the plastic arts which had its beginning in the local tradition, we should need to confine ourselves to the Chiusi district; here the process of giving an individual character to the aniconic cinerary urn had already reached the stage of human representation in the 7th century, first by applying masks, then by lids having the shape of heads. The conceptual connection, however, does not explain the figurative developments; how these came about is a mystery, in that one of the most ancient examples, the bronze mask now at Munich, already bears witness to a full mastery of artistic means within what is an inorganic whole, so that the various

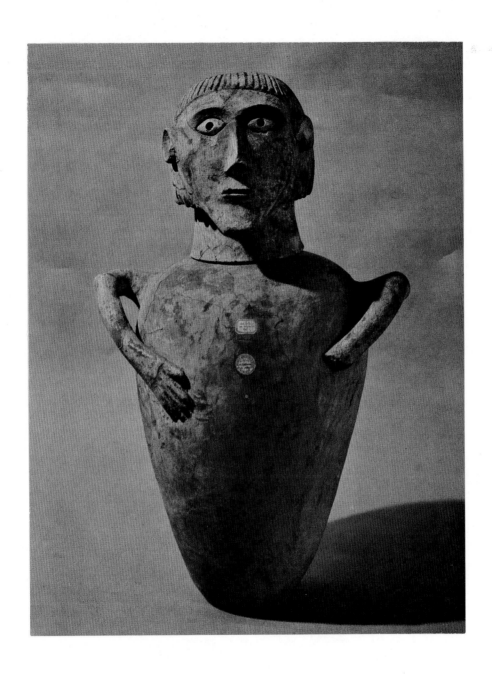

PLATE 5 – Fictile *canopus*. 550–500 B.C. From Cetona. *Museo Archeologico, Florence. Height 61 cm. Cf. p. 50*

parts of the face are practically independent of one another. Stylized in a marked degree, an archaic *canopus* with a woman's head (Florence, Museo Archeologico) encloses the parts of the face within a simple linear scheme. The *canopus* often reinforces its anthropomorphic characteristic by adding the arms, either in relief on the body of the urn, or added separately to it; it is often placed on a chair with a rounded back. It has often been remarked that it is difficult to date *canopi*, and therefore to establish or disprove a connecting line of development, but it is very probable that a line of cause and effect does not exist, and quite certain that differences of style are not to be taken as chronological pointers. Any intention to produce a portrait can be excluded; individual representation is allusive at most; it cannot go to the extent of reproducing the subject's features, something inconceivable at so remote a date. Thus, even in the most ancient *canopi*, certain almost constant characteristics can be recognized, — low forehead, 'full face' pose, particular emphasis on eyes and mouth, inorganic superficial treatment. Thought to be somewhat older in general than even the *canopi* are the cinerary urns surmounted by a statuette and by a considerable number of figurines along with griffin 'protomes' derived from the orientalizing style. The faces of the two main statuettes closely resemble the *canopi* heads. Somewhat different, with its sketch-like representation of the personage at table, attended by a servant, is the well-known ossuary from Montescudaio (Museo Archeologico, Florence); it is certainly older, or at least more conservative because it has the forms traditional to the Middle Villanovan biconic type.

However, even if it shows these original and distinguishing features, the Chiusi district's production is a local phenomenon, restricted to an eminently conservative province; and the appearance of figurative plastic elements in the cinerary urn is in all probability a reflex of the sculpture which was beginning

Canopi
FIG. 14
PLATE P. 49

Dating

Constant characteristics

PLATE P. 52

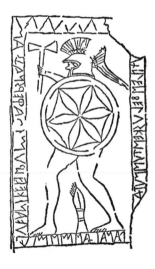

FIG. 15 – *Funerary stele of Avle Pheluske, from Vetulonia. 7th century. Museo Archeologico, Florence*

to be produced in other parts, as at Vetulonia, except that in this case it aimed at singling out individuals, a need scarcely felt elsewhere. It is from Vetulonia that we have perhaps the oldest example of an iconographic monument specifying precisely, by inscription, the personage; this is the stele, with graffito drawing, of *Avle Pheluske*, followed by the two from Volterra, in relief, of *Larth Atharnie* and *Avle Tite*, the latter one being more completely Ionicized, like the Fiesole one of *Larth Ninies*. There seems little doubt that these monuments, alien in their combination of iconographic and epigraphic elements to any Italic tradition, are the result of Greek influences which remained with practically no further effect in Tyrrhenian Etruria. This raises the problem of why the *monumentum* specifically designed to 'introduce' the personage, as an individual — the inscription is there, as in the Greek stele, to give a name to the figurative expression of what is intended as a portrait — should be so rare among the Etruscans, whose use of writing was exceedingly ancient. The phenomenon is rare from another point of view, because the purpose of the stele was to commemorate in visible form, whereas the whole of Etruscan funerary art, except for the *cippi* of the archaic age from Chiusi, and the northern and Bolognese steles, is entirely destined to be permanently shut up in the sepulchre, *canopi* included.

Stele
FIG. 15
FIG. 16

Inscriptions

This problem goes to the very heart of the spiritual state of Etruscan civilization as a whole: a conservative society, in practice restricted to a few families, and from what we know of the earliest ages with almost no internal political life, had basically little need for the individual to assert his own personality, and the problem of survival and the funeral cult was seen, it would seem, from the point of view of the clan, not of the individual, and consequently, even later on, in the chamber-tombs, intentional portraits are not very common in the archaic period; the terracotta statuettes from Caere, partly in the Museo dei Conservatori, and partly in the British Museum, are certainly examples of such portraits. We shall need to speak of these terracotta statuettes again later, as also of the Ionic style sarcophagi with recumbent figures; they are included here for obvious reasons as part of the 'pre-history' of the representation of individuals which, we should remind ourselves, has always a very different significance within the inaccessible whole of a tomb from that of the single, visible iconographic monument, the stele or *cippus*. The very nature of Etruscan religion, deterministic in the extreme, and the absence of an organic thought outside it, were themselves factors opposing assertion of individual personality. It is not that the individual is subordinated, in obedience to a formal programme, within the collective organization, as in the archaic democracies of Greece, but he was denied existence, we might say, for the very opposite reason, for the impossibility of asserting himself in a dynamic internal political life, not even to the extent that that was possible in the aritocratic *res publica* of the Romans. Thus, the isolated cases and purely local aspects can be explained

Sociological aspects

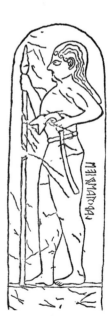

FIG. 16 – *Limestone stele of Larth Ninies, from Fiesole. Early 6th century. Museo Archeologico, Florence*

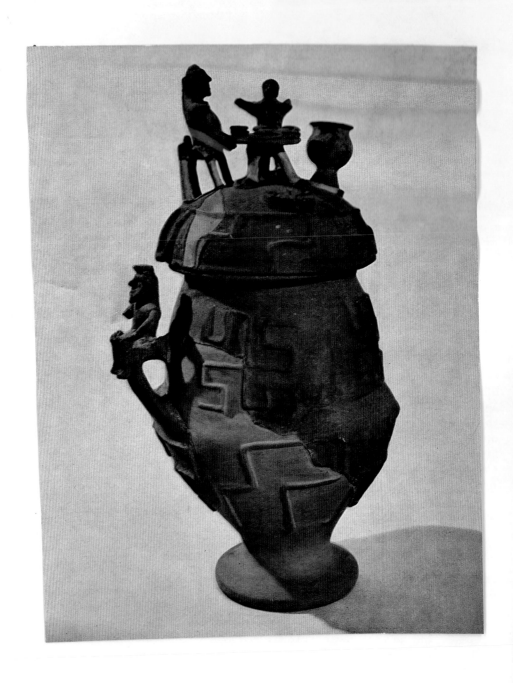

PLATE 6 – Terracotta cinerary urn with figured plastic decoration. About 700 B.C. From Montescudaio (Volterra). *Museo Archeologico, Florence. Height 64 cm. Cf. p. 50*

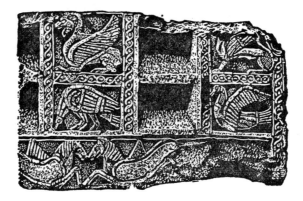

FIG. 17 – *Architectural relief, from Tarquinia. 6th century. Museo Nazionale, Tarquinia*

by influences from outside. Local features, however, persisting while the cultural forms characteristic of the 7th and 6th centuries were being acquired, must not be overlooked.

Sculpture in stone, in full relief, is documented at an earlier date in the Vetulonia sculptures from the Pietrera tumulus. These great personifications of the dead, bearing the mark of manifold influences, carried out in a style which sets out to simplify, that gives little place to detailed description, introduce for the first time the *kouros* and the *koré* in what is an essentially religious form. The Pietrera sculptures result, like the *canopi* heads, from independent and mainly frontal, viewpoints, not from a special feeling for plastic values. This comes about because these sculptures very probably owe their origin to small craftwork models, apparently enlarged versions of ivory or metal reliefs. The main channel by which the orientalizing forms came was the craftsmen, and influenced by their work Etruscan plastic art took its first steps; thus it lacked a feeling for structure. The same is true of the beginnings of sandstone sculpture in the Bolognese orientalizing style of which we shall shortly speak and which shows a common feature with the Vetulonia sculptures, the breaking up of a composition into separate views. It is therefore impossible to continue to accept the early date claimed for another famous sculpture, the Vulci Centaur, which

Stone sculpture

PLATE P. 56

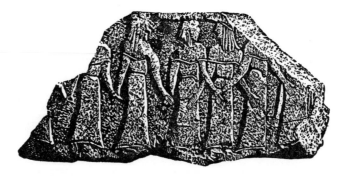

FIG. 18 – *Relief in stone (dancing scene) from Chiusi (Clusium). 6th century. Museo Nazionale, Palermo. Casuccini Collection*

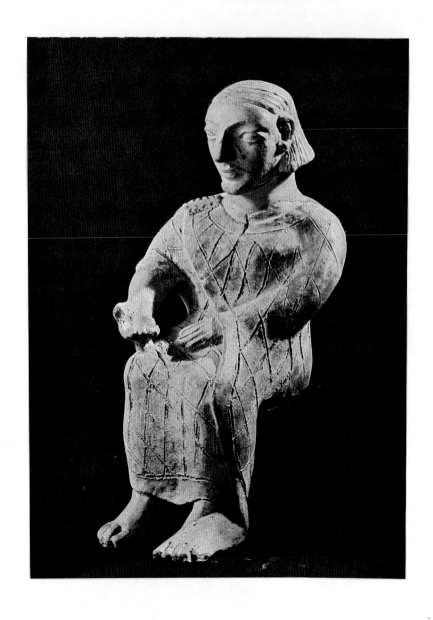

PLATE 7 – Terracotta statue of man, seated. About 600 B.C. From Montalto di Castro or Caere. *Museo dei Conservatori, Rome. Height 27 cm.*

in its human part follows the Hellenic type of *kouros*, of the Peloponnesian variety. The Centaur carries out a conception which is still not a plastic one, because the working out of its cylindroid and spheroid masses is purely superficial. It is the first work of a truly Etruscan character in that it shows this very tendency to simplify the definition of masses, presenting them in their elementary forms, with notable emphasis of certain parts, particularly the head. One would also place at the beginning of the archaic period the snake-footed *kouros*, already in the Ionic style, from Vulci, which gives the impression of a cut stone slab. The most representative example however, it too from Vulci, is the statuette, now in the British Museum, from the so-called 'Tomb of Isis'. The emphasizing of details is toned down by a multitude of influences and a 'daedalic' presentation which calls for further explanation, because its source lies mainly in the daedalic style of southern Italy and hellenized Sicily. The contradiction between the strongly stressed plastic quality of the face and the flattening of the back, and the analysis of detail in the hair in contrast to the simple close fitting of the drapery in the front, shows very clearly the impossibility of fusing what was traditional and what was freshly learnt in one effective synthesis. This is tantamount to the recognition of what from this moment on will remain definite characteristics of Etruscan sculpture throughout the archaic period and even later. The orientalizing experiences, it remains to say, had no echoes in sculpture apart from purely decorative exceptions, as in the slabs in relief from Tarquinia, at present partly in the Museum at Tarquinia, and partly in that of Florence, where the narrative element is inserted along with the figurative themes serving as an ornamental device. We are now at the precise moment when the orientalizing phase is outstripped, a fact also documented in pottery in relief, under the influence of the Greek High Archaism, and also confirmed in the insistent repetition of like motifs like the *threnoi* and the dancing women of a stone relief from Chiusi (former Casuccini Collection, Palermo, Museo Nazionale) and in the 'funeral bed' of the Cortonese sepulchre at Camucia.

We can thus trace two streams, of free-standing sculpture and relief, noticeably differentiated as early as the first half of the 6th century. The head of a sphinx now in Berlin, probably from Vulci, is clearly in the Centaur tradition, with an expression so accentuated that it might at first seem dramatic. We find no great dissimilarity of form in the Munich warrior, from Chiusi, where attention is focussed on the enormous *gorgoneion* on the shield, which also imposes an absolutely frontal viewpoint; with this work there can also be compared two Cortona sculptures — the fragment of a head reproduced in this book, and another woman's head with the same stylized arrangement of the curls on the forehead. The same motif and a relationship between the parts comparable with that in the sculptures referred to above is found again in the Poggio Gaiella (Chiusi) sphinx, which would accordingly need to be attributed to about the same time. The curled-up wings attached to the shoulders are a legacy from the methods used in the orientalizing style. We shall find the same cultural inheritance, though accompanied by Ionic ornamental motifs, in the

Daedalic style

FIG. 17
FIG. 18

PLATE P. 90

PLATE P. 58

55

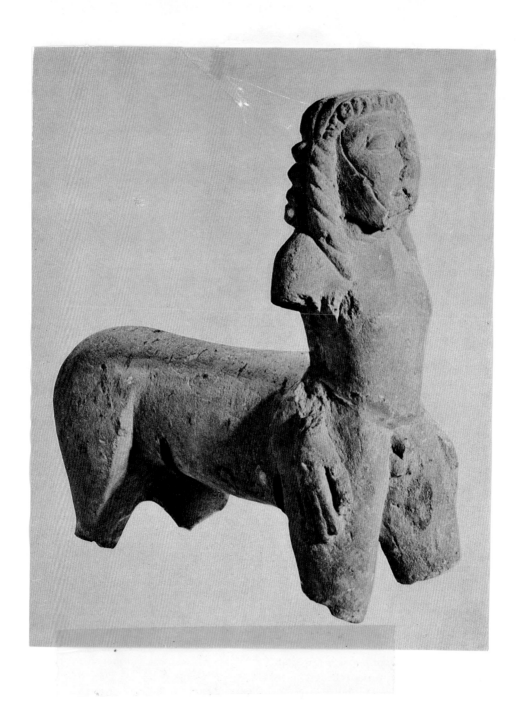

PLATE 8 – Centaur in local stone ('nenfro'). About 600 B.C. From Vulci. *Villa Giulia National Museum, Rome. Height 77 cm. Cf. p. 53*

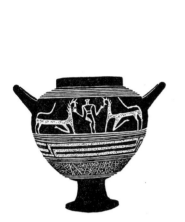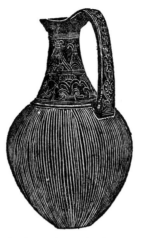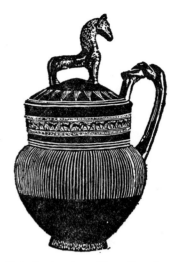

FIGS. 19, 20, 21 – *Terracotta crater, place of origin unknown (Faliscan territory?). End of 7th century. Museo Gregoriano Etrusco, Vatican City. Bucchero vase from Orvieto. End of 7th century. Archaeological Museum, Florence. Bucchero vase from Caere ('Calabresi tomb'?). End of 7th century. Museo Gregoriano Etrusco, Vatican City*

northern Etruscan *cippus* from Settimello, with its four big lions looking back with the same forced look as the steers in the Bolognese Malvasia stele, and in addition a stress on expression, a suggestion of horror, in the bared teeth. Taken two by two the lions compose heraldic pairs, like the Bolognese goats and steers, flanking the 'trees of life', which appear in the shape of Ionic palmettes. The imposing of the new form on the orientalizing tradition is clearly recognizable. The top of the *cippus* has a shape found in the Chiusi area and will be found again at Marzabotto.

The statues of Chiusi and Sarteano, of the deceased rather than of divinities, have less individual character; they adopt the motif of hands on breast of the female figures of the 'Pietrera tomb'. The latest sure documentation of this tendency is given by the warrior's head in the Crocefisso del Tufo necropolis (Orvieto), carried out also in spheroid masses, but already showing a noticeable influence from Ionic Greek archaism. PLATE P. 60

Many are the influences reflected in the Etruscan national ceramic form, the *bucchero*, and in the parallel kneaded-clay pottery, *ceramica d'impasto*, varnished red or ruddy-brown, which follow chronologically the painted vases with figurative and geometric elements from the Faliscan territory and the geometric ones from Visentium (Bisenzio). The kneaded-clay pottery, in which the decorative and technical legacy of the Villanovan past is not to be excluded, at least in the early stages, is otherwise almost completely independent of the prehistoric tradition, above all continuing to imitate the shapes of metal artifacts, as happened in the middle Villanovan period at Bologna. The repertoire changes later, with the addition of graffito decorative elements of orientalizing character on the smooth surfaces, often associated with plastic details on

POTTERY

Legacy of Villanovan civilization
FIG. 19
FIG. 20

57

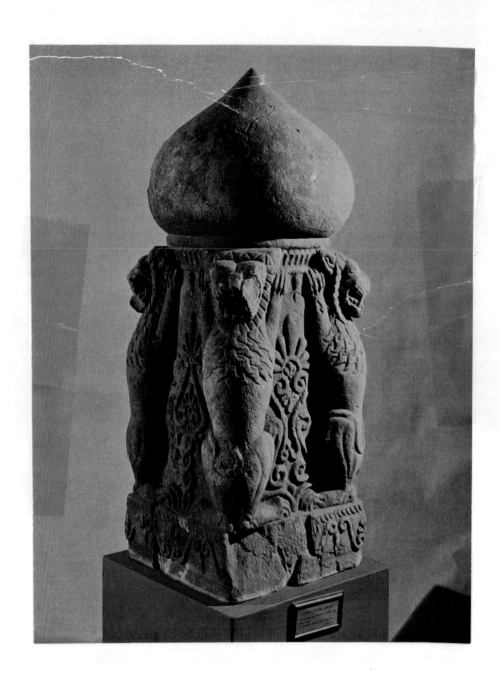

PLATE 9 – Funerary *cippus* in limestone. 6th century. From Settimello (Florence). *Museo Archeologico, Florence.*
Height 1.05 m. Cf. pp. 55–57

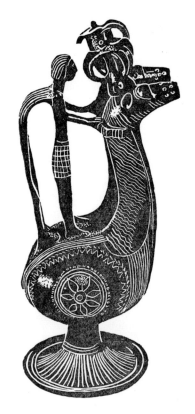

FIG. 22 – *Bucchero vase from Caere (Necropoli del Sorbo).
End of 7th century. Museo Gregoriano Etrusco, Vatican
City*

handles and holders. The red pottery of southern Etruria has often decorations
in relief, impressed by die.

In the *bucchero* in particular there is insistence on refinement of design, es-
pecially in the older examples of the 'thin' *bucchero*, which often turns to
imitation of metal receptacles decorated in relief and carved ivory objects. Their
function as cheap replacements of more valuable articles explains their being so
very widely found, as part of a general movement towards the embellishment of
articles in everyday use and towards an ever greater levelling-up, for a great
many different levels of society, to the refined taste of the economically more
prosperous classes. The accumulation of plastic details, applied also without any
feeling for wholeness, which increases the complexity, the baroque quality
of shapes, especially in the later 'heavy' *buccheri* from Chiusi, is a feature of local
taste. The fragility of the material was a further spur to a high rate of produc-
tion in the case of many classes of artifact which the public liked and which
gave the artisan great scope for imaginative detail and composition. The pro-
duction of *buccheri*, therefore, included a vast range of expression; from the
compact shapes of the *rhyton* with a human head, to the fine intaglio work of
the uprights of high-standing goblets, or that delicate synthesis which is the
unique vase from Caere with a stylized charioteer and two enormously length-
ened horse 'protomes', in which it will not be out-of-place to see an inheritance

Bucchero

FIG. 21

FIG. 22

59

PLATE 10 – Warrior's head in local stone. About 525 B.C. From the Crocefisso del Tufo necropolis, Orvieto. *Museo Archeologico, Florence. Height 43 cm. Cf.p. 57*

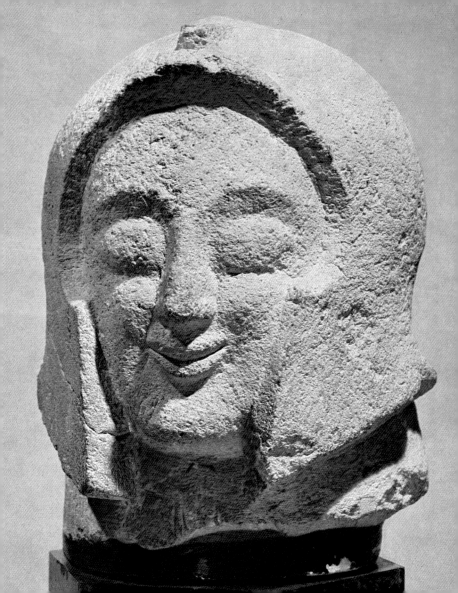

from the figured vases of the Middle Villanovan period. The Greek-style shapes of the *oinochoai* decorated with bean motifs and of the graceful high-handled goblets are embellished with figurative themes standing out in bands around the body of the object, either isolated, or in a continuous series — the plastic equivalent of the decoration found in painted pottery.

Bucchero vases of hellenizing type take up the human 'protome' motif until finally they unfold narrative themes, as in some Chiusi examples (*oinochoai* with the capture of the bull, at Florence, with a musical and dance spectacle, at Hanover, and with the myth of Perseus and the Gorgon, at Palermo), and others from Orvieto (*oinochoe* with wheel-shaped handles, showing a religious dance), and Tarquinia (*oinochoe* with Gorgon 'protomes' and *ephebi* dancing). It cannot be claimed that the production of *buccheri* is a genuine internal development; it is something that was taken from elsewhere, changing with times and tastes and, though keeping the technique and that predisposition towards the emphasizing of masses, it mirrors in a significant way the environment's reactions to different influences, which successively overlay, rather than substituted one another: motifs from the orientalizing repertoire still appear in late productions, which were steeped in the prevailing Greek influence. The distribution of these ceramics offers us a special measure of the extent and depth of the environment's reactions. What became fixed with time was the division into bands, with the figurative and narrative decoration concentrated in one strip where the object had its greatest girth. The strongly-marked plastic relief of the figures is matched by a correspondingly marked relief of purely ornamental motifs, so that this association is perfectly balanced without spoiling the shape of the object, which gains from the uniform colour of the surface.

Dating the *buccheri* and using those dates in an outline of art history are no easy matters, in particular because the die-stamping technique made it possible to keep and re-use the matrices presumably for long periods, and because the work of the artist, once the prototype was made, was limited to the engraving

Hellenizing style

FIG. 23
FIG. 24

Dating

FIG. 23 – *Detail of bucchero pitcher from Chiusi (Clusium). 7th century. Museo Archeologico, Florence*

61

PLATE 11 – Small plaque in ivory with a *kriophoros*. About 550 B.C. *Museo Archeologico, Perugia. Height 8.7 cm.*

of detail, as long as this was in use. For all these reasons, though valuable as indications of the state of taste, *buccheri* cannot be used as completely safe guides in determining the transition from the orientalizing to the archaic period. Research has recently turned to painted pottery, a product that could more closely keep in step with the outer world, and particularly to one variety of it, the Corinthian-type pottery, the production of which in Etruria has interesting parallels with that in Magna Graecia and Sicily. Study is at present hampered by chronological problems which find certain scholars in disagreement, and by material not having been fully published; such study is, however, necessary if we are to understand the latter end of the orientalizing style, and the mingling of the elements which were to form the art of the early archaic period.

FIG. 24 – *Bucchero pitcher, with reliefs (The Killing of Medusa). 6th century. Museo Nazionale, Palermo, Casuccini Collection*

From the very first years of the second half of the 7th century there is a constant synchronous link between the original Corinthian tradition and its influence in the Etruscan area, whether in the black-figure technique (the 'Painter of the Bearded Sphinx', and other painters on pottery), or in the graffito technique, the latter of which cannot be considered without reference to the local *bucchero*. Otherwise purely local taste and traditions were to all intents and purposes inactive and the state of affairs indicated is one of unconditioned acceptance of foreign influences, given still more significance by the physical presence of Corinthian artists, also corroborated by the tradition of the arrival in Tarquinia of Damaratos the Corinthian with a following of artists. Even if not easy to accept to the letter, the story cannot be entirely dismissed in substance. The Corinthian influence, on the other hand, is largely combined with other Hellenico-oriental influences (Ionia and Rhodes) so the general aspect is eclectic, with an eclecticism which cannot disguise the formative elements, and betrays very plainly an inability to become up-to-date in some particulars. Local production lapses into exercises in calligraphy and the dissolution of form into coloured snippets. It is at this point in time that the connection has been suggested, and rightly, I think, with the pictures in the 'Campana tomb' at Veii, the most ancient documentation of Etruscan wall-painting (Szilàgy, and Colonna). It is a regressive moment, with folk-art overtones, but with a vigorous revival from the vast circle of the painter of the 'Rosoni' and other more or less individuable masters, in whose personal culture, along with the Corinthian, can be seen very active Laconic and Ionic elements; this is connected with the crisis in Corinthian influence, in about the year 600.

Corinthian influences

The history of ceramics, however, must not lead us to forget an importation of products from the eastern Greek lands, or from the Asiatic Orient, brought presumably by Greeks or Phoenicians, the last wave, according to G. Hanfmann, of the orientalizing art of the last decades of the 7th century. These

Importation from Greece and the Orient

63

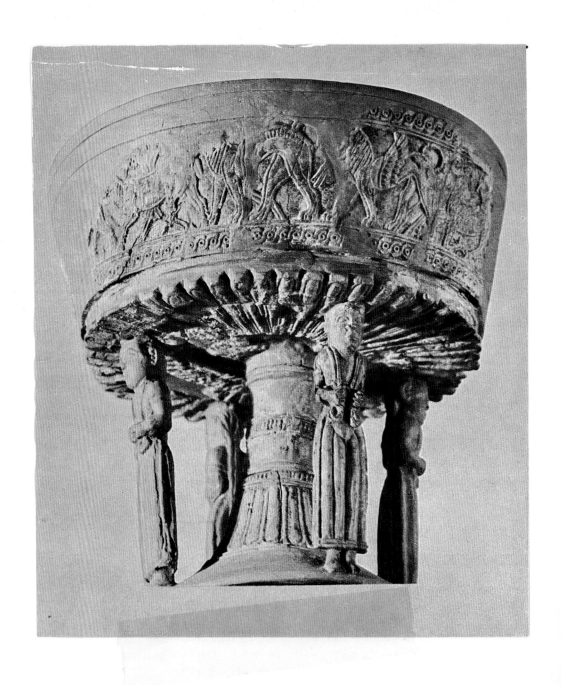

PLATE 12 – Ivory goblet with plastic bearers and reliefs. About 650 B.C. From the 'Barberini tomb', Palestrina. *Villa Giulia National Museum, Rome. Height 14 cm. Cf. p. 66*

FIG. 25 – *Small ivory pyxis from Caere (Necropoli del Sorbo). Latter half of 6th century. Walter's Art Gallery, Baltimore*

products are even more important in quality than the local painted pottery and indicate the artistic taste of those Etruscan *philótechnoi* who accepted them. This all illustrates the nature of the Etruscan orientalizing style in its final state, and the part played by the different elements, or even the mere suggestions of elements, in the formation, maturing over a period of some decades, of Archaism proper. That is true even if the formation must be considered as taking place outside the area of the Etruscan civilization, which was a participator in the process more than anything else, in that it freely received and continuously brought itself up-to-date. To mark the stages of the process itself some points in time will be useful, though we cannot fix them with complete accuracy. The 'Campana tomb' at Veii, which shows Cretan influences associated with the break-down of composition into coloured 'snippets' and with the retention of the orientalizing characteristics, is dated as of the early decades of the 6th century: the diminutive rider on the horse with very long fetlocks recalls the frieze by Prinias. At about the same time the 'Aeolic' capital was introduced in the 'Tomb of the capitals' at Caere; this was for long the equivalent in Etruscan architecture of the Ionic, as the decorative order for interiors, whilst under Ionic influence the most ancient form of temple decoration, terracotta tiles in relief, takes shape. With the Ionic — and certainly in consequence of migrations in the Anatolian area — influences from the Asiatic continent, though less apparent, continue to have their effect, with Gordion as an intermediary (Pallottino), and elements of Syro-Hittite derivation develop on a still vaster scale, conferring on the art of northern Etruria and the late 'orientalizing' style of Bologna a character all its own.

Syro-Hittite influence

As in the case of goldsmiths' and potters' work, we may suppose that there was an internal trade in ivory intaglios; these too were produced in accordance with the features of the orientalizing style. That the material came from the East and Africa suggests closer contacts, but the same thing happened in the case of ivory as with gold, — the imported material was given an artistic treat-

FIG. 26 – *Detail of ivory pyxis from Chiusi (Clusium). First half of 6th century. Museo Archeologico, Florence*

PLATE P. 64

ment which conformed with local taste. But the material, in this case too, influenced the use to which it was put, both because of its precious nature and because of the possibilities it offered. The tradition of orientalizing shapes can be traced from the most linear and archaic Barberini goblet with stem, from Palestrina, to the 'pyxis' from Caere, now at Baltimore, which, with its division into zones (cf. also the better known small *situla* from La Pania, near Chiusi), is connected with proto-Corinthian and Corinthian pottery on the one hand, and can be related to the formative elements of the art of the situla on the other. Another Chiusi pyxis shows a more specifically local character, representing women with long tresses.

FIG. 25

FIG. 26

Ivory sculptures The contents of the Montagnola tumulus tomb at Quinto Fiorentino are of a special character. The importance of the find goes far beyond the relatively small amount of material which has survived a tomb robbery. Of the many pieces of ivory intaglio work there stands out the fragment with 'the tree of life', an oriental feature which is very common in northern Etruria. The link with the Syro-Hittite region evidenced by this motif, by the theme of the rampant rams, flanking the tree in heraldic fashion, and by the small cloaked female figures, has suggested connections not depending on southern Etruria. The problem comes up again in a second northern area of the orientalizing style, that of Bologna. Here the orientalizing tendency was foreshadowed in the break-up of the geometric tradition in pottery, and in bronzes in relief, in the late Villanovan age, a phenomenon which was already taking shape in the Villanovan III. The dates when the orientalizing tendencies manifested themselves fall between the Villanovan IV and the first strata of the Felsinean culture, but we cannot exclude the possibility of this being not an intermediate stage, but a clear sign of a flowing together of the most ancient characteristics with the more recent. Some imported objects (goldsmiths' work from Vetulonia) are found in association with Villanovan tomb contents; these, with the Aureli plaques with small Hatoric heads, are evidence of external influences in forming the characteristics provisionally called 'proto-Felsinean'. This style moreover is locally found in forms quite different from those of

southern Etruria: the examples are of a monumental order with sculpture and reliefs sometimes of great size, and the 'tree of life' motifs and heraldic animals are dwelt on; there is thus a close approach to the art of Quinto Fiorentino. Examples of association with the tomb contents are still not entirely trustworthy; the funeral memorial in relief is grafted however on the Villanovan tradition in the stele of Crespellano and Cà Selvatica, which have an oblong body crowned by a disc, a form repeated in a stele of the beginning of the 5th century. The great stele of Via Tofane, one of the most ancient, decorated with the 'tree of life', was certainly at first of the same type, and later reworked to include a scene from the journey on a chariot to the after-life, for which reason this recent find can be put beside the better-known 'Zannoni stone'. The grandiose 'Vitelli stone' is one of the most ancient achievements of large-scale plastic works, with an original height of more than 9 feet, in the entire Etruscan cultural area. Along with the refined decorative quality of the Cà Selvatica and Via Tofane stelae, and the vigorous presentation of masses in the 'Vitelli stone', the Gozzadini head is certainly a representative and fully achieved work. What remains of a man-faced monster, it is unusual in that the sculpture attempts to present an independent vision for each face, without achieving any plastically valid whole, a shortcoming too of the 'Vitelli stone'. This is something to be expected in an art which has specialized in relief. Stone first used in large relief-steles, was used again in the 4th century; to the existing heraldic motif were added formal processions of animals, a most widely used feature of the orientalizing style of decoration and one which continued in use in the oldest of the stelae that stood over tombs with furniture consisting of Attic pottery. For the themes of the Felsinean orientalizing sculptures, attention has often been drawn to Anatolian monuments very far back in time; what is certain is that the northern area shows autonomous characteristics in comparison with those which are general in the Etruscan orientalizing style, since, in spite of undeniable parallel features, it offers problems all its own.

With the Felsinean civilization of the early 5th century, mentioned at this point because of its relationship with the orientalizing style, the Certosa *situla* is connected; the discovery of the latter has for long led to the belief that 'the art of the *situlae*' was an exclusively Felsinean (and hence Etruscan) phenomenon. In fact, it does not seem likely that the *situla* springs from late Villanovan decorations, nor from the proto-Felsinean orientalizing style, and, even less likely, that it is a parallel of Felsinean atticizing steles. The problem of 'the art of the *situlae*', to day, must be seen as one on an extremely wide, on a European scale, related on the one hand to the continental civilizations of the Iron Age I, and on the other to a complex of importations, ideas and influences which include those from the orientalizing style, but also actual oriental, Mesopotamian and Urartian traditions, and determining influences from the Greek geometric style and proto-Corinthian and Corinthian ceramics. In the Certosa *situla* the division into zones is very strictly carried out, and the complicated scenes are presented in continuous development, each making complete sense. It is the outstanding example of a style and still more so of a range of interests

not at all classical, but not archaic Etruscan either, with the immediacy of its representation of scenes from everyday life, clearly apt for the specific occasion, whether these include, as in this case, ranks of warriors bearing the marks of their special functions, or religious procession, or scenes of rustic life, hunting and feasting.

V. ARCHAISM AND THE ART OF
THE 6TH CENTURY

The matter contained in the last chapter has perhaps caused us to overstep to some extent, at least in some sectors of specialist craftwork, the border line usually drawn for the archaic period, which, with the 'Orientalizing', is in a sense the most creative of the whole course of Etruscan art. Dividing lines are not easy to draw, because of the persistence of a multitude of orientalizing and sub-orientalizing details, handed on, it may well be, entirely as craft traditions.

By the same medium, it may be assumed, came the new architectural forms, *'Aeolic' capital* which remained however of a purely decorative character; I refer to the so-called 'Aeolic' capital, which in fact is scarcely to be identified with the Greek Aeolic. There are about a hundred years between the two most ancient examples, that of Chiusi which has come down to us in isolation, and that of the 'Tomb of Capitals' at Caere, since the first — the only one of real interest to us at this point — can be dated, though not with complete confidence, about half way through the 6th century. It is not a true voluted capital, but a cubic block decorated in flat relief which comes out in virtue of the depth of the carving of the outlines. Its forerunners as to style are in great part Asiatic, not Greek (Ciasca). The more recent (Caere) version is more clearly in line with typically 'Aeolic' shapes, though its date rules out direct derivation; and although it is more functional in conception it does not succeed in being anything other than relief.

The handing-down by means of craftsmen, as with the 'Aeolic' type, probably *Tuscanian style* did not occur in the case of the Etruscan order, i.e. the Tuscanian, which, moreover, in actual monumental, architectural use, we know only in Roman versions, when the rules of the Tuscanian order were already established on the analogy of the Doric. The vexed question of the Tuscan order can be summed up with the judgment that its relationship with the Doric was not one of dependence, but that rather it developed, like the Doric, from the very ancient precedents in the Mediterranean area, in which Egypt, Crete and Mycenian Greece had a hand. The Pompei 'colonnette' with a Doric capital and marked entasis and base cannot be taken into account, because its date is not known exactly and because the area of Etruscan influence in Campania, in so far as it existed, was one where it came face to face with the Greek, the archaic Doric having developed on a grandiose scale on the Campanian coasts. The column in the 'Cuccumella tomb' at Vulci has no entasis but a conical shaft, which is carried to still further extremes in the 'tomb with Doric Columns' at Caere, where the shaft itself has flat faces, as in that of the 'Aeolic' columns of the 'Tomb of Capitals'. The fluted column, whether of the Doric or the Ionic type, was unknown to Etruscan Archaism. Nor are the

massive Doric capitals of Caere linked in dimensional and proportional relationship with the columns that stand below them. It is a case, at most, of a mere isolated echoing of Greek forms. The Cuccumella column, the capital of which has something of the archaic Doric, does not however give rise — there are no other examples — to a complete architectural order, in the sense of a relationship that gives a coherent and indissoluble link between the elements that support and the elements that are supported. Even if we have recourse to architectural elements on figured monuments in lieu of lost architectural originals, we find that the bearing member, from an aesthetic point of view, is sufficient unto itself and remains indifferent to what it supports. The same can be seen too in the celebrated example of the Tarquinian 'Tomb of the Lionesses', where projections of Tuscanian columns are painted in the corners, and it explains why the triglyph, sharing the same structural genesis as the Doric temple, is unknown to Etruscan Archaism, and why the same triglyph, the purpose of which was not understood, makes its appearance only very much later, when it had no more than a mere decorative value.

Lack of architectural system — Thus the architectural order, as a logical unity, was not apprehended as a need by Etruscan architecture, which from Archaism onwards was fond of associating the bearing element, Doric in its genesis, with the continuous frieze of Ionic origin, notwithstanding the fact that the entire architecture of southern Italy and Sicily, with which the Etruscans could have had contact, was solidly Doric. The continuous frieze, which we shall briefly consider later on, was carried out by placing terracotta slabs side by side. Neither did the 'Aeolic' capital, for its part, offer any coherent system of relationships, nor did the powerful, active influence of the Ionic centres succeed in imposing in Etruria the functional voluted capital. Direct Ionic influence is seen, rather, in ad-

Fig. 27 – *Funerary stele from Londa. Early 5th century. Museo Archeologico, Florence*

dition to the fictile temple decorations, in the voluted and palmetted crowning decorations of the north Etruscan steles (S. Agata di Mugello, Londa, S. Ansano), of which some isolated proto-Felsinean examples are forerunners. Typical of the decorative forms of the archaic style are the torus, bulging in contour and mouldings, and the double, semicircular string moulding with a flat strip between. The basic Etruscan feature of the bulging torus is found in the archaic Latian sanctuary of Lavinium, and in Rome itself in the monument found in the Forum and known as the *Lapis Niger;* from it there then develops the moulding with double torus with a flat strip between, in the 'altars' of Vignanello and Marzabotto. A second motif is often repeated in the plinths of tumuli and in the façades of rock-tombs, in forms destined to remain long unchanged. Etruscan architecture, as we shall have occasion to repeat, rarely feels the need to 'bring itself up-to-date', and this shows a considerable degree of indifference, as compared with the irregular but undeniable adaptation to the times revealed by the figurative arts, and high-lights its character as one directed towards the achievement of practical ends.

FIG. 27

Of the problem which occupies a central position in Etruscan art, that of the temple, I prefer to speak later, although there are reasons for supposing that in the 6th century its forms and structural and decorative detail had already taken shape. Far more liberally documented are the tombs, which, of themselves, are never works of art, nor even, in the strict sense, works of architecture, because they were excavated, and not constructed. When pseudo-cupolas and pseudo-vaults ceased to be built, construction was concentrated on chamber-tombs hewn out the rock, even when, as at Caere and Tarquinia, the traditional tumulus was erected over them, the tumulus being by now normally set off by a corniced plinth.

Tomb construction

The tumuli, which at first stood in isolation, were later subjected to a sort of 'town-planning', which in some cases, such as the remarkable one of Caere, made the necropolis completely regular: the filling in of blank spaces by later tombs led to the taking in within the scheme of even the most ancient of the tumuli, each of which by now contained several tombs with many chambers. The prehistoric tradition of the single chamber, coinciding with the central vertical axis of the tumulus, was thus definitively outmoded, but was nevertheless to reappear in a new form in the organic architecture of the Romans. The multiple-chamber form, in its most complex version, was planned on an axial principle, which is one of the few reasons for which it has any significance in the history of art. The tombs would otherwise have little to interest us, apart from their decoration. The extremely archaic 'Tomb of the Shields and Chairs' ('Tomba degli Scudi e delle Sedie') in the Caere necropolis is an interesting first example of a need being felt to represent things realistically, whereby pieces of furniture and objects in an ordinary room are translated, through relief and sculpture, into durable form as stone; the painted shields in two rows in the second chamber of the 'Campana tomb' have the same intention. Painted decoration, extremely frequent in centres such as Tarquinia, is of very great interest for the study of the principles of composition in wall-painting, various

Planned lay-out of necropolis

Tomb decoration

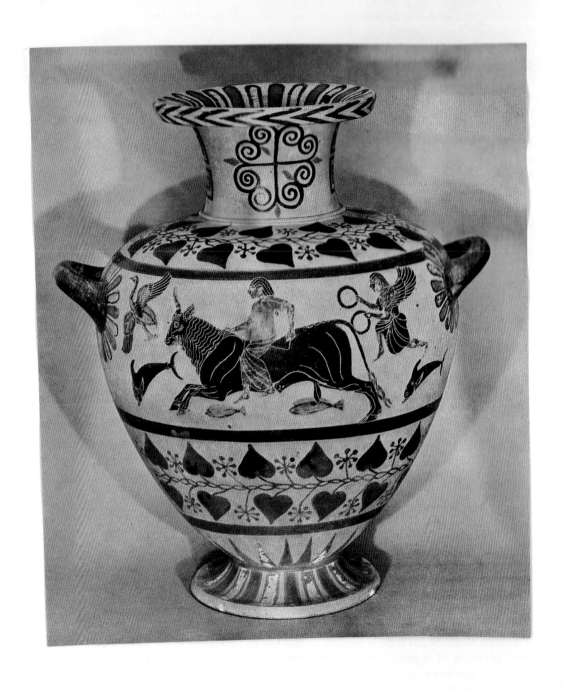

PLATE 13 – *Hydria* from **Caere:** the Rape of Europa. Shortly after 550. *Museo di Villa Giulia, Rome. Cf. p. 74*

FIG. 28 – *Black-figure amphora by the 'Painter of Paris'. Detail. 530–520. Antikensammlungen, Berlin*

examples of which will be examined later. Moreover, the tombs are of value as indirect documentation when we bear in mind the connection between tomb and house, a connection, however, of which perhaps a little too much has been made.

In general, it is a question of translating into stone, inside hypogea, elements made of light materials, and which, in the sizes in question, would be impossible in fact to achieve in stone, except in the rare cases of tombs with columns, as mentioned above. Standing out from the rest is the false roofing, with its parts converging on the semicircular area, of the Caere 'Tomb of the Painted Lions' ('Tomba dei Leoni dipinti') which achieves the effect of coffering. At the end of the orientalizing period there are the Tarquinian slabs in relief already mentioned, they too probably being roofing material. The great increase in big tumulus or hypogeum-type tombs, still more so than the formation of older rock-hewn tomb complexes like that of S. Giuliano, bears witness to the consolidation of the dominant aristocratic caste in the Etruscan cities, and its growth consequent on the increase in wealth. The caste was not then, everywhere, a closed one, but relatively disposed to open its doors to others, as is quite natural in an economy based mainly on industrial productivity and commercial activity. The Etruscans, as has been so often said and repeated, felt the need for permanence only for their last resting place, for the tomb thought of, moreover, not as the burial-place of the single person, but as one common to the family and clan. Certainly, of their schemes and achievements it is the funerary ones that we know most of, and them we must thank if so much of importance in ancient art has been preserved, particularly in painting. With the almost complete disappearance of the painting of antiquity the Etruscan tombs thus take on the highest possible importance, provided we are careful

Sociological aspect

not to be led astray by their uniqueness when we make our judgments about their quality.

POTTERY

'Campana tomb' at Veii

The 'Campana tomb' is in a way the last representative of the orientalizing taste; with what remains of the 'Tomb of the Lions' and the 'Tomb of the Painted Animals' it is almost alone at its time, as an example of a way of wall-painting that is exceedingly well-documented, on the contrary, from the second half of the 6th century onwards. The phenomenon is preceded, and accompanied, by a steady importation of Attic pottery, which first joins, and finally takes the place of the great stream of Corinthian ware. The presence of the Ionic ceramics poses the problem of how to attribute a unified group of painted potteries, called, from the place where they were found, Caere potteries, which, chronologically considered, follow and in part precede the 'Campana tomb' at Veii, and in part are contemporaneous with the most ancient Tarquinian painted

PLATE P. 72

tombs. The shape of the vase is always that of the *hydria* and the division of the surface is generally a single figured zone between decorative friezes. The problem of these painted vases, within the black-figure technique, yet with abundant polychrome notes, is one of the most warmly discussed in Etruscan Archaism: with the lay-out of the scenes generally spacious and well-balanced, the colour construction closely related to that of original Ionic pottery, both technique and taste in decorative elements soon suggested that these might be the work of Greek craftsmen, whilst the possibility has been expressed, because of some realistic and caricatural features, that they may be local productions. The

Hydriae at Caere

thesis, recently put forward again, that Caere *hydriae* are the work of Ionic artists (rather than of one single artist), immigrants into Etruria, is not at all improbable; production, however, can be localized, in that no amphorae of this kind nor vases of the same painters have been found outside Caere. A particular

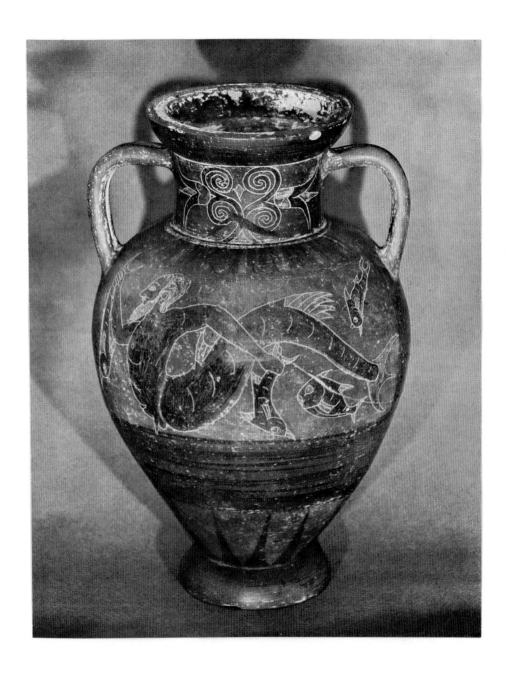

PLATE 14 – Black-figure amphora with triton. Latter half of 6th century. *Museo Nazionale di Villa Giulia (former Castellani Collection), Rome. Height 35 cm.*

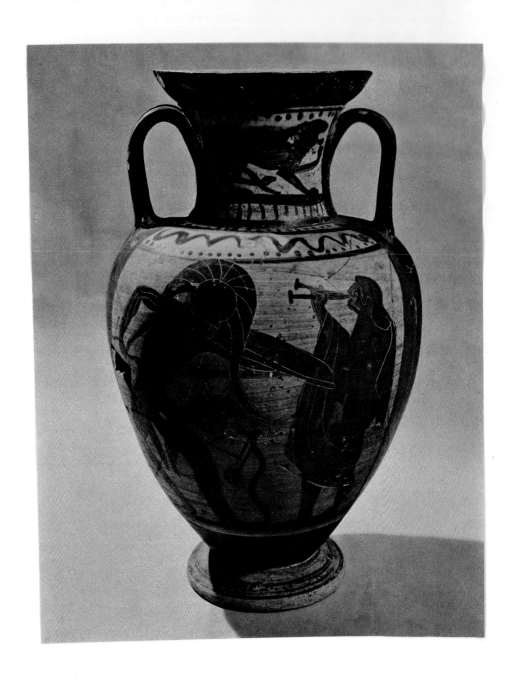

PLATE 15 – Black-figure amphora with warrior and flautist. Latter half of 6th century. *Museo dei Conservatori, Rome. Cf. p. 77*

characteristic is the use of graffito in the details, which is not so delicate as in original Ionic pottery.

In a sense the question is still open, but the Caere *hydriae* are probably the only works of art attributed to Greek artists in Etruria which will remain so classified, and this because of their specifically Ionic look. Etruria on the contrary was sympathetic to ceramic styles of the most diverse origins; besides Ionic, there were also the Laconic, the Chalcidian and the Attic, so that eclecticism is a likely phenomenon; but the Caere *hydriae* cannot be called eclectic. To a workshop in southern Etruria too have been attributed the so-called 'Pontic' vases; and the name has been conventionally accepted. The Pontic vases, roughly contemporary with the Caere *hydriae* group, do not in general reach a very high artistic level. The prevailing interest is not in this case for figurative elements, which are less firmly expressed than in the Caere *hydriae*, and the colour synthesis is less thorough; one cannot here exclude an eclecticism in composition when so many different elements and traditions converge. The principal exponent in this style is the 'Painter of Paris', who with other works painted the amphora, now in New York, showing women at a banquet (?), which has a remarkable decorative effect. The Etruscan-made black-figure pottery of the end of the 6th century was executed under the prevailing Attic influence, to which it is the local alternative. The painter Micali (from Vulci ?) shows a highly personal style, though with only modest results; he produced vases in large quantities, which were widely distributed, in a style that was rapid and had notes of realism.

Thus, though it reached an average level very far from that of its models, Etruscan black-figure pottery at the end of the 6th century was not infrequently capable of expressing itself in a language of its own, laying particular stress on the black silhouette, little impaired by graffito 'finishing', and effectively representing schemes in movement. It is impossible to list here the various artists who have been identified, and these general references seem sufficient. The colour of the clay and the varnishes, always more opaque than that of the Greeks, and capable of many overtones, gives Etruscan dichromatic pottery a special value; but it does not seem that this dichromatic quality was ever deliberately turned to account to achieve expressive ends. The stylistic repertoire of black-figure pottery, which survived much longer in Etruria than in the Greek lands, is in general very different from that of funerary painting, and one can exclude any connection between the two classes; this is easily explained, since in what was carried out under foreign influences the various artists or craftsmen worked with a high degree of independence.

In the middle Archaic period Tarquinia was as far as we know, with Caere, the most active centre for painting, in the only kind we are acquainted with, that is, tomb painting.

The 'Tomb of the Bulls' ('Tomba dei Tori') takes its name from the figures in the smaller frieze, where, on a white background otherwise left almost completely blank, figures of bulls, one with a man's head, are flanked by realistic erotic groups leaving nothing to the imagination. The larger frieze, beneath,

Pontic vases

FIG. 28
The
'Painter of Paris'

Micali

PLATE P. 76

FIG. 29

WALL-PAINTINGS

'Tomb of the Bulls'

FIG. 30

PLATE P. 79 adds an episode from mythology, the famous painting of Troilus ambushed, which is something very much the exception in the Etruscan high archaic, the only surviving example of narrative wall-painting in the whole of Mediterranean Archaism. That it is a descendant of a well-known Greek cartoon is evident, but also evident are certain details, such as the rendering *en masse* of the leaves of the palm-tree, and the giving individuality, by means of colour, to the separate blocks of which the well is built. The little trees in the lower section are in another style, set out realistically and irregularly. The 'Tomb of the Bulls', which can be dated about 530, is also the oldest example of Tarquinian painting, which achieves, a little later, one of its most meaningful expressions in the 'Tomb of the

'Tomb of the Augurs'
APPX. PL. 7
Augurs' ('Tomba degli Auguri'). As in the 'Tomb of the Inscriptions', perhaps a little older, the figured frieze uses almost the entire height of the wall, between a true plinth, painted black, and a higher band in horizontal polychrome strips. This simpler system of Etruscan wall decoration gives the fullest emphasis to the figures, which are arranged according to the principle, not carried out in entirety, of isocephaly. The

PLATE P. 83
world represented by the painter of the 'Auguri' includes solemn figures of worshippers, on either side of the false door in the background, violent wrestling scenes expressive of pure animal vitality, the much-discussed and cruel sport (?) of the man with his head in a sack, being attacked by a Molassian mastiff, the person in a short tunic and pointed cap, in flight, depicted as *phersu* in the preceding scene, where he was egging the dog on. The value of the pictured cycle lies in the fact that the artist has adapted iconographic patterns, taken from cultural tradition, to give expression to subjects not found in the Greek repertoire, though working, formally speaking, under Ionic influence.

'Tomb of Hunting and Fishing'
PLATE P. 87
The 'Tomba della Caccia e della Pesca', so called after the subject of the painting in one of its chambers, dating from the decade 520 to 510, is generally considered the most significant original in Etruscan archaism. It is, as it were, a passage drawn from nature, where the plinth, representing water, dissolves into the decorative system of the frieze proper, which expresses life on the earth and in the air, the diaphanous nature of

PLATE 16 – Mural: the Ambushing of Troilus. About 530. 'Tomba dei Tori', Tarquinia. *Cf. p. 78*

which is suggested by birds in free flight. In the middle there are *de genre* scenes, — those of the fishermen, the slinger, the young man diving, and the other who climbs wearily on to the rock. This vision of life in the open, however, does not escape from the conventions of archaism, does not achieve spatial freedom; the rocks are represented with 'zones', *à flambes*, and birds and fishes are given conventional colours. The merit of the painting lies mainly in the drawing, which is rapid and directed to essentials; the line has here its particular, individual function.

'Tomb of the Lionesses' The 'Tomb of the Lionesses' ('Tomba delle Leonesse') shows the full Greek influence, even to the extent of palmettes and calyces alternating under the horizontal zone which divides the walls into roughly equal parts; beneath are waves, fishes and birds, rather in the manner of the 'Tomb of Hunting and Fishing', but stylized in a more refined fashion; above are the banquet and dances, by now the *leitmotiv* of Tarquinian funerary painting. The wall's decorative system includes, in isolation, pseudo-architectural items, tall columns with polychrome capitals painted in the corners, imagined as a support for the ceiling, but without any cross-bearing members. The division of the walls accentuates the horizontal characteristic, contrasting with the upward movement suggested by the columns, which the viewer consequently feels unnecessary, merely decorative. The isocephaly of the frieze exhalts the figures of the reclining banqueters on the side walls, as compared with the other figures in the Etruscan archaic style, but the lack of harmony in composition is seen when they are compared with the static figures of the musicians on either side of the big *krater*. Of special interest is the figure of the dancing girl on the right-hand side, outlined in red, with considerable departures from the first draft on the plaster, and being thus a significant document of the Etruscan painter's ways of working. In the 'Tomb of the Painted Vases', ('Tomba dei Vasi dipinti')

'Tomb of the Painted Vases' there is also a dissonance implicit between the solidly constructed bottom scene, with the couple feasting in their domestic environment of children and servants, and the dynamism (more in the intention than the achievement) of the dancers with swallow-tail and somewhat archaistic draperies.

FIG. 30 – *Detail of painting from the 'Tomba dei Tori' at Tarquinia. 6th century*

With the examples given us by these tombs we arrive at the end of the century and perhaps the early years of the next one, and we may end with the 'Tomb of the Baron' ('Tomba del Barone'), which is a somewhat unusual case in that dynamism and extravagant effects are totally eschewed, so much so that it has often been wondered if it should be attributed to a Greek painter. The regular arrangement of figures and groups, the emphasis on symmetry, should not however be taken as sole criteria, notwithstanding their being so reminiscent of the archaic Greek world, as for instance the sarcophagi of Clazomenae. The form is indefinite, the composition not entirely organic, and the painting technique of 'doubling' the figures with zones of a neutral colour should be given special attention. The artist is an Etruscan, who as an exception felt himself reined in by Greek sense of form, but only as far as composition was concerned. The case remained an isolated one; it is not on this artistic experience, but on that of the 'Tomb of the Lionesses' and the 'Tomb of the Painted Vases' that the painting of Tarquinia will in the next century be grafted, keeping the fundamental theme of the dance and taking up again that of the banquet, which however will not take place at the family table, as in the 'Tomb of the Painted Vases', but in a hedonistic environment.

'Tomb of the Baron'

Pliny (35, 17) records the existence at Ardea of paintings 'older than Rome'; there were also other very ancient pictures, according to him, at Caere. It is difficult to draw up a chronology on so vague a basis, and we can do no more than admit the existence in remote times of large-scale painting of a religious character (at least the Ardea pictures were in a temple) and which from Etruria may have reached Latium, a fact which may, just possibly, be set against the arrival in Italy of the Corinthian artists who were with Damaratos. About the real age of these paintings Pliny may well have been wrong, for sub-archaic forms persist in Etruscan painting almost until the end of the 5th century. Nor is it possible to estimate the influence exercised in central Italy and Latium by the Greek (or Italiote?) painters, Damophilos and Gorgasos, summoned in 493 to decorate the temple of Ceres in Rome.

Monumental religious painting

Painting at Caere from the middle of the 6th century is mainly represented by three groups of painted fictile tiles, — the Boccanera tiles, the Campana tiles, and the fragments discovered in the Campetti in 1940. The last group is the only one with a mythological content, in two of the slabs which have been put together again. The scene portraying the decapitation of Medusa and the flight of the other Gorgons, is one of the first of the Hellenic mythological themes enthusiastically admitted into the Etruscan repertoire, which was already showing a tendency, as it would continue to do, towards 'horror' themes. A horizontal element marks off, above, a minor frieze, with horsemen and a banquet scene; the picture is thus divided in the same way as many funerary pictures of the same period. Of particular note is the severity of the colouring, with the heavy, dark-red tone of the backgrounds, against which the figures stand out in black and white. The tiles were not each an entity to itself, as in the typically Doric arrangement in a metope, but were placed side by side to give narrative continuity. The same applies to the Boccanera tiles, eclectic in

Painted fictile tiles

APPX. PL. 11

PLATE 17 – Mural with wrestling scene. 'Tomba degli Auguri', Tarquinia. *Cf. p. 78*

character with their mingled Corinthian and Ionic influences; the orientalizing sphinx serves evidently as a sort of terminal sign, a decorative punctuation mark in a figurative context, as in reliefs and the decoration of vases. The tiles, in fact, belonged to a tomb, and made up a frieze not carried out on the site, an alternative to the painting carried out directly on the walls. Of the Campana tiles some would appear to contain, within themselves, a certain finality, but even here one should think rather of a continuous frieze, since one of the tiles was cut in antiquity to adapt it to the architectural context. Moreover, even in the Italo-Greek area, in the sanctuary near the river Sele, Doric decoration in the frieze permitted narrative continuity from one metope to another. The style of the Campana tiles is more refined than that of the other two groups, with clearer drawing and greater colour discipline. It is perhaps the most recent of the three sets.

ARCHITECTURAL DECORATION Architectural decoration during the first part of the Archaism mostly developed the continuous frieze motif of Ionic origin, even if other elements were added as details to the main Ionic thread of influence to form a composite picture; connections with Cretan art (and therefore with the 'Campana tomb' too) can be seen in a slab from the Roman Forum (Antiquarium del Foro, Rome), while elements from the orientalizing repertoire are still to be found, as in the 'Campana tomb', and in the Poggio Buco tiles (from the Statonian territory, at Copenhagen). The themes continue on certain fixed lines, — processions of warriors on horseback or in chariots, scenes with circus artists (Caere; Rome, the Esquiline; Palestrina; Tuscania) with some occasional naturalistic representation, which may achieve an impressive effect in portraying the rush of the charge, and a manner of decoration in which the adding PLATE P. 88 of wings to horses is more an echo of the past than an explicit suggestion of speed.

The formal expression itself varies from substantially complete copies of Greek cartoons to an intelligible simplification or a fluid modelling that destroys the formal coherence of the motifs that served as starting-point. Another theme is that of the 'assembly', for civic or for ritual purposes (Velletri), where the regular repetition of the motifs is more evident, though varied by episodic particulars. Colour is constantly applied to make the figures stand out from the background and bring out details, more matters of painting than plastic art, relief being slight and modelling playing a secondary role. In the coloured parts there is not infrequently a break up of composition (Tile of Velletri, in the 'Museo delle Terme'). Somewhat later, antefixes with protomes were produced with their volumes reduced to simpler forms.

FREE PLASTIC ART
PLATE P. 56
PLATE P. 91 Free plastic art in the Archaism tends at first towards the use of daedalian styles, already met with in the Vulci centaur; the stylized figures of the Brolio *stipe* (Museo Nazionale, Florence), serving as the legs of a piece of furniture, are typical; they are greatly drawn-out in length and great emphasis is placed upon the volume of the heads. Freedom of movement and the separateness and articulation of the arms show that this sub-daedalian quality is only one item in a culture that remains highly composite, with something left to personal

taste. In representing warriors the movement of the arms and the turning of the head break up symmetry and the frontal quality, presumably because of the greater freedom offered in relief. Geometricized volumes (and, in the case of women, schematized ones, still in the tradition of the xoanon type) become rounded under oriental influences. The expression differs from the massy volumetric quality of the centaur and the form is given grace and lightness by the lengthening, such as to warrant our taking the Brolio bronzes as a fixed standpoint in time for the start of certain long-lined stylizations, destined to be carried still further, and to reappear throughout the course of Etruscan art. In comparison the xoanon-type stylization of a female statuette now in Florence, with details carried out by graver, seems quite mechanical. The geometricized warrior of Leyden, said to have come from Ravenna, still has a look of the daedalian; its only Ionic feature is the type of helmet.

The Elba 'Worshipper' ('Devoto dell' Elba'; in the Museum, Naples) comes close to the sub-daedalian types in its geometrical forms and the structure of the head but the Ionic element is to be seen in the profile of the back of the head, in the fluidity of the surfaces and the wrap-round of the draperies, wherein is to be noted, however, that stress on volumes which will for long remain a striking feature of Etruscan art. The 'Worshipper with the *lituus*' in the Florence Museum is more clearly Ionic in style; subdaedalian echoes are here altogether muted and the clinging draperies have the conventional motif of the pleated hem. These examples are attributed for purely formal motives to the early decades of the 6th century, along with others more outspokenly decorative, such as the winged goddess of Perugia, or the winged female figure.

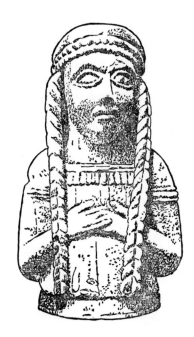

FIG. 31 – *Bust of woman (upper part of cippus) from Chiusi. First half of 6th century. Museo Archeologico, Chiusi*

The *kouros* type, that is, the nude youth, standing, does not become frequent till later, introducing into the Archaic formula highly segmented anatomic detail, carried out with marked accentuation of volume. (*Kouroi* in the Falterona *stipe* in the Louvre; the Palestrina *kouros* at Villa Giulia, the latter greatly elongated

FIG. 32 in form). The formula is differently applied in the *kouros* now in Berlin, in that the anatomical features are almost entirely eliminated and the forms compressed into cylindroid masses. Often personal decorative interpretations are to be observed, as in the presentation of collar-bones, — naturalistic in one of the Falterona *kouroi*, schematized into a broad v-shape in the other, and transformed almost into neckware in the *kouros* from Palestrina. It is doubtful whether we can regard as authentic the '*kouros* from Campania' at Boston, notable for the standing out of the ribs and its rigid symmetry, emphasized by the feature of the two hands on the hips, usually limited to the left side only in originals of certain authenticity. The Etruscan Archaism certainly showed little affection for the classic' *kouros* type, with arms straight at the sides, rather preferring — at any rate in the small versions we have — more lively movement and clearly expressed action. The stance with arms outstretched is not very common even in the corresponding female forms (*korai* or goddesses) which are more faithful in reproducing Ionico-Asiatic styles in the drapings (two *korai* in the Gregorian Etruscan Museum). The type where one hand raising the hem of the garment became

FIG. 32 – *Small archaic bronze. Place of origin uncertain. 6th century. Altes Museum, Berlin*

PLATE 18 – Mural (detail). 'Tomba della Caccia e Pesca', Tarquinia. *Cf. p. 78*

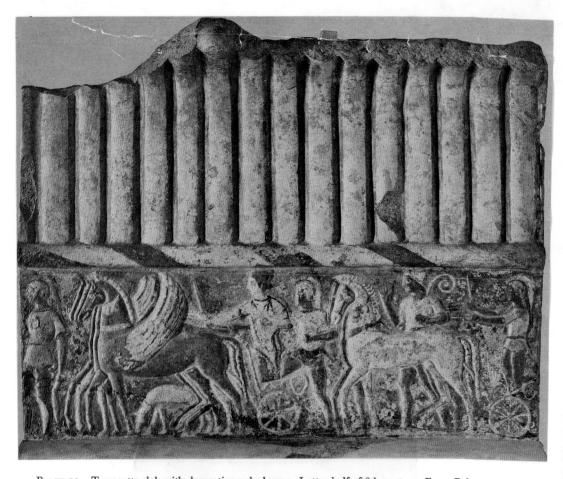

PLATE 19 – Terracotta slab with decorative polychrome. Latter half of 6th century. From Palestrina. *Museo Nazionale di Villa Giulia, Rome. Cf. p. 84*

more frequent as time went on, in forms which were decorative, virtuoso and almost abstract (Turan (?), from Perugia, now in Berlin), later schematized and flattened in everyday reproductions for votive-offering purposes.

Kouros and kore The *kouros/kore* pair is found as a regular item in the *stipe* from the end of the 6th century onwards, changing frequently from the one to the other type, — at Marzabotto, for instance. The *kore* largely reproduces the anatomic shape of the *kouros*, hardly affected by the presence of clothing. There is always emphasis on details, stressed in the volume, specially of eyes, lips and hair; Etruscan Archaism is thus linked, on the one hand, with the artistic climate of the preceding decades, and, on the other, fixes upon those aspects which will find expression later, for example in the Veii terracottas.

Small bronzes, in the Etruscan full archaic period, included many idols of divinities, which might be regarded as deriving from the big religious statuary, such as the Fiesole Hercules, where the powerful presentation of volume is accentuated by the smooth surface of the lion skin in which the body is, as it were, sheathed, or in types such as the *Menrva* and the *promachos* warrior *(Maris?)* which belong rather to the beginning of the 5th century from the point of view of style. Deriving from the type of plastic art represented by the Hercules is the bearded 'god' from Hadria (Adria) (Este, Museo Atestino) which is centainly expressive of a taste and artistic sensibility far removed from the Ionic ones of the Hercules, if only for the piling up of descriptive and attributive detail. The spheroid and cylindroid treatment of volumes, for example, in the Fiesole Hercules or in the *kouroi* or in the *Menrva* at the Louvre, modifies as time goes by as a consequence of substituting an oblique for the front view (*Menrva* from Fermo; Archaeological Museum, Florence) and was destined to become frequent in the *promachoi* of the 5th century. At the start of this new PLATE P. 93
orientation there are echoes of sculptural groups such as the 'Tyrannicides', with which in a sense we may associate the bearded fighter *(Maris?)* of Apiro, which is also, in the shape of the head modelling, and overall scheme, clearly Hellenicized. The continuing presence of drawing traditions (from pottery rather than works in relief) can be recognized in a famous bronze, the *Menrva pro-* PLATE P. 95
machos in the Modena Gallery, in which volume is annihilated in the body, re-maining, incoherently, in the head alone, where the expressionlessness of the countenance is in contrast with the violence of the pose. The external treatment aims at striking certain notes, and mainly these three, — the smooth *chiton*, the pleated hem of the overskirt, and the shield, finely worked over with the engraving tool.

The most obvious examples of faithful adherence to Ionic styles in Etruria in *The Loeb tripods*
the middle of the century are the so-called Loeb tripods (Munich, Antiken-sammlungen). In spite of remaining doubts about recomposition, the modelling APPX. PL. 9
and design, in volumes completely and simply defined with decorative discipline and coherence, are in perfect harmony with the style of the reliefs and cast metal additions. In the repoussé reliefs the well-defined outlines, in some cases made quite explicit, mark the standing out of volumes which show externally in broad and coherent curved surfaces, an idea found again in the cast figurines of the edges and lids. The group is the work, it seems clear, of one artist, who has been linked with the author of other plaques in relief (with enamel additions to the eyes), of which one is the struggle between Zeus and a giant; this artist is considered to be the chief of a group of workers in bronze at Perugia. This raises a difficult problem; the bronzes have, it is

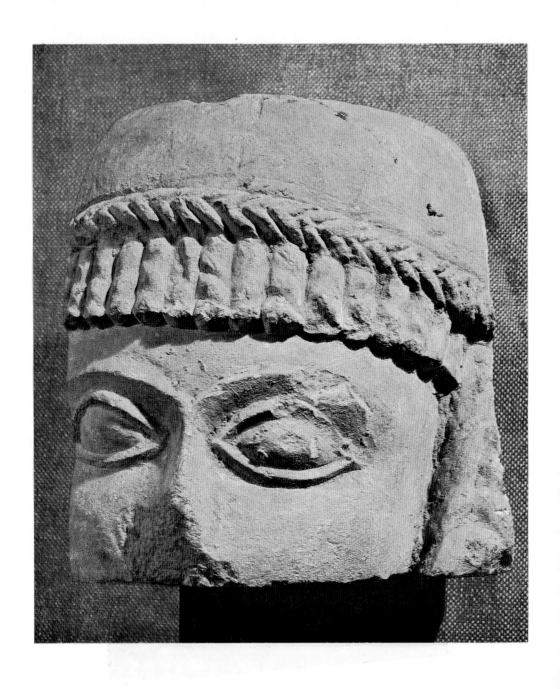

PLATE 20 – Limestone sculpture. *Museo dell'Accademia Etrusca, Cortona. Cf. p. 55*

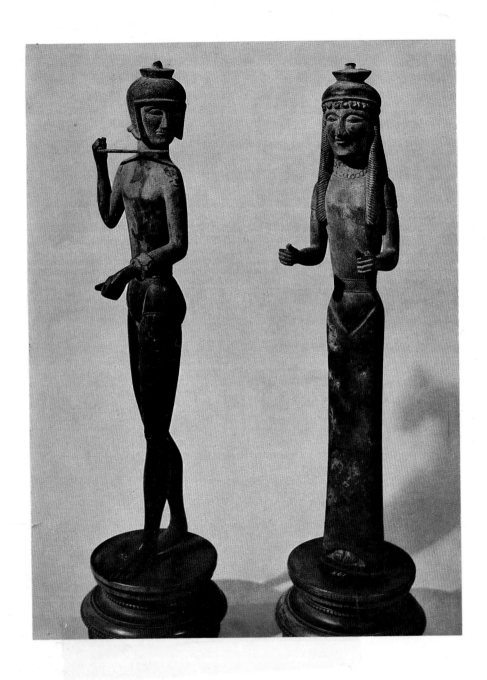

PLATE 21 – Two figured supports for furniture, in bronze. About 550 B.C. From Brolio (Arezzo). *Museo Archeologico, Florence. Height of male figure 36.4 cm; height of female figure 36 cm. Cf. p. 84*

FIG. 34 true, all been discovered in Umbria, but there is not, on the other hand, supporting documentation to indicate any considerable degree of Etruscanization in Umbria in the middle of the 6th century.

Reliefs Belonging to the same group of reliefs found in Umbrian territory there is also the metal plaque portraying the Amazons, now in the British Museum, more decorative than the Loeb tripod compositions; in it, beside the plastic element, there is an attempt at chromatic effects, obtained by additions of silver. The chariot plaques from Castel San Mariano, one containing the great

FIG. 35 figure of the Gorgon between lions, and the others hunting scenes and fantastic creatures, offer alongside the mythological content of the Loeb tripods a more general narrative theme which enabled the artist to use items from a repertoire from other sources. The style is more inclined to episodic detail and lacks the tight coherency of the Loeb reliefs, but it has, against this, a force and a representational efficacy which come in fact from its greater independence of forerunners and cultural influences. More linear in style is another plaque, a woman bearing a perfume casket, with more insistence on the descriptive element. This suggestive complex, which has not yet been thoroughly studied, shows a flowing together of various tendencies, though all within Ionic horizons and each of them outspoken, not an eclectic phenomenon, all of which might be taken as a contradiction of the theory that there was a local centre of production. The small lions in cast bronze, soberly finished by burin, show a still further tendency, — the symbiosis between the stylized decoration of the heads and the body articulations from which the details are brought out.

Two female heads have a similar Ionic character; these *sphyrelata* are among the most important works of archaic Etruscan art.

In the same Ionic current as is represented by the Loeb reliefs, but with a persistent tendency towards geometric forms, are two well-known bronzes thought to be from Vulci, — the Munich candelabrum and the small chariot now in the Louvre. In both a nude youth is brought in as a bearing element, though the arm movement, as for that matter was the case in the Brolio figures, does not correspond with any practical, architectural function. Etruscan art, which knew nothing of figurative elements with a true and proper architectural

FIG. 34 – *Bronze plaque from chariot. From Perugia. 6th century. Antikensammlungen, Munich*

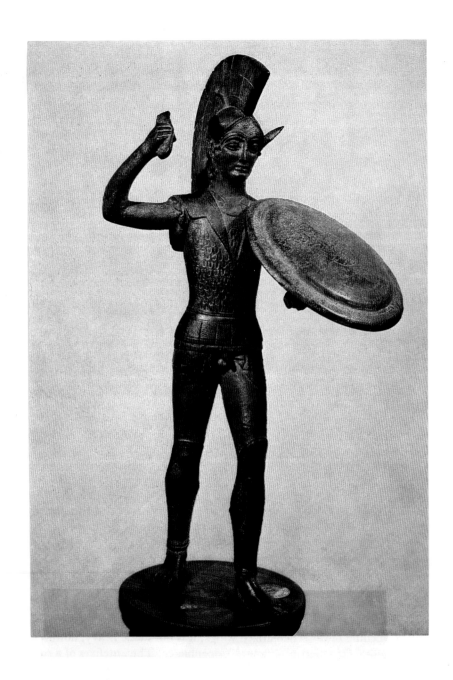

PLATE 22 – Votive bronze (warrior fighting). About 450 B.C. Place of origin unknown. *Museo Archeologico, Florence. Height 33 cm. Cf. p. 89*

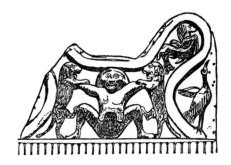

function, animating, that is, and giving human forms to structural members, did however like to apply the principle in small decorative objects.

Tripods with
supports
FIG. 36

'Bar-tripods' have a different character from the examples previously examined; they too are thought to come from Vulci. Descending from the 'rod-tripods' of the High Archaic period, these richly decorated objects enjoyed much popularity; they were copied in the Magna Graecia area (Metapontum) and also exported directly, — a famous fragment of one of them was discovered on the Acropolis at Athens. In the Loeb type, the sheet-metal support balanced, in volume, the mass of the vase it supported; in these latter types the stand has no volume of its own, but as in the rod-tripods, only the vase has a definite mass. The stand is made up of elements worked on the *à jour* method, with richness of decoration, volutes representing plants, and figurative groups. The style rich in and often with a superabundance of detail meets the decorative need, arranging figures in couples and groups of three as in the Acropolis fragment, or putting in the place of the unrelated paratactic groups others more complex and episodic (Hercules and Achelous; young men with horses). The Acropolis fragment, in the tradition of works in relief, is not far removed from a very well-known small bronze, the Phuphluns of the Modena Gallery.

The great variety seen in bronzes illustrates the manifold influences that were exercised in the field of Etruscan culture, and in the presence of which that culture reacted in various ways, and not infrequently in a way all its own. The variety shown in large-scale coroplastic art is much less, if only because we have few samples. The chief example of autonomous decorative plastic art, — that is,

FIG. 37

apart from plaques in relief, is the group with Eos (in Etruscan *Thesan*) carrying off the young man Kephalos. The group however is conceived as a relief, with considerable flattening, and the plastic element thought of mainly as helping the colour; the form grows broader, in the stance, in gesture and in the opening of the schematized wings; it is not made heavy, however, as in the 'Frontone dei Guerrieri', now at Copenhagen. The antefixes of a small archaic

FIG. 38

temple at Veii, their shapes broad and volumes spheroid, have an individual character; they are of about the middle of the 6th century.

Terracotta
sarcophagi
FIG. 39

The most grandiose and impressive example, and which with its companion now in the Louvre is sufficient witness to what was achieved in large-scale plastic art, is certainly the Caere sarcophagus, portraying the deceased man

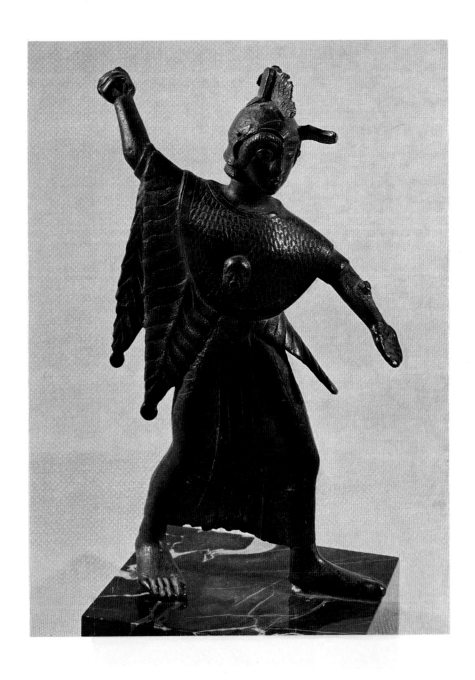

PLATE 23 – Small bronze (Menrva *promachos*). First half of 5th century. Place of origin unknown. *Galleria Nazionale Estense, Modena. Cf. p. 89*

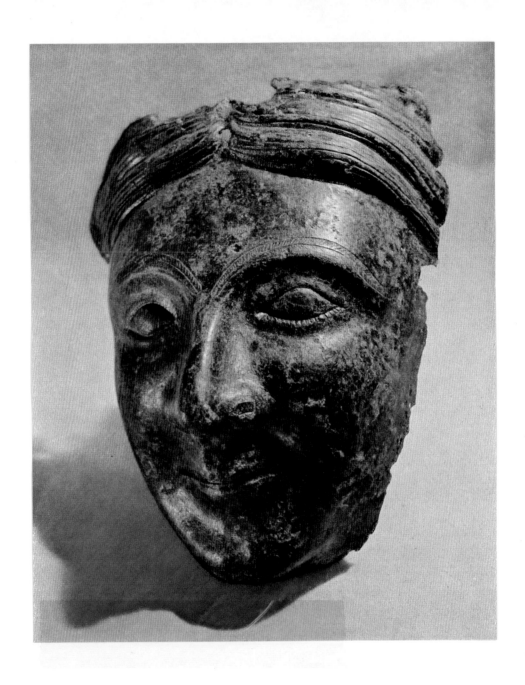

PLATE 24 – Woman's head in bronze. About 550 B.C. *Museo Archeologico, Perugia. Height 12 cm. Cf. p. 92*

and wife, in the Villa Giulia Museum. The composition is within the triangular framework which has as its base the ample extent of the *kline*. The character of this terracotta and above all the refined stylization of the faces has encouraged the survival, for a certain time, of the hypothesis that the artist was an Ionian, but this hypothesis was later seen to be unnecessary and inconsistent, if we consider no more than the illogical passage from the statuary mass of the upright busts to the disembodied flatness of the legs. The problem of the semi-recumbent figure received only this illogical treatment, which the artist endeavoured to accommodate with the folds of the draperies and the piling up of cushions. Purely coroplastic partial solutions, such as the marginal folds and representing the tresses as thick cords are more noticable here than in the Louvre example, where the insistence on detail is less, but less too perhaps the immediacy of expression, in spite of the same taste shown in the composition, the sharpness of the profiles, the almond-shaped eyes, and the rhythm of the draperies.

PLATE P. 4

The faces on the Caere sarcophagi prompt us to take up at this point the adoption by the Etruscans of the 'archaic smile', which has been much misunderstood, varying from the traditional, literary interpretation of a sentimental expression, of pleasure, historically indefensible, to that of a straightforward technical means of optical correction. The latter has indeed been used, but as a means of emphasizing a form of expression; the 'archaic smile' results from the carrying out on the various parts of the head (front view and side view) of the drawing of the eyes and the mouth as if front and sides were seen as independent planes. This is, in fact, the case, I think, with the Caere sarcophagi, an indication of their being under the direct influence of Greek Archaism, which, in this case, from the way surfaces are worked out, clearly goes back to Ionic

'The archaic smile'

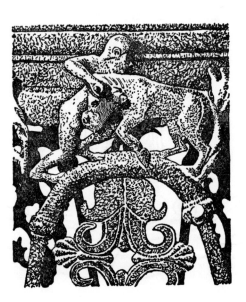

FIG. 36 – *Bronze tripod from Vulci (?). Detail: contest between Hercules and Achelous. Early 5th century. Hermitage, Leningrad*

models, also shown by the methods used for folds in the clothing and the sharp profiles with projecting details. (Cf. the recumbent figure in the Geneleos group.) Only rarely, elsewhere, has Etruscan art captured the meaning implicit in the archaic presentation of the human face, tending rather to use, until the time of the Veii statues, an intensity of expression based on the volume of the various parts, and on the broadening and emphasizing of some, in particular mouth and eyes, without, however, seeking after 'sentimental' expressions, which would have been quite alien to it.

The sarcophagi of Caere offer us perhaps the most consummate expression of the grandiose in Etruscan art, of a monumental tranquillity speaking in terms of large volumes composed of continuous surfaces in the draperies of the bier and in the male nudes, and modified by refined techniques in the female figures. They are isolated cases in the plastic art of the second half of the 6th century; only the couple on the *kline* of the Tarquinian 'Tomb of the Painted Vases' shares with them that characteristic of grandiose tranquillity. The small-scale replicas of the married couple theme (Caere) seem no more than mere sketches. The tendency mentioned bears witness to an episode of *rapprochement*, of unanimity almost, with Ionic taste; this, however, was not destined to be the direction chosen in certain future attitudes in Etruscan art.

PLATE P. 99 Towards the end of the century, the head found in the sacred area of Sant' Omobono in Rome is of another kind in respect of the presentation of volume. It is true that the frequency and variety of influences, which give the Etruscan archaism a multiform if not consequential physiognomy, make it impossible to draw those lines of development which exist — it is worth repeating — outside of but not within the Etruscan world. Such hints as are to be found are again in decorative works, such as the vibrant, dynamic group portraying the

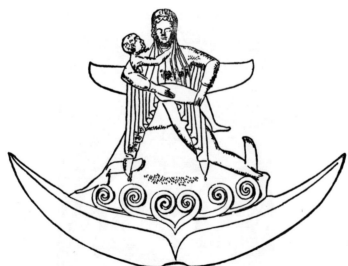

FIG. 37 – *Terracotta acroterium: the Rape of Cephalus, from Caere. Middle of 6th century. Antikensammlungen, Berlin*

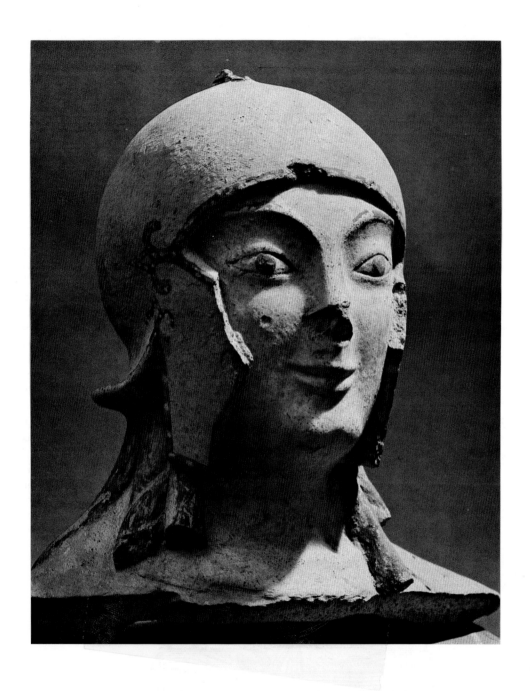

PLATE 25 – Polychrome terracotta head (Menrva). About 530. *Museo Nazionale di Villa Giulia, Rome. Cf. p. 98*

contest between Hercules and Apollo for the hind, in the visor of a Corinthian-shaped helmet from Vulci (Bibliothèque Nationale, Paris). But we must accept only with reserve the thesis according to which Etruscan art is the art of movement, or rather of the emphasis of movement. The iconographic schemes of Etruscan art are no more representative of movement than those of Attic ceramics, which wield, from the end of the 5th century, almost exclusive influence. In many cases the very translation of figurative compositions into decorative terms itself prompts an altered scheme necessitated by the surfaces to be decorated. As a generalization we must consider that the very emphasis on movement is a consequence of a lack of feeling for harmonious proportions, of a failure in co-ordination between the internal details of the iconographic scheme on the one hand, and its relations with the other figurative elements, on the other. There thus often occur unexpected juxtapositions between static figures and figures in movement, each of which gains emphasis from the contrast. This is something frequently found in reliefs from Chiusi, which form a fairly coherent series and offer a consistent documentation of a local taste, outside the range of direct foreign influence, at a distance from the landing points, one might say, of influence from abroad. The subject repertoire is really quite limited, — scenes of banquets, dancing and public spectacles, weddings and

PLATE P. 103

FIGS. 41–46

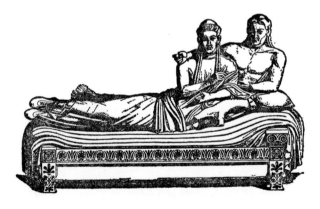

FIG. 39 – *Terracotta sarcophagus from Caere. Middle of 6th century. Louvre, Paris*

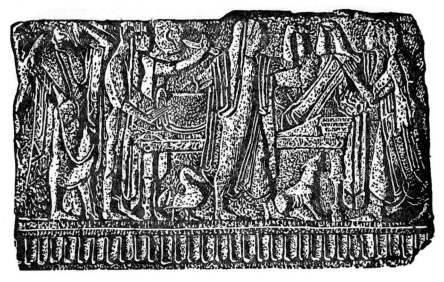

FIG. 40 – *Funerary relief from Chiusi. 6th century. Louvre, Paris*

FIG. 41 – *Left-hand side of a cinerary urn from Chiusi. 6th century. Altes Museum, Berlin*

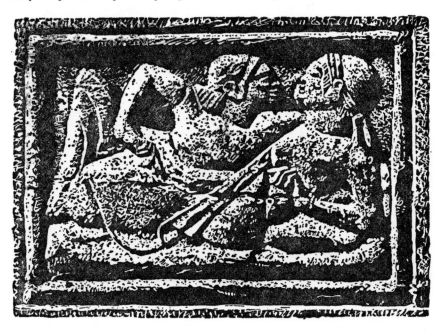

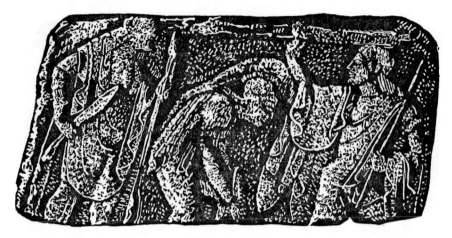

FIG. 42 – *Relief on funerary cippus from Chiusi. Early 5th century. Museo Barracco, Rome*

funerals, and later of war, repeated times without number, on sarcophagi, urns and *cippi*, throughout late Archaism, and for long during the sub-Archaic period, a parallel development with funerary painting, from which, for that matter, the art of the Chiusi *cippi* is not far removed, with its flat-relief character, much more a draughtman's than a plastic art. Breadth of forms and uniformity of surface (small urn with banqueters and dancers; National Museum, Florence) are found along with an insistence on the linear element (sarcophagus in the Louvre; round *cippus* in the Chiusi Museum; *cippus* with a *prothesis* and nuptial scene in the Museo Barracco) and with simplified shapes, reduced to essential elements, almost folk-art, as in some small urns now at Berlin, one of which shows a banquet scene with a flautist in the middle, with his head turned to the front — clearly suggested by vase-painting, or as in the temple-shaped

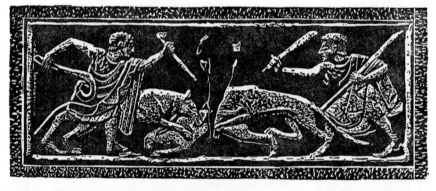

FIG. 43 – *Front part of cinerary urn from Chiusi: hunting scene. Second quarter of 6th century. British Museum, London*

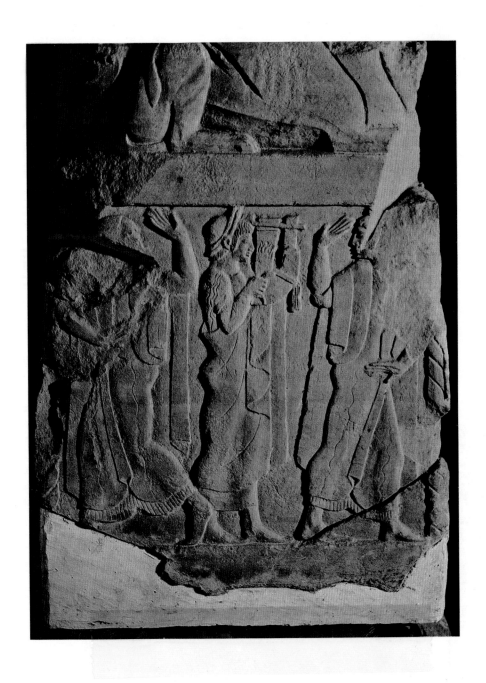

PLATE 26 – Funerary *cippus* with dance scene. From Chiusi. *Museo Archeologico, Florence. Height 50 cm. Cf. p. 100*

FIG. 44 – *Funerary cippus from Fiesole. End of 6th century. Altes Museum, Berlin*

FIG. 45 – *Architectural slab from Poggio Buco. Latter half of 6th century. Glyptothek Ny Carlsberg, Copenhagen*

urn in the Chiusi Museum, showing a nuptial scene and country activities. At other times elements of the most diverse kinds meet in the same monument, as in a Casuccini *cippus* (National Museum, Palermo), where to the mechanical repetition of a race between three-horsed chariots is added a loosely contructed games scene where much more recent elements (the warrior and the woman castanet player) are inserted into a context in the archaic tradition. The Casuccini funerary statue, now at Palermo, imposing a head in the canopic tradition on to a body of the geometric block pattern for the seated figure, occupies a cardinal position in the art of Chiusi, always able to show extreme variety though within the narrow limits of the obligatory themes. Quite independent of the types found at Chiusi are the forms and types of stelae and *cippi* in the Fiesole territory.

FIG. 46 – *Funerary cippus from Vulci. Museo Archeologico, Florence*

104

VI. ETRUSCAN ART AND CLASSICISM:
THE 5TH AND 4TH CENTURIES

A critical appraisal of the relationships between classical Greek and Etruscan art can only in part be set down in terms of dates. The difficulties of a comparison are indeed heightened, a comparison which as we have seen cannot be escaped even though we avoid making it a comparison of quality. The historical situation itself made it difficult to maintain contacts. The 'grand siècle' of Greek classicism, the 5th, is marked at the beginning by the success of the Greek cities against Persia, by the rise of Athens as a state that served as political and spiritual guide, and by the growth of economic activity under Attic leadership. To Etruria the opposite happened: the defeat at Cumae and the hostility of Syracuse, which had already become the major power of the western Greek world, and the increasing sharpness of the Graeco-Punic conflict, keeping the western Mediterranean in a state of perennial uncertainty, had just cut off Tyrrhenian Etruria from the great Mediterranean sea-routes and made trade with Greece difficult. Even if the fact that some Etruscan cities were in conflict with Syracuse did not mean that all of Etruria had hostile relations with all of Greece the factual conditions remained, to complicate relations. During the 5th century the importation of Greek pottery into Etruria steadily falls, to the advantage of the new route which had been opened in the upper Adriatic, carrying enormous quantities of Attic vases to the markets of Spina and Felsina, a pointer to commercial exchanges as intense as they were limited in duration. But although Etruscan and Greek interests on the shores of the Adriatic were one, that could have only modest effects for the opposite side of the peninsula: the new direction taken by northern Italic trade was in the main subordinate to other, vaster commercial relationships, to the new situation in the Celtic countries and the need to maintain contacts between Greece and central Western Europe other than by the Tyrrhenian sea-route.

Greece, moreover, was evolving socially and politically as her democracy broadened, while Etruria remained bound to her unchanging aristocratic political structure, which has not been called feudal without good reason. The legend of Aruns of Chiusi, as told by Livy to explain the descent of the Gauls into central Italy, though improbable as it stands, shows nevertheless a state of affairs when conflict within the inner circle of the ruling caste could have incalculable effects, not excluding foreign intervention, as indeed happened later, from another direction, when the Romans were called in to repress a popular uprising in the community of the Volsinians. Almost a century after Cumae, Veii fell into the hands of the Romans and twelve years later came the action of Dionysius of Syracuse against Pyrgi (Santa Severa). In our total ignorance of Etruscan history in the 5th century (except for the episodes of the

Social conditions

conflict between Rome and Veii), we can have no clear picture of the internal situation in the country, but it is certain that with reduced contact with the Greek world economic regression could have a harmful effect on artistic enterprises.

Relations with classical Greek antiquity

From the viewpoint more strictly of the figurative arts, the process which began in Greece in the first decades of the 5th century was in fact an incomprehensible one for anyone without the Greek mentality and background. The rationalism implicit in formal elaboration, the successive idealistic synthesis, the posing and solving of the problem of representation in terms of inner syntactical, organic relationships, were such as to jeopardize the course set by Etruscan art in relation to Archaism. This led, of necessity, to Etruscan art's turning back to the forms of late Archaism, so that, when in Greece itself, at the hands of a later generation than that of the great 5th-century masters, classicism came round to the use of more comprehensible and more easily acceptable forms, taking on what may be called the characteristics of good taste rather than those of poetic creation, becoming 'popular', Etruscan art could return again to its former course. Through the means indicated, contacts were renewed, with a certain effort on the Etruscan side to 'get up-to-date'. The acquiring of classical elements, when we consider the matter as a whole, came very late, though some influences naturally filtered through even before the end of the 5th century. Two mirrors are of special significance in relation to the problem of contacts with classical art. The example from Vulci (Etruscan Gregorian Museum), showing Hercules and Atlas, a masterpiece of Vulci engraving technique, refined in its execution of line-work and showing awareness of problems of form, is directly under the influence of pottery-painters' design; indeed, the style of this mirror is so near to that of the 'Painter of the children of Niobe' that we can refute the usual dating of the mirror as the end of the 5th century. The second example, of unknown origin (Antikensammlungen, Berlin), is in relief, and was known at one time, without good reason, as the 'specchio dei Cabiri'; it shows a funerary scene, and its main interest lies in the fact that the modelling and representation of the nude are very close — even in anatomical details — to the style of Myron, a fact worthy of our attention, particularly when we take into account how faint an echo Myron's work had outside of Greece.

Adoption of Greek technique, form and iconography

But obviously contacts of the kind could more easily happen in the artisans' sphere than in plastic art or painting; this calls for a revision of our chronology, specially for older, red-figure painted ceramics. In this case, in fact, it was a matter of mere transposing; and the copying of the Greek technique and form can be explained, as can the adoption of Greek iconographies, slightly adapted, for example in the Felsinean figurative stele, as being under the influence of Attic ceramic drawing; in fact, as we shall later see, representation in the Felsinean stele is of the nature of drawing rather than plastic work. The relationship is therefore of the same kind as that of the mirrors and painted vases. Composition in the plastic form brought very different problems, beyond the scope of the surface decoration and volumetric structures of Archaism. Etruria

had nothing which can be compared with the historical climate in which there took place, in Greece, that artistic revolution which made it possible to escape from the 'dead point' of late Archaism and turn to the pursuit of an organic synthesis. Profound study of the human body, not so much to obtain dimensional data as to learn the linking relationship of parts in movement, is something foreign to the Etruscan mentality. Etruscan art, for a long time, did not get beyond sub-archaic segmented anatomy and remained on its typically improvisatory plane, schematizing the human figure, as for instance in the frequent use of the type with a narrow waist. What was lacking, in short, was the antecedent reasoning, the historical climate for a follow-up. Perhaps in no other period as in the 5th century can one appraise Greek art as something absolutely isolated and incommunicably locked in the inmost essence of its greatest creative personalities.

These two circumstances, the changed politico-economic situation and the difference in the historical climate, join in explaining why the parallel courses of Greek invention and Etruscan reception and interpretation are separated by a long delay, accounting for that aimless wandering and that acquiescent retention of superseded forms which is a feature of Etruscan artistic production in the middle decades of the 5th century. Moreover, in Greece, the crisis at the beginning of the century which led to idealism was followed by the other, brought on by Sophistry and Socrates, which led to man's meditating upon his own inmost nature, in terms such, in this case too, as were not capable of being comprehended outside the circle of Greek culture.

All this explains too why it is not possible in Etruscan works to find any sign *Episodic nature* of a seeking after an ethos: Etruscan art, even in its finest manifestations, is always episodic in nature, takes interest in the fact at the moment of its birth, and feels none for its reverberations, in what led to it and what followed after. Its need to represent something at once, and its aim-determined character, meant that in Etruria there was no echo of theories about an 'educative' factor in art, something substantially foreign to both religion and to politics. The actuality of Etruscan representation, though far from the sketchy anecdotism of Campania and southern Italy, did not attain the historic dimension, a role reserved for the art of Rome, at a time still far off, and as a consequence of a process with which Etruscan tradition had nothing whatever to do.

A peculiar characteristic of Italic self-expression, including those particular *Carelessness about* aspects which are Etruscan, is the lack of interest in finish *ad unguem*, to use the *finish* Latin term, not thought of as necessary and increasingly less sought after as archaic experience is left ever further behind. Elaboration, that is *akríbeia, diligentia*, cannot go hand in hand with impulsive execution, of the moment, — hence the contradiction in terms, of authors such as Pliny, who, led to exhalt the classic form, at the same time evoke nostalgically the works of Italic archaism.

The most recent excavations at Marzabotto allow us to date within the first ARCHITECTURE half of the 5th century that 'master-plan', carried out with scrupulous exacti- AND TOWN- tude, down to the merest detail, which so clearly shows the new line taken by PLANNING

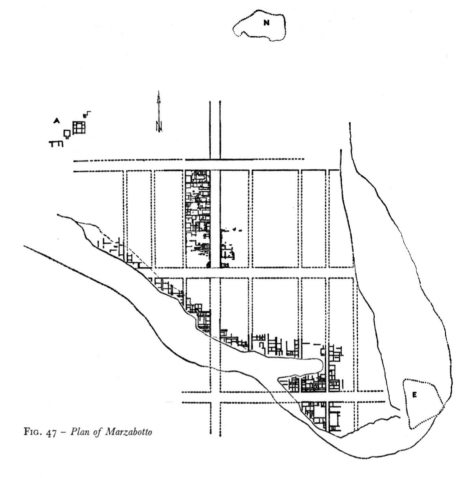

FIG. 47 – *Plan of Marzabotto*

FIG. 47

town-planning in the Etruscan world during the century in which Greece itself saw the building up of town-planning as a science and an artistic phenomenon. It is of no significance that the date here proposed for the Marzabotto 'master-plan' precedes in time the theoretical plan of Hippodamus of Miletus. The latter is a point not of departure but of arrival, — to the work of Hippodamus there contributed a centuries-old, in some respects a millennium's experience from the East and the outer Greek world. What is important to make clear is that Marzabotto town-planning was conceived and carried out not only for functional but also for aesthetic purposes; the long, broad main streets, with the breadth and limited height of the buildings placed along them — the houses were of one floor only — emphasize the spaciousness, and the plan is quite happily introduced into the environment, even though the rectangular scheme seems imposed on the terrain, having been theoretically worked out in advance. Both acropolis and town, as is shown by the identical way they face, were born

of the one architectural idea, the second as a continuant of the first, regarded as a sacred place (the Marzabotto acropolis having no military function); that is the original and distinguishing mark of the Etruscan conception, which clothes with Hellenizing forms its own religious, immanentist legacy. In such terms the Etruscan 'town-planners' solved, in accordance with their own ethical principles, the Greek equation in which the town-planning κόσμος is the tangible expression of the political κόσμος of the city community. The Etruscan was *homo politicus* only within certain limits, as we have seen, because his habit of seeking the causes and progress of human events in external forces and in the will of fate (which Etruscan *disciplina* sought to discover and execute) stands in the way of the evolution of institutions in a democratic direction, the feudal oligarchy maintaining itself in power for centuries. The religious determinism and immanentism also probably blocked the formation of that juridical consciousness that for so great a length of time and in face of almost insurmountable difficulties was the unifying force and the incentive to expansion of the Roman community.

Simple construction

To come back to Marzabotto, we may remark that the town-planning aims, in their broad design and effective execution, were carried out all the better the less recourse was had to external monumental apparatus. The building was unadorned, poor almost, austere too in the temples where the sober decoration of the figured antefixes was paired with geometric decoration in the painted fictile facing-slabs. The well-known 'altar D' in the acropolis bears a double moulding in cut stone which at once reminds us of central and southern Etruria in its energetic presentation of volume in the swollen double cyma. On the other hand the series of tombs and rock-hewn façades of Caere, Bieda, Norchia, San Giuliano and Sovana, which reproduce series of town-houses in reduced form, are no more than a succession of cubic volumes, bearing at their base and top an elementary relief of continuous mouldings.

BUILDING
Connection between tomb and house

The connection between tomb and house cannot, as we have seen, be called in question; it is an established cultural fact found at various social levels and over a great part of the Mediterranean area, but for the period which we are

FIG. 48 – *Model of house (cinerary urn) from Chiusi. Altes Museum, Berlin*

discussing, the examples offered by certain small urns, which have often been studied, are more worthy of attention, perhaps, than those of the oft-repeated chamber-tombs with axial plan. Etruscan architecture was not interior architecture, in the sense of distribution of interior volumes to achieve organic spatial aims; it was rather, as in their temples, a façade architecture. Therefore, since all the 'elevations' are lost, we can have only a one-sided and incomplete idea of it.

Small urns
FIGS. 48-49

The small urns show three types; one with an open central court with hipped roof (Museum, Berlin), a second one with projecting roof and open gallery with small columns, a third one like a detached house with rusticated stone walls and an order of columns with voluted capitals reaching up to the roof, an allusion, no doubt — since the actual dimensions in such a version of an object cannot be taken at their exact face value — to a portico surrounding a building. In the identical character of the four sides of this urn, the only one with an architectural aim beyond a purely functional one, I would see the influence of classical architecture, an influence quite foreign to the chamber-

APPX. PL. 4

tomb tradition. The same classical influence accounts for the 'temple-aedicule' tombs, standing on a base, at Populonia.

Types of house

At Marzabotto the houses are of two kinds. The first has an open central court reached by an approach corridor, is of some extent and has several rooms, arranged paratactically one after the other within a rectangular plan corresponding to that of the town. The centre court, as I see it, has elements such as to give it a place in the history of the Etruscan *cavaedium*. The second type of house is much more difficult to describe; it is more compact, and perhaps had a different purpose. When we refer to reports on the excavations of the last century, Marzabotto would seem to have had perhaps the most ancient reinforced city walls with architecturally decorated city-gates. The chronology of the town's foundation, as ascertained from datable materials found in the town and necropolis, runs from the end of the 6th century to the middle of the 5th. The rectangular plan and the types and construction of the buildings are documented elsewhere, in the Bolognese area, in the same period. The house, of itself, and from what we know from the above and other documentation, presents no problem of concern to art history proper, in the sense that it has to meet needs of a practical, functional nature; the distribution of parts or the solution of technical problems are at most capable of elaboration as means of artistic expression, but they did not first come about to that end. The axial principle at Marzabotto is fairly strictly observed, but

APPX. PL. 8

the symmetry is not so absolute as in the tomb plans. The fact that in the multiple-chamber tombs the approach corridor (a true and proper *dromos*) is carried outside the rectangular scheme in which the rooms are arranged and is not inserted into it, as in the houses at Marzabotto, is a consequence of the particular needs of funerary architecture.

Differences between house and tomb

Though not casting any doubt on the connection between house and tomb it is however quite obvious that a complete parallel cannot be maintained, in view of their different purposes, the tomb having to expand underground, and

FIG. 49 – *Model of house (cinerary urn) from Chiusi. Museo Archeologico, Florence*

the house to find its place among others; further, in the case of the tomb, there were clearly no problems of ventilation and illumination, but a need instead for closure and inaccessibility. The known examples of architecturally presented, house-type funerary urns prove that the Etruscan private house had careful exterior proportions (with further evidence, for that matter, from the rock-tombs' façades), and could indeed, as in the urn representing a detached house in rusticated stone, get beyond the simple front-view presentation, which, as we shall see, was the characteristic of the temple. The 'architectural representation' of the urn repeats the same design, two by two, on the faces, and will be clearer to us if we think of the tall columns with voluted capitals as isolated from the context and imagine them as a sort of portico round the building, as in the peristyle urns. These urns, it is true, seem to be quite late, but we are compelled to make use of them, and give them retrospective significance, the more so in that the observations which we are making here seem applicable too to later times. What we in fact lack, whether in basing our study on actual house remains, or chamber-tombs, or urns, is a chance to check on the existenc of a real functional and aesthetic connection between the outside and the inside of the building, that is to say of that organic quality wherein architecture's true values consist. Speaking objectively, judging from the material that remains, we are led to say that this organic quality did *not* exist, and this is completely in accord with what else we know of Etruscan art; this is also why I said above that the problem of the Etruscan house does not directly interest the history of art. The urn at Florence portraying the private house in rusticated stone is an example of an accumulation of external decorative elements rather than a real expression of architectural feeling. On the other hand, a Chiusi urn reproducing a *loggia* type house betrays in its representation of the details of the cornicing such a criss-cross of lines that they defeat their object, so that a third urn, now at Berlin, very well known because it seems to represent the type with hipped roof on *cavaedium*, seems no more than an example of chance consequences arising from the simple functional aims of a country building style. Examination of the tombs leads us to further conclusions: the frequency of pseudo-supports for structural bearing-members clearly shows that the hypogea are translations into terms of stone of constructions which in every-

FIG. 49

FIG. 48
Architecture and buildings not meant to last

111

day use would be in light, perishable materials, so that we cannot accept that Etruscan builders had that thought for durability which is the unquestionable mark of all great architecture-producing civilizations. The constant use of enormous *columina*, which if carried out in stone, in real circumstances, would represent enormous weights, in comparison with the light architraves over the doors, as we have seen in the archaic and sub-archaic chambers, is very indicative of this characteristic; in the absence of convincing representation of the structural details light is thrown too on the fundamental aspect of chamber-tombs, — they are allusive to the town house in a vague sense, and in them the whole and the details are developed in a way of their own and with quite fortuitous aims. This will happen likewise later in the Caere 'Tomb of the Painted Reliefs' where the rafters of the roof rest directly on the capitals of the big pilasters, whereas the *columen* is independent, resting on one side on the door, and on the other on a sepulchral niche.

Interior architecture The funerary chambers, rather than actual reproductions of architectural interiors (except to the extent that they offer evidence of the use of decorative elements, projecting pillars and capitals in interiors, and the growing tendency to embellish these), remain mere developments of the chambers-under-a-tumulus of proto-historic tombs, characteristics remaining typical, even in times nearer to us, of chamber-tombs (the 'Tomb of Shields' at Tarquinia, the 'Tomb of the Velimna family' at Perugia), along with a return to extremely archaic forms (centre pilaster in the 'Tomb of the Typhon' at Tarquinia and in the 'Inghirami tomb' from Volterra, reconstructed at Florence). The main interest, in the house-tomb relationship, would lie in deciding, where possible, if the wall decoration of sepulchres could be attributed to the houses too; within certain limits the answer is probably yes, in that the aristocratic society of the Etruscan cities had probably a tendency towards embellishment and luxury in the houses they lived in; we are not however in a position to measure the consequences of this in the field of art.

Painting Judging from the evidence we possess, only the chamber-tomb was certainly decorated by paintings, and these draw attention to structural elements (roofs, *Horizontalism* and internal spandrels) or to the division of the wall into sections, always in the direction of the room's length, marking off a base zone, one or more friezes, and several bands. All this, in addition to generally making possible the development of figurative friezes into continuous units, shows a clear attachment to the horizontal which could have architectural connotations, in that it tends towards an apparent enlargement of the space, generally limited in the chambers of the sepulchre. The very ample use of painting shows that space in interiors was thought of as a place for colour, it fills entire walls and ceilings; but a true and consistent concept of 'coloured space' does not seem to have been arrived at, because of a congenital absence of feeling for the organic and a lack of interest in linked-up spaces. Horizontalism is moreover a standing characteristic of Etruscan architecture; besides the examples of cube-shaped rock-tombs, it is very evident again in the late chamber-tombs, such as the
PLATE P. 113 'Tomb of the Cardinal' at Tarquinia or that of the Reliefs at Caere, where the

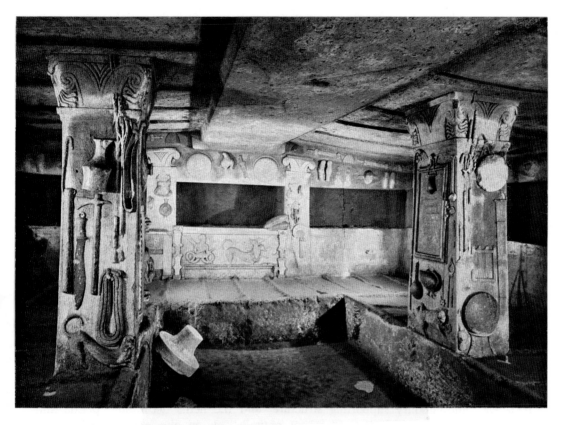

PLATE 27 – Interior of 'Tomba dei Rilievi Dipinti'. Caere. *Cf. p. 112*

same planning lay-out applies; the extremely long housing-blocks at Marza-
botto were made up of very low buildings, giving rise to unending fugues of
horizontal lines. Here, as an exception, and because of the unusual extent of
the houses, the open space of the street is set off to advantage.

The crucial problem of Etruscan architecture — and we consider it in concrete
terms on the evidence of the 5th century, though our considerations could be
applied to the entire extent of Etruscan civilization — remains the temple, one
of the most discussed features of Italic archaeology. Here too our documenta-
tion is rather scanty, since no temple building, Etruscan or in the area in-
fluenced by Etruria, has survived above the level of the foundations or the
podium, so that once more the conditions in which there might have been drawn
up an *exposé* of the problem, from the art-history point of view, are far from
satisfactory, and the matter runs the risk of being settled at the antiquarian
level or as part of the history of religion.

In fact it is only in recent years that discussion of the very fundamentals has
been put on a different basis, in that doubts have been expressed about the

TEMPLE
CONSTRUCTION

*Historical and reli-
gious considerations*

113

strict pertinence to Etruscan religion of the use of triadic groupings (Banti); in consequence it would appear no longer essential that the Etruscan temple should be composed of three *cellae*, on the contrary there is a tendency to think that the triadic cults and the temple construction deriving from them were a Latin conception and spread through Roman influence, even though the artistic execution was for obvious reasons under Etruscan influence when it did not actually imply the direct participation of Etruscan artists, as in the famous case of the Capitoline temple. The problem has thus been posed in broader terms, but also illuminated, opening the way to interpreting the remains of sacred buildings outside the narrowly predetermined lines largely imposed by Vitruvius's theories about the Tuscanic temple. It is clear that Vitruvius, who wrote in the times of Augustus and had practical and not historical aims, drew on experience much more recent than the most anciently dated Etruscan temple building. His texts were produced when 'Etruscan' temples had no longer been built for a long time, and were based on book-learning, though written in a systematic frame of mind in which the influence of the Greek treatise writers had its part. However that may be, the accounts of Vitruvius, which do not refer to any particular single moment of Etruscan architecture, are not of an aesthetic character, but have a practical, utilitarian one. Nor did the mentality of the Etruscans feel any need to put sacred buildings in an aesthetic category. A different way of thinking about dimensional rhythm and relationship — proportion, that is — puts Etruscan architecture on quite a different plane from Greek, even though the exchanges of exterior decorative elements were manifold.

Theories of Vitruvius

The Etruscan temple essentially consisted of two components, — the wood-and-masonry supporting structure, and the fictile decoration, plastic and painted, which covered it not entirely only in obedience to strict functional requirements; the framework of the front, itself, with the heavy *columen*, is a functional incongruity. The lack of sensitiveness for functional coherence, that is, for the architectural values, lies in the imperfect connection between structure and external decoration, which latter follows its own course (specially in its multiplicity of colours, understood only in part as a means of underlining the functional quality of the various members), not giving expression to the structure, which being in great part in wood limited the architectural possibilities to the modest resources of the carpenter. The forms of the Etruscan temple, low and stumpy (*barycephalae, humiles, latae:* Vitruvius III, 3, 5) must be considered on their own, outside the frame of any rash comparison with the Greek temple cubic volume defined in space.

Structural elements of the temple

In the main, with its inevitable frontal quality, the Etruscan temple becomes an architecture *de façade* whose contours, far from becoming clearly marked, dissolve into their background in the macroscopic confusion of the lines of the antefixes and *acroteria*, something external and decorative, that is, not organic and spatial. The frontal quality and the very presence of the podium with its flight of front entrance steps are derivatives of Ionic architecture, but the architectural forerunners of the Etruscan temple, which is unknown in fact

Significance of the frontal aspect

before the phase of Ionic influence, are to be sought in the forms which preceded the artistic development of the Greek temple, it too, at first, incapable of being looked at from more than one point of view, and, in its derivation from the pre-Hellenic *megaron*, having only one main front, that of the entrance. This basic ancestry of Etruscan architecture is apparent also in the forms of the columns and capitals, developments from Mediterranean exchanges in a period before the Greek orders were systematically worked out. In the absence of an organic way of looking at things the non-existence of a true and proper architectural order is to be expected. The Etruscan functional column is the Tuscanian, but here we have a shape independently worked out from common ancestors and not derived from the Doric. But the development of the Tuscanic forms into an order, that is as a complete context of dimensional/structural relationships, which in the Doric attain to a comprehensible statement of mathematical perfection, is a consequence of its use by the Romans, revised after classical and Hellenistic experience. The Tuscanian column is a simple bearing member, and the forms taken by the horizontal, supported elements are quite foreign to it; they are prevalently — when present at all, and then always out of context — of Ionic origin. But to call this hybrid juxtaposition 'eclectic', in the usual sense of the term, would be historically inexact; the truth would be better expressed as a gathering together of various threads but with no unity achieved.

Their associating plastic and colour elements of Ionic origin with the Tuscanian order, in temple architecture, sprang from the decorative value colour had for the Etruscans, with their interest in the external effect. To evaluate this relationship in the context we must refer in this case also to samples in which small-scale objects reproduce architectural models, — such as the little urn from Chiusi, now in the British Museum, with enormous antefixes projecting from the roof edge, in line with the rows of tiles, and moulded animal figures set out along the top of the lid. A small terracotta model from Nemi has often been cited in evidence for the reconstruction of the upper part of the Etruscan temple; moulded groups are applied to the ends of the cross-beams which support the roof construction, two on the sides, the other on the top, on the *columen*, whilst on the epistyle there is a row of antefixes standing forth from the empty space of the fronton, which in the archaic period was always left open. A similar arrangement, with the row of antefixes on the fronton, is found again in a Volterra urn: the antefixes, in this case, could not be for purely decorative purposes. The eye-catching quality of the figured *acroteria* is not obvious of itself, but in comparison with the constantly reduced dimensions of the building; this is the case with the now famous *acroteria* from Veii, the group reconstructed in Berlin and coming from Caere, of Eos and Kephalos (Aurora and Cephalus), and again in the fragment with warriors, from the Faliscan 'Temple of the Fallen Stones', the latter of which shows in low relief what is evident in the Veii groups in the round and in the Caere complex reconstructed at Copenhagen, that is, a seeking after a broken-up effect at the edges, with intervening empty spaces through which the light could shine,

Plastic and colour elements in construction

FIG. 37
PLATE P. 117

between the terracotta modellings. The same is to be seen in the carved cornices of temples at Satricum (Conca) and Falerii, which composed airy marginal borders, thought of perhaps as a needful antithesis to the weighty mass of the building itself.

The story of the Etruscan temple is in a way that of its plastic decoration, in that the figured and painted apparatus divorces itself and becomes independent of the discipline of the architectural context; the temple terracottas — especially those that have a plastic autonomy of their own — are among the most characteristic and original expressions of Etruscan figurative art. Even the antefixes, those from Veii with Gorgon 'protomes', and the very numerous like examples, can be taken on one side and evaluated in and for themselves, without regard to the contexts from which they originally came. In the construction of their temples, therefore, even with the non-consecutive documentation we possess, the national character and the Etruscan mentality is revealed, with its determining immediacy of aim, the structure illogically mixed with the external decoration, which pursues, I repeat, its own course, made up of separate episodes, because, in fact, intended to stress certain structural elements, the groups applied to the ends of beams, or the antefixes, by reason of their very magnification in dimensions, have quite exceeded their proper function in a sort of *quasi exaggerata altius oratio*, to use a famous Ciceronian metaphor.

Wood as building material All the details that we have been setting down up to this point show why in the Etruscan civilization there was never an awareness of the need to pass from the perishable structure in wood to the durable one in stone, and particularly in the temple, the building we should have expected the Etruscans to view as the major expression of their religious feeling. The durable material was kept for the tombs alone; this indicates that the life of the individual beyond the tomb and the continuance of the relationship with him after death mattered much more to the Etruscan than his relationship with the divine. It is very probable that conservatism in their religious rites stood in the way of a translation into terms of stone of the temple form and in fact Tuscanian temples completely realized in stone came only in Roman times; what is certain is that a stone version of the temple would have implied, much more than the 'architectural representations' which were the tombs, not only difficult problems of statics — which could have been solved by following the Greek examples — but also an attitude towards organic harmony basically foreign to the Etruscan mind and indeed to their entire psychology. Thus, funerary, building apart, Etruscan civilization remained without an architecture in stone, that is without an architecture in the full sense at all. Recourse to stone structures in the podia, which in themselves brought no aesthetic problems, served a double practical purpose, protecting the wood and clay structures from the dampness of the soil, and making possible and convenient the construction of higher floors.

Other building purposes Of public buildings in general we know nothing at all. The painting of the Tarquinian 'Tomba delle Bighe' ('Tomb of the Two-horsed Chariots') testify to

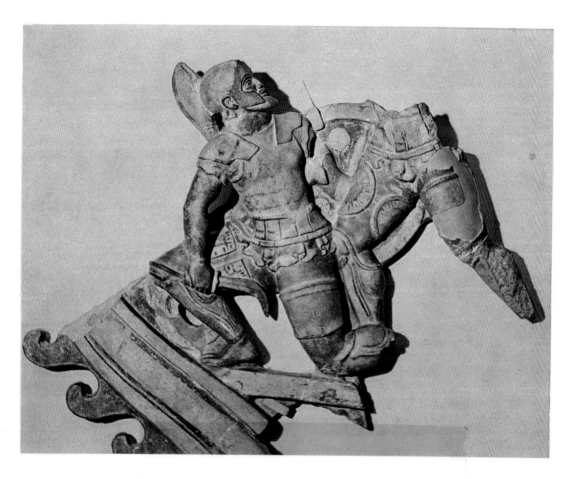

PLATE 28 – Polychrome terracotta *acroterium* with battle scene. About 490 B.C. From Tempio dei Sassi Caduti, Civita Castellana. *Villa Giulia, Rome. Height 68 cm. Cf.p. 115*

the existence of places for public spectacles, but they were temporary hustings, similar to the scaffoldings still set up in Italy today for public performances of an occasional nature.

Scenes of meetings for religious or political purposes are quite frequent on reliefs and terracotta tiles, but no indication of the surroundings is given, and we are left to suppose that such meetings took place out-of-doors and not necessarily in a specially constructed environment. Search around Etruscan towns has yielded no clues, though this is no reason for totally denying their existence.

The Veii terracottas gave from the moment that they came to light a decisive turn to the critical evaluation of Etruscan art; they are in fact a hinge-pin in its whole history. One cannot, of course, speak of them as a point of arrival, as the end of a process, nor the starting-point of a new course that had a later,

SCULPTURE
Veii terracottas
PLATES P. 119

117

PLATE 29 – Terracotta statue of Aplu (Apollo). Early 5th century B.C. From the Portonaccio sanctuary at Veii. *Museo Nazionale di Villa Giulia, Rome. Height 1.75 m. Cf. p. 117*
PLATE 30 – Terracotta head of Turms (Hermes). Early 5th century B.C. From the Portonaccio sanctuary at Veii. *Museo Nazionale di Villa Giulia, Rome. Height 37 cm. Cf. p. 117*

consequent development; the unrepeatable character of Etruscan works of art excludes any considerable echoes even in the applied arts. At the very time — as we have already explained more fully — that Greek art was working out its own large-scale renewal, and was at a crucial turning-point, this singular and remarkable phenomenon takes place in Etruria, apparently one for which there was no preparation and no premonitory signs, and arrives with a decisiveness, strengthened by its comparative isolation, which is not the least of reasons for linking the Veii terracottas with the name of the only Etruscan

Vulca artistic personality known to written tradition, Vulca of Veii, remembered for having carried out religious statuary in Rome and exterior decoration on the Capitoline temple, begun according to tradition by the first Tarquin, finished by the last representative of the Etruscan dynasty, but dedicated by republican Rome's first magistrates. Our sources tell us no more; we know nothing further save that the face of the sacred image was painted red, which is nothing extraordinary, a convention indeed common to archaic and sub-archaic art. It is natural, I repeat, that the name of the Veii terracotta artist should be recalled in connection with the clay statues of Portonaccio, those of the Apollo group and that of the 'Contest for the Hind'. But, even if we do not care to attribute the statues to the well-known artist personally, the existence and skill of the 'Vulca School' are amply documented, and the discovery has not only opened up to us the artistic life of a great Etruscan town such as Veii, but has also shown the extent to which Etruscan art had reverberations in Rome, at the time of the passage from the monarchy to republican forms of government.

The Veii Apollo Later discoveries at Veii have shown that together with the individual but not entirely coherent manifestation of the Apollo group, there were others within a period of a few years, which clearly suggests several people working at the same time. The 'Contest for the Hind' group has been reconstructed; it was designed, it seems, to be seen from below, placed on top of a temple, but it does not appear that the artist took the question of its destination too seriously. The Apollo is imposing for its expression of physical power, realized by the mass thrust forth in the figure's stride, signifying the inevitability of the divine concern, and for that air of abstraction with which the sharp, geometrical profiles of lips and eyes come forth, and for the quivering presence of the folds and curves of the drapings which do more to represent the dynamic stance than the attitude of walking itself. The relationship between body and garments is such as to express independent bodily power and clinging movement in the material of the folds. The encumbrance of the stand between the legs of the statue, rather than being concealed, enters in lively fashion into the context, setting the curves of its volutes over against those of the hem of the cloak, thus finding itself a place in the general decorative system governing the entire composition, whose pyramidal structure it effectively underlines.

As an example of Etruscan art, the Veii Apollo is quite emblematic, because it is a work of art realized on the instant, not meditated upon in advance and worked out rationally. The Ionic drapings therefore seem to us to be an acquisition from abroad, from iconographic and cultural sources, not a transposing,

PLATE 31 – Bronze she-wolf. Early 5th century B.C. *Museo Capitolino, Rome. Height 85 cm. Cf. p. 122*

not a copy of a Greek archetype. Here we have the fundamental point about the relationship and the independence of Etruscan art, evident too in the forced nature of the anatomy, meant to reinforce the effect of mass and the projection of the lines of force. As evidence of a lack of a predetermined, rational plan, in a word, of style, it is sufficient to contrast the Apollo head with that of Hermes-Turms, in the same group, softer, more plastic and 'human', even though the formula for mouth and eyes is the same. But there is no need, really, to suppose different artists; we must not seek to define the personality of an Etruscan artist in the same terms as those we should use for a Greek, — his inventive freedom has no awareness of logical coherence as a measuring-rod. Thus, let us not feel concerned to consider alongside these the inorganic 'Hind', wherein the powerful surface effect prevails. Though it lies within the same range of ideas, the female figure with a child in her arms seems to us quite different from the Apollo; more refined and immediate, also richer in

APPX. PL. 10

dynamic effect than the Apollo, it is less coherent, because of the difference in intensity between the front and rear planes, a difference which serves to stress the persistence of the frontal viewpoint underlined too by the difference in the dominant colour.

That plastic form cannot be divorced from colour, in Etruscan terracotta in general, is clear when we consider the 'horrific' Gorgons' heads on the ante-fixes of the temple at Portonaccio, so free from any discipline, plain examples of a seeking after immediacy of expression. Indeed it seems that the works spring into being on the instant, from an intuition that is at once both one of plastic form and one of colour.

The Capitoline
She-Wolf
PLATE P. 121

To the 'School of Veii' and the circle around Vulca has been attributed one of the most famous bronzes of antiquity, the Capitoline She-Wolf, a work of universal celebrity, but for which a satisfactory detailed critique is still lacking. I can make no claim to supply it here, because the matter calls for a deeper study; but it is certain that the aggressive vigour of the Capitoline bronze, which later became the emblem of Rome, clearly marks it as belonging to the art of the Etruscans. The linear and geometricized version of the head, without doubt the part most fully achieved, is accompanied by a disciplined rendering of the skin, which stands out for its tone values and shows the attention paid to Greek art. Its closer connections with the art of Veii, when we compare it with the hind, are seen in the rendering of the anatomy, expressed in the quivering surface of the shoulders, legs and flanks. It is not naturalistic re-presentation, nor an abstraction, such as we know in archaic Greek represent-ation of animals. Less archaic probably than it seems, the She-Wolf too lacks unity in the execution of its parts, reaching, however, powerful expression in the head and the hollow flank. That it *is* a Veii production cannot be said absolutely, but the fact of its being at Rome makes it very probable. Com-paring the She-Wolf and the Veii terracottas reflects moreover two different needs, to consolidate the plastic form and fuse it in bronze on the one hand — whence the calligraphic features of the skin —, and on the other to give free expression to an invention immediately realizable in the easier medium.

The
Monteguragazza
stipe
PLATE P. 123

That the influence of the Veii style was considerable is shown by traditions about the greater production of cult objects achieved in Rome; it can be traced, in small-scale works, even far afield; I think it can be recognized, though now grown cold and lacking the enthusiastic inventive fervour that informs the Veii groups, in the bigger of the small bronzes in the Monteguragazza *stipe*, in the Bolognese Apennines. In the stiff votive figures, which have no call for dynamism, there is a similar emphasizing of masses, there are the block-like volumes of the heads, the incoherent relationship between bodies and the clothing that surrounds them, more evident in the male than in the female figure. Somewhat later than the Veii terracottas, which are still the finest

The Pyrgi group

APPX. PL. 12

expression of Etruscan representational art, comes the fragment of a wrestling scene, discovered in the recent excavations at Pyrgi (Santa Severa). If the Veii *acroteria* are composed of free-standing statues, in the Pyrgi group a spatial presentation appears along with a composition based on the interplay of mass

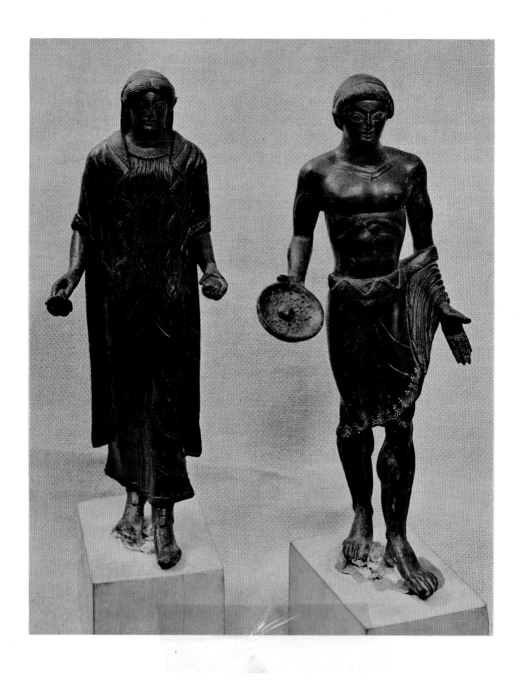

PLATE 32 – Bronze statuettes of worshippers. 1st decades of 5th century B.C. From the Monteguragazza stipe. *Museo Civico, Bologna. Height of male figure 24.5 cm; height of female figure 36 cm. Cf. p. 122*

against mass. The dynamic quality is in the violent movements, in the oblique lines set against one another. The Greek sense of measure is not there, and this lack is confirmed by the great, broad heads, but a capability for fairly close observation can be recognized in the interest shown for anatomy in the large areas of the nude, and indeed the up-to-date treatment of the nude is in contrast with the archaism of the heads, still tied to formulas and not showing much progress from the protomes of Sileni, in antefixes. Another internal, unresolved contrast is that of the opposition between the violent movement of the figures wrestling and Menrva-Athene, who is immobile without being solemn. Evidently taken over from a Greek cartoon, the scene scarcely represents the abstract solemnity associated with a divine manifestation; the figure of Athene retains however a documentary value, that of the axial quality of the composition and the link with the lines of the architecture.

PLATE P. 117

Compared with this work and those at Veii, the plastic groups of the Faliscan 'Temple of the Fallen Stones', seem more simply decorative, especially the well-known group of soldiers fighting, somewhat heavy in its description of the details of their armour. The composition is carried out as a relief, but in the flat surface at the back the figurative work is completed in paint. This Faliscan group is linked in a sense with the group of Caere *acroteria*, now at Copenhagen, and with the rider coming from the same source and in the same museum. A simple comparison between the heads of the horses with those of the 'Pegasus', also from a Caere *acroterium*, in the Gregorian Etruscan Museum, is enough to let us perceive in the latter an adherence to the Greek way of seeing and a 'classicist' attitude that goes beyond the mere figurative scheme, whilst a head of a fallen warrior from Satricum (Villa Giulia, Rome) has a formula very like that of the fallen warrior in the Pyrgi group. The combat theme is of course of frequent occurrence in the repertoire of the coroplastic artists at the beginning of the 5th century; it shows non-Hellenic forms in the armour too, whereas the decorative tiles, palmetted and voluted, are straightforward transpositions from the Greek, save for an occasional accentuation of the bodies (Falerii, Sassi Caduti, at Villa Giulia). The antefixes with protomes (women, Maenads, Sileni) come from fairly constant types, diffused with slight variants over a wide area from Capua to Marzabotto, emphasis being based, now on the plastic, now the decorative aspect, with an accent sometimes on simplification (Conca, Lanuvium; at Villa Giulia) and with stress on exterior decorative apparatus at the expense of the figurative (Capua, at Naples Museum; Caere, at Berlin), sometimes with classicist attitudes (Falerii, Vignale; at Villa Giulia), none of which has the expressive violence and the freshness of execution of the Veii antefixes with Gorgons, the greater part having been carried out by stamp.

The well-known antefix with a woman's head, crowned, without the shell frame, found in the Capitoline area at Rome (Museo dei Conservatori) presents a discerning interpretation following archaic Attic formulas. The antefixes with full figures from Satricum and Lanuvium (Villa Giulia and the British Museum) have different and independent characteristics, but are at a simple craft-

PLATE 33 – Terracotta head of male divinity (Tinia?) Latter half of 5th century. From Belvedere Temple, *Orvieto. Height 27 cm. Cf. p. 126*

workers' level, as also those with pairs of dancing maenads and Sileni, where movement never becomes dynamic and the episodic nature sinks into a 'folk' manner of looking at things. The small Caere group with the mythological theme of Hercules and Minerva (Louvre) is also incapable of escaping from an episodic manner, whilst other mythological subjects, formally classicist (*Pótnia therôn*, from Segni, Villa Giulia; Harpy, the same museum) which are markedly later, turn to pure decorativism. The group of big terracottas from

Satricum terracottas Satricum (Villa Giulia) are in appearance formally influenced by — or in reality perhaps only analogous with — the examples from Veii; but it is more placid and composed, so that it finds its own solution in the fine linear work of the drapings. But the Head of Jove is perhaps the most interesting example in

PLATE P. 125 Etruscan sub-archaic art of an attempt to present majesty and divinity in a balanced and solemn way rather than through mass and movement.

The small bronzes field, even if we wish to leave out of account the great accumulation of purely decorative pieces, offers us such a vast anthology of versions and so dense a network of connections as often to make it an almost hopeless task to discover the workshop from which they came, a task in which it will always be necessary to take care not to subordinate to source-seeking the evaluation of quality, as is happening in the case of Greek ceramics. An analysis of the production of small bronzes would take up an enormous amount of space, and it will be necessary to use the method of studying examples; it is clear that the artistic climate is very different here from that of the terracotta figures. In Etruscan art every art and craft specialization has its own character, its own formulas, its own background of taste. The small bronzes are generally refined, scrupulously worked-over, at least to as great an extent as the coroplastics are free and not bound by pre-judgments. And the small bronzes, too, as we have already to some extent seen, are one of the activities in which the forms and conventions of archaism are most faithfully preserved. Putting works into chronological order is here again not easy; many bronzes, perhaps the best, belong to museum collections without any indications of origin, and even when the associations are known, specially in respect of tomb-furniture, the dating of single pieces cannot be done exactly. To some extent the work in bronze more closely reflects Greek influences, largely Attic, whether from the iconographic point of view or that of style, and often thrusts to the forefront the problem of relations between classicism and Etruscan art.

Details of this iconographic influence are shown in the draperies (decorative figurines from Montepulciano; Museo Nazionale, Florence), up to the late archaic tradition preserved in the little Bologna group (in the Museo Civico)

PLATE P. 127 of the woman and child, the crowning decoration of a large candelabrum, for which the attribution to the early decades of the 5th century is difficult to maintain; the inventory of the tomb covers a period in the middle decades of the century (*c.* 460–430). Stylistically the Bologna bronze is related to the one now in New York, showing a satyr and maenads dancing, a theme found again in a third one now in the Cabinet des Médailles, Paris, attributed, like the little Bologna group, to a Vulci workshop. The Modena Dionysus-

PLATE 34 – Support for candelabrum. From the Necropoli dei Giardini, Bologna. *Museo Civico, Bologna. Height 15 cm. Cf. p. 126*

Phuphluns, neatly enclosed in the plumbline straightness of the clothing, is perhaps the most noteworthy product of the series; close to it is the small bronze (a priest?) recently discovered at Marzabotto, which shares, with the Phuphluns, delicacy in working-over with the burin.

However, alongside these examples, where the artist's attention is directed to a study of externals, there is a series of experiments where an attempt is made at anatomical research, following the lead of Greek art of the proto-classic 'severe' style. It is to be observed, of course, that the acceptance is not a complete one, the Etruscan mentality lacking the sensibility to present the nude as an harmonious coherence of parts. The anatomical representation remains conventional, often casual, having as its main intent emphasis on volume. This series, to which belongs the Kriophoros from Orvieto, now at Copenhagen, which fails to resolve anatomy into movement as in the discobolus of Villa Giulia, reaches in one direction the Ajax committing suicide, from Populonia, at Florence, in which anatomical analysis and movement are divorced, and in the other the bearded discus-bearer of Modena, which shows a return to the static scheme. In the warrior wearing a *chlamys* (Florence) the fluidity brought out in the lines of the drapery does not allow an anatomically satisfying composition.

PLATE P. 123

The two currents unite in a certain sense in the main couple in the Monteguragazza *stipe*, to the dependence of which on the Veii experiments attention has already been drawn. In the figure of the male making the offering the muscles are visible as a statement of mere volume and in a decorative context, emphasized by the casual presentation of the *chlamys*. The figure of the female worshipper follows the same plan as that of the male, with the drapings adapted schematically to it, presenting a noticeable contrast between the front and rear views; the female figure is thus not achieved as a plastic entity. Within certain limits a Hellenizing influence is more evident in the 'Strozzi Jove' at Florence, which is without the usual motif of the narrow waist, a feature of

Votive images of warriors

most sub-archaic nudes. A third current is represented by votive images of warriors (of the god Maris?), elongated and with movement expressed in the details of the dress and armour (London and Florence). From these come as descendants the drawn-out, schematically thread-like figures which are generally much less archaic than they would seem (the small Borgia bronze at Naples; others at Perugia and in Rome, Villa Giulia), or a warrior *promachos* from Perugia whose execution lacks coherence. The sub-archaic aspects are recognizable in the decorative elements (*krater* handles in the Louvre; from Spina, and fragment at Marzabotto). The leaping goat from Bibbona, now at Florence, goes back to the tradition of animal representation of the beginning of the century.

The Arezzo Chimaera

A vital moment is represented by an exceptional bronze, the Chimaera of Arezzo, the subject of infinite argument about Greek or Etruscan paternity. To date it a little later than the mid-point of the 5th century does not prevent our recalling the leonine heads of Himera, but this would be an iconographic relationship which is easily explained, Siceliote-Etruscan contacts being what

PLATE 35 – Bronze lamp. About 450 B.C. From Cortona. *Museo dell'Accademia Etrusca, Cortona. Diameter 45 cm.* *Cf. p. 130*

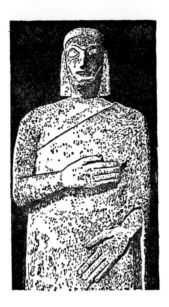

FIG. 50 – *Cinerary urn in stone, in shape of man, from Chianciano. First half of 5th century. British Museum*

they were. The absence of further examples contemporary with the great Etruscan bronzes does not allow us to answer the question. If on the one hand it is not possible to exclude importation, on the other there are several elements, such as the overemphasized form of the lower part of the mouth, the somewhat unclear modelling of the muscles, the decorative form of the paws, which would be unevennesses in an entire whole, and therefore can scarcely be maintained to be Greek, but is rather an Etruscan product of high quality, influenced to an unusual degree by a classicism no longer up-to-date, but markedly backward-looking. Comparison with the great cornice of Himera underlines this last aspect. In nationalistic literature one often finds side by side reproductions of the Chimaera and the Cortona lamp, for chronological reasons, but such a juxta-position only stresses the contrast: the Cortona lamp is a heavy decorative work, in dubious taste, not one of the best of its kind, though certainly one of the significant products of Etruscan work in bronze. The artist who decorated it showed no evidence of imagination nor acumen in composition in accumu-lating heterogeneous elements from the figurative and ornamental repertoire; perhaps the fame of the piece has been the source of argument leading to an unfavourable judgment on the work of the Etruscan craft-workers.

Anthropomorphic cinerary urns

With Arezzo and Cortona we come back to the inland region, to which Chiusi belongs, one of the old Etruscan centres where classicist influences are most noticeable. At Chiusi, and in its countryside, anthropomorphic cinerary urns succeed *canopi*, as we have already seen; following upon the ancient experience of the Casuccini statue, from the middle of the 5th century onwards work is

FIG. 50

produced such as the cinerary urns of Chianciano, Città della Pieve (Florence and Copenhagen) and Chiusi (Chiusi Museum), in the form of seated-figure

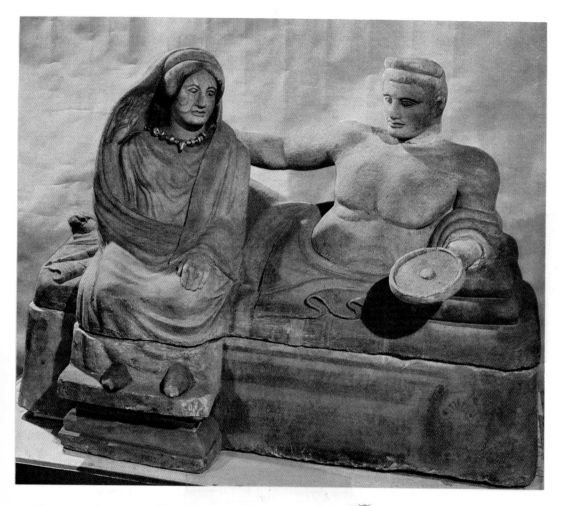

PLATE 36 – Sarcophagus with deceased couple. Last decades of 5th century B.C. From Città della Pieve. *Museo Archeologico, Florence. Height 1.10 m. Cf. p. 131*

states and like those in the shape of a sarcophagus with a single figure (Sarteano, Berlin) or with two figures (from Città della Pieve; Florence) and the deceased and *lasa* (from Chianciano; Florence). The statues with seated figures combine classicism in the faces and decorative elements in the throne with an axial rigidity and symmetry in the archaic tradition, noticeable in the heavy archaic-style folding between the feet (Città della Pieve; Copenhagen). The symmetrical rigour of the heads is also to be found in the sarcophagi, where however co-ordination between the parts of the recumbent figure is lacking, and the anatomy of the nude is reduced to a collection of spheroid volumes. The local tradition's carving skill is seen in the details of the countenances

PLATE P. 131
PLATE P. 133

and the descriptive details of hair and diadems. Where the seated figure (in groups) is brought out of the symmetrical scheme, it loses all coherence. The cinerary urns of Chiusi, taken as a whole, give a good idea of how classical influence affected the Etruscan area, a valid idea in that these are not highly elaborated and cultured productions. It is a vague classical attitude, which does not give reprints of iconographies or motifs, but simply adds to certain of its own products an air of exterior solemnity.

Classicism　A fictile antefix in the Chiusi Museum and probably coming from Chiusi throws light, if not on the previous experiences, at least on the parallel phenomena, in non-funerary art, of this classicist tendency. The Greek sense of proportion is here expressed through forms in the 'severe' style. The phenomenon belongs not only to Chiusi, but also to Veii, and indeed it is at the very end of production in this great art centre that we can probably discover the special place it occupies in the movement. With the head from the sanctuary of Minerva we can place the statuette of the youth from the sanctuary of Portonaccio. Less evident than in the female head the influence of Polyclitus can be seen in the youth's face, which is somewhat softened, but the syntactic elements are clearly observable in the nude body. Neither of the two works, certainly, possesses the power and qualities of suggestion of the so-called Malavolta head, which also comes from Portonaccio, a work that really shows the ability to achieve an original interpretation. It is not the Polyclitus of the 'Doryphorus' ('The Spearbearer') or the 'Diadumenos' who is the source of the experience which finds its reflexion in the Veii head, but the Polyclitus of the 'Kyniskos', as is clear from the proportions of the countenance and the shape of the eyes. We lack, unfortunately, the links in the chain that connects them, links that were formed in what must have been a quite brief period of time. The execution is certainly more powerful, the assertion of the artist's personality more decisive in the passage from the 'Kyniskos' to the Malavolta head than in that from the Olympic Zeus to the head from Falerii of which we shall speak later. The importance of the Veii head lies in the fact that this is no copy, no 'true-to-type' exemplar, but a derivative, a lesson turned to good account, which is a very different thing.

Faliscan plastic art　Moving from different bases the plastic art of the Faliscan area, about the end
PLATE P. 135　of the 5th century, produced the polychrome head which derives from the Olympic Zeus type, so as to earn itself a place in the documentation for a reconstructed history of the influences that resulted from the art of Phidias. The manner in which colour is applied is an added feature which betrays local taste. It is however symptomatic that this translation of the great original by Phidias (not direct, certainly, but based on an unknown intermediate version) should follow, chronologically, the revivals, clinging to post-Phidias mannerism, represented by the terracottas of the temple of San Leonardo at Orvieto, which can be dated about 420, more 'classicist' than the head of Zeus itself, in that they apply re-elaboration principles from Attic art, and not without some echoes of the 'severe' style. The classical inspiration of the terracottas of the Vignale temple represents, moreover, a special tendency of the Faliscan

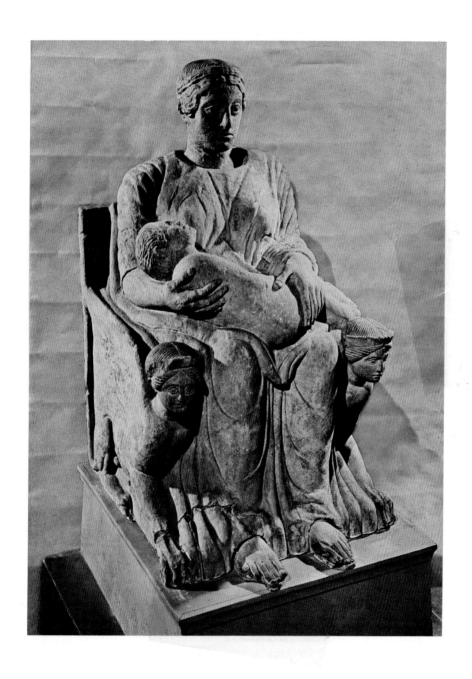

PLATE 37 – Limestone cinerary statue. Latter half of 5th century B.C. From Chianciano. *Museo Archeologico, Florence. Height 1 m. Cf. p. 131*

territory, which is the very one in which, not much later, the production of the most original of the painted pottery began. Falerii was a district with its own character, neither ethnically nor linguistically Etruscan, though directly implanted within the Etruscan cultural world; it certainly had features and experienced developments all its own, even though it started from premises which can all be found within the Etruscan experience. It was in fact characteristic of Etruscan art that, without being itself truly unified, it had such influence on a number of surrounding territories that it is difficult, except at a very late date, to draw a clear line between the general body of 'Etruscan' art and the artistic manifestations, for example, of Latium or of Umbria. The classical influence fell to a varying but quite general extent on the whole territory possessing an Etruscan culture; modest fictile fragments from Marzabotto bear witness to this influence even in what is clearly no artistically creative centre, while a true translation of classical motifs cannot fail to be recognized in the funerary steles of the Felsinean tombs.

Felsinean funerary steles

The art of Etruscan Bologna in the 5th and 4th century is concentrated in the production of these funerary sandstone steles. The vast importation of Attic painted vases, often of the highest quality, rules out the possibility that there could be, or the need that there should be ceramic production by a local body of craftsmen, who produced only earthenware vessels of no artistic interest.

PLATE P. 137

Goldsmiths' work and bronzes

The same is true for goldsmiths' work and bronzes; metal tools, candlesticks, figured and votive bronzes are for the most part imported, at Bologna as at Marzabotto, Spina and in the periphery of the Etruscan Po valley. The circumstances, at any rate, are such as to suggest a substantially eclectic attitude in the artistic life of the most northerly part of the Etruscan world. The Certosa ring is an example of such eclecticism, having in its bezel a winged demon's head and classicist figures at the ends of the 'rod' of the ring proper. It is, exceptionally, chisel work, a little sculpture in massive gold, one might almost say; but it is not at all sure that it is local. Other works in gold, found in relatively small quantities between Bologna and Spina (apart from the lost ones of Marzabotto) are all in repoussé lamina, with granulation, and knurling of a prevalently industrial character. At Spina in particular powerful influences can be seen — perhaps actual importations — from southern Italy and techniques using mechanical reproduction by means of dies. All this has little to do with the history of art.

What remain, then, as an undoubted expression of the local environment, are the funerary steles, which are no masterpieces, but bespeak the presence of Etruscan themes, closely linked with the Tyrrhenian area, and which, far more than is the case in the Tyrrhenian area, take on a figurative form with recourse to iconographic motifs and the Attic repertoire of types. Sculpture in the round disappears from the Felsinean world, which finds expression only in a flat, almost pencilled relief, so that we are led to conjecture a compensating feature of colour. In fact Felsinean steles are more in the nature of drawing than plastic art; acquaintance with Attic painted ceramics has doubtless played a decisive role in this respect and in imposing that sense of balance and proportion which

Felsinean style

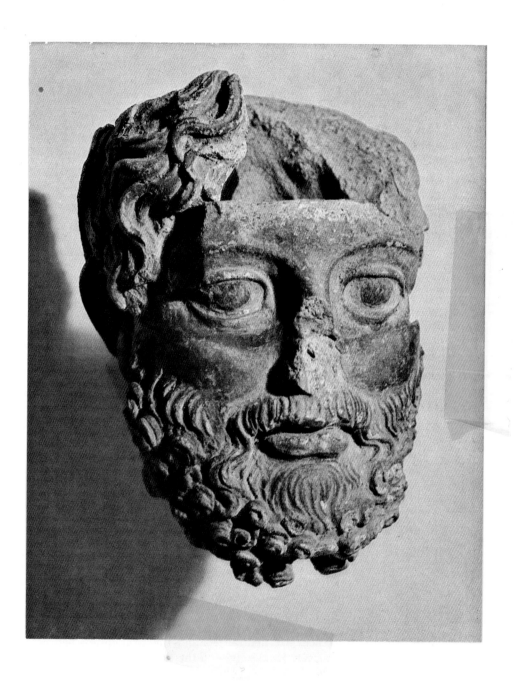

PLATE 38 – Polychrome terracotta head of Tinia. End of 5th century B.C. From Civita Castellana. *Museo Nazionale di Villa Giulia, Rome. Height 16 cm. Cf. p. 132*

eliminates from Felsinean steles indiscipline of form or exaggeration of expression. It is plain that the masons of Felsina stopped at the externals, when confronted by Attic works, without understanding the intimate values of rhythm and form to be seen even in craft-work such as pottery; it is plain that they took only schemes and attitudes that coincided with their own immediate aims. Thus, from the combat scenes of the Attic repertoire come the little 'novelties' of the Felsinean catalogue, the 'celtomachies', the oldest of the representations of warfare against the Celts in Western art, in that a date can be given them in the last few decades of their production. The stele, as a monument of commemoration and communication, is something not known to southern Etruria, but has analogies with central and northern Etruria, from Chiusi northwards. In the Felsinean way of seeing, much better than elsewhere, the

Tomb iconography stele gives expression to all that figurative and symbological inheritance which in central and southern Etruria remained inaccessible, locked in the chamber-tombs, — scenes of farewell and of the last journey, funeral gymnastic and musical contests, what one might call biographical episodes, such as duels with Gallic adversaries, representations which are 'in character' with the deceased, such as that of the warship in the gigantic stele of Vel Caicna. Sometimes an inscription is added, to integrate the figurative representation with the commemorative aim, the total concept which inspires the *monumentum*. That concept is not that the tomb is seen as the 'home' of the dead, but that the memorial is a means of recalling his memory to the living.

The graphic character of Felsinean art, referred to above in relation to Felsinean steles, remains more or less restricted to functional and technical needs, but in the same area we see reflected the consequences in plastic art of working out the influences deriving from Polyclitus. In the 'success story' of Polyclitus, Etruria played its part, but, in this case too, in the indirect way of re-elaborations, whence the autonomous character of the Malavolta head. The theories

PLATE P. 139 of Polyclitus are interpreted not as motion but as rest, and low, wide proportions and an affirmation of volume appear again. Of this nature is the small bronze from the Monte Capra *stipe* at Bologna, a highly-thought of example of an indirect 'Polyclitus' tradition, eclectic from the first. That mere 'weighty' quality is also found in small bronzes repeating the 'warrior' type like that in the Falterona *stipe*. The 'warrior' votive offering no longer has the stance of a combatant, but is static, his lance lowered. Very close to the Falte-

APPX. PL. 14 rona bronze is the celebrated group from Marzabotto portraying the warrior and the woman who offers him the parting libation. Although the group is composed of two elements coming from different traditions it achieves a union in which the differences are neutralized and the relationship between the protagonists is made clear. Its affinity with the Falterona warrior, also seen in the richly detailed tool work, suggests a common origin. The faces clearly

The 'Mars' of Todi reveal a line of influence, coming after Phidias, as in the greatest example of Etruscan bronze work of the beginning of the 4th century, the 'Mars' of Todi, which was also a votive offering. Leaving out of account the modern helmet, the Todi statue is nothing but a large bronze statue, ill-structured by reason

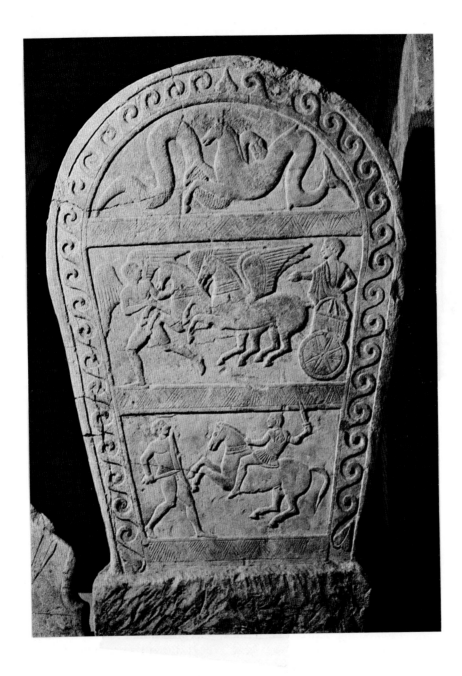

PLATE 39 – Funerary stele in sandstone (fight between serpent and hippocampus, i.e. sea-horse; journey to the Underworld; 'Celtomachy'). About 400 B.C. From the Bologna necropolis. *Museo Civico, Bologna. Height 1.80 m.* *Cf. p. 134*

of the mechanical and badly-proportioned relationship between the parts, uneven in its rendering of anatomy, and expressionless in the face, — and yet in it attempts have been made to find echoes of Phidias. There is indeed a vague, general Attic quality, but the head is rendered quite superficially. The small bronzes are in this respect much more effective; but all the works here referred to probably come from an original, which, the figures being armed with a cuirass, will more probably be Italic than Greek.

A bronze of unknown origin in the Estense Gallery at Modena may be considered as close to these, in chronology as in taste, yet new, and a solitary example of the scheme it follows; it represents a bearded, wounded warrior, on the point of falling. Though this theme is rendered on the whole somewhat mechanically, the head is one of the masterpieces of the small bronzes of its time, and even the shortened trunk goes a long way to suggest the failing of the body within the rigid cylinder of the cuirass. These works cannot easily be given a firm date. The persistence of the cuirass theme is certainly symptomatic, being also found on mirrors and steles to which I shall refer; the cuirass, offering the solution of the cylindroid trunk, does not come into the Greek plastic and organic view of things. It is not unlikely that this is a case of borrowing from the repertoires of painting, since the male figure with a cuirass is foreign to the classical ideal of statuary, accompanied by a steady continuance of borrowings from iconographies of late archaism and an inclination towards a formula which made it possible to avoid fundamental problems of form and proportion. Then the use of the theme became a habit and continues to be found for a long time in decorative works, particularly in the handles of cists, even outside the Etruscan area proper.

Orvieto terracottas Some terracottas from the temples of San Leonardo and Belvedere, at Orvieto, show that the 'classicizing' tendency continued in the 4th century, though in a somewhat inconsequential way; alongside normal figures appears the hero (?), nude, but with the *chlamys* fastened beneath the chin with a round fibula, a much-misused formula. The nude body is ordinary, though correct; it is not that which characterizes this work, but the surprising head which is virtually foreign to the body to which it is joined, with a violence of expression in its absence of symmetry, in the half-open mouth with teeth exposed, with the concave discs of the pupils. This fixed, apparently unintentional look of horror appears again in the head of the old man who plucks at his beard, in the same group. The beard of the nude hero is expressed not by corrugation but by long cord-like locks repeated unvaryingly one after the other. The dilated eyes and open mouth between the two oblique lines of the moustache give an expression of something between amazement and absorption, as unintentional, perhaps, as the 'horror' of the other head. The fact that these are mere episodes within a larger context shows their casual nature; they are episodes not sought after with a view to their effect in the whole. This casual character is also found in the 'folk-style' ploughman in the bronze group from Arezzo.

Faliscan area In the Faliscan area the classicist tendency already mentioned continues, without the indiscipline, which is so significant, and the attempts at interpreta-

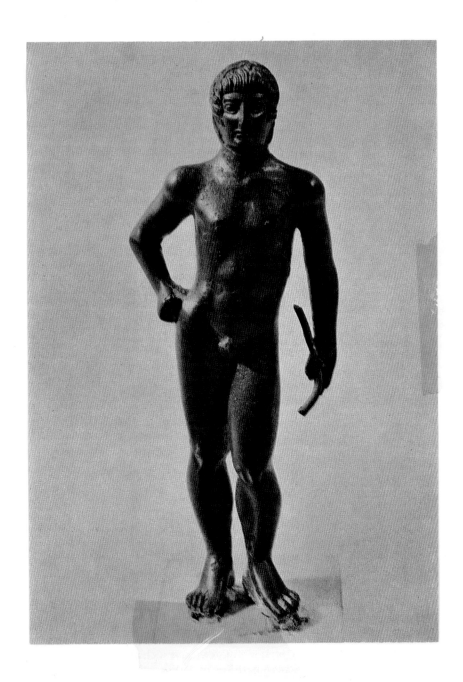

PLATE 40 – Small votive bronze. Early 4th century B.C. From the *stipe* of Monte Capra (Casalecchio di Reno). *Museo Civico, Bologna. Height 1.36 m. Cf. p. 136*

PLATE P. 141

tion found in the Orvieto district. We may take into account the passage of a certain period of time, but it is clear that we have here two different ways of artistic feeling. The Scasato terracotta group are correct but impersonal translations, where, if at all, as in the case of the 'Apollo', we can see a certain rhetorical emptiness which may suggest the need to date the works later. The forms of the face and the twist of the neck, along with the high-styling, fullness and painter's presentation of the hair, recall the iconography of Alexander the Great. These general characteristics reminiscent of Scopas, here and in other heads, do not depend directly on the dramatic style of the sculptor of Paros, but on the widely diffused forms, from Scopas' followers, that had become part of the common language of Hellenism, and which are here particularly evident in the most expressive of the heads, that of the young hero with the small beard. More than anything else these sculptures, together with their faithfulness to Hellenistic forms accepted as such, show the possibilities of 'translation' of statuary types into coroplastics, which is by now to be considered as the common artistic medium of the Italic area. In this case, relationships of time and place that can justify their inclusion in a history of Etruscan art can be admitted only in the technical aspect. The Faliscan terracottas, on the other hand, are isolated phenomena which local needs had not prepared for and which did not lead to noticeable later consequences. Quite close to them in respect of taste and historical position are a head of a youth from the Antemnae territory, and one of Jupiter, coming from Roman trade in *objets d'art*, and now in Munich, which can be put with the enlarged Hellenistic versions of the Zeus type. The *acroterium* from Fabbrica di Roma with the flying figure (Villa Giulia) seeks painter's and illusionistic effects through fluidity and inconsistency in the modelling.

The 'Etruscan Renaissance'

What has been called the 'Renaissance of Etruscan Art' is in reality no more than a considerably increased production, but one of little originality in all that concerns architectural decoration, which in the purely ornamental sector has very ordinary characteristics and often shows only bad taste. We must therefore look elsewhere for manifestations which are more interesting and specific, and particularly in the field of funerary sculpture, not neglecting to remark how the acquisition of Hellenic forms, documented at Falerii on the basis of a local tradition going back to the end of the 5th century, is the symptom of a cleavage, which was then developing, between this form of cultivated art and the local forms, perhaps anticipating slightly the time limits given for this phenomenon by Dohrn.

Bianchi Bandinelli, moreover, long ago drew attention to the emergence of these aspects, episodically or on a larger scale, and more recently Pallottino has included the Etruscan manifestations in a wider picture of Italic art. The position of the Faliscan territory, moreover, is such as to provoke serious thought about what the particular position of Rome might be, even though direct documentation from Roman soil is limited to remains which would be difficult to classify. That such a situation, however, extended to the Latian area, is shown by the production of engraved cists, throwing much light on the state of taste, and with the chief example carried out at Rome. The 4th century is also the

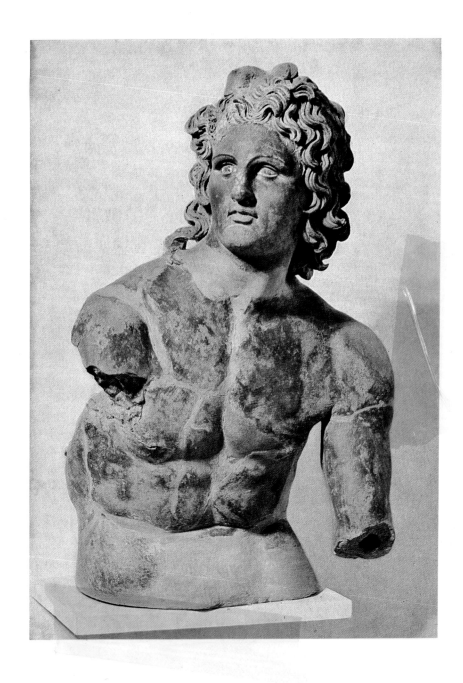

PLATE 41 – Fragment of terracotta statue (Apollo?). Early 2nd century. From Tempio dei Sassi Caduti, Civita Castellana. *Museo Nazionale di Villa Giulia, Rome. Height 56 cm. Cf. p. 140*

period of maximum development of Faliscan painting, which is a phenomenon independent of Etruscan art.

Sarcophagi with
recumbent figures

To continue with the subject of sculpture, we may find an undeniably original note at Tarquinia, where the tradition of sarcophagi with figures portrayed on the lid is taken up again, in very many examples, such as those of the Parthunus and then of the Pulena families. The figures are represented in relief on the lids, or half-recumbent, and in the latter case they go back to the archaic tradition, never entirely lost, particularly at Chiusi. The representation of the figures totally recumbent in low relief is something entirely new, acquired from Mediterranean contacts. The flattening of the bodies leads to the heads being sometimes sunk into the cushions, thus reducing the extent of the relief.

The sarcophagus of Velthur Parthunus, the so-called 'Sarcophagus of the Magnate' (Tarquinia Museum) shows the figure stretched out on the lid with the nude body presented in large smooth surfaces and the drapings simplified to a few elementary folds, a sign of the scant interest felt in the effects of the clothing and its relationship with the body. The portraiture is clearly intentional, and there is a three-dimensional composition of the face which is the Italic equivalent of the formal classical structure. The casket (which here as elsewhere has relationships in type with Asia Minor and the Hellenized regions of the Pontus) bears a frieze based upon painting, the 'Centauromachy', in which the figures in relief stand out on a monochrome background. Another sarcophagus from the same group, with the figure a little raised, the hair long and the left hand supporting the head, was modelled more softly, developing more logically, a more relaxed presentation, and, in the head, a more diligent characterization of the subject, yet not at all a realistic individual portrait; the drapings too have a more lively presentation of mass, and of light and shade. The varieties of the recumbent-figure type extend from the completely horizontal (Caere, 'Tomb of the Sarcophagi', Gregorian Etruscan Museum, with formal procession scene, in flat relief, polychrome, on the casket) to the half-recumbent; in this respect we must not overlook a Vulci sarcophagus (Archaeological Museum, Florence) where the head is quite isolated, supported by the arm, as in the type of the fully Hellenistic period, able to present the

FIG. 51

FIG. 51 – *Lid of sarcophagus from Vulci. 4th century. Archaeological Museum, Florence*

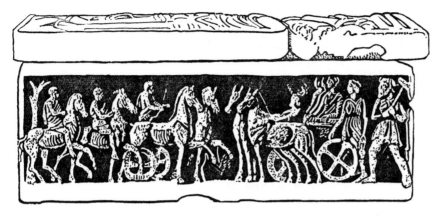

FIG. 52 – *Main face of sarcophagus in stone, from Vulci. 4th century. Glyptothek Ny Carlsberg, Copenhagen*

recumbent figure but only with the bust held erect in the asyntactic manner of archaism. Unique (or, so far, isolated cases) are the two Vulci sarcophagi (Museum of Fine Arts, Boston), with the married couple embracing on the marriage couch, where the presentation of the figures on a plane surface is converted into movement. The portraiture is intentional, and a classicist effect can be seen in the female heads.

The decoration in relief frequently ignores the panels of the wooden-coffin type of casket in order to use all three main faces (Sarcophagus with Hunting Scene; Copenhagen, Glyptothek Ny Carlsberg). The prevalently mythological themes, sometimes with allegorical and cathartic functions, alternate with decorative elements (deer, griffins and lions) or with the 'Etruscan' episodes of the ac-companying procession and the funerary world where one can plainly see the formal disequilibrium, between figurative work copied from Greek cartoons and that with a local subject. Etruscan art of the 4th and the 3rd century did not again express its own Etruscan world in the forms suggested by the Greek experience of form, as did come about for example in the archaic *cippi* of Chiusi. A typical representation of the Etruscan concept of life beyond the tomb, with frightful and tormenting demons, is given in the sarcophagus of a member of the Pulena family (Tarquinia Museum), with the figure on the lid sitting up with an open scroll on which were incised his name, genealogy and offices, the first example of a commemorative inscription in an Etruscan monu-mental group, and by this time, I should say, a sign of Roman influence. The Pulena sarcophagus is in fact somewhat later than the most ancient *elogia* of the Roman sepulchre of the Scipios.

The most impressive example of sarcophagi with a mythological theme, taken round all the sides, is that from Torre San Severo (Museo dell'Opera del Duomo, Orvieto). On the longer sides Etruscan demons act as a framework for two extensive treatments of the sacrifice of Polyxena and the funeral of Patroclus; on the shorter are two myths from the Odyssey — Circe, and the

FIG. 52

Roman influence

PLATE P. 147

PAINTING

Calling-up of Tiresias. The relief is flat and heavy, and was given strongly contrasted polychrome treatment.

Painting in the 5th century, with an evident lack of inspiration, continues on the same lines as what went before it. As far as our knowledge goes there was no painter sufficiently outstanding to be placed beside the terracotta artist who carried out the statues of Veii. This could perhaps be a sign of a loss of independence and a weakening of interest in pictorial expression. Etruscan art loved colour, but viewed it mainly, one might say, as a complement of plastic shapes (and the Veii statues are the most valid witness to this); the observation may be extended to the manifold elements of temple decoration. The taste for painted plastic art emphasized what underlay Greek archaism, at the end of which the plastic form, for its own sake, little by little became prevalent. A clear point of contact is that shown by the Olympia fictile group (Zeus and Ganymede), which is not very distant, chronologically, from the works of the followers of Vulca. But after this Etruscan art always kept to the line laid down between the 6th and the beginnings of the 5th century, taking up in this respect a 'sub-archaic' attitude until late in the period of Hellenistic influence.

Tarquinia
PLATE P. 144

There is at Tarquinia a small fictile urn, belonging to the first decades of the century, decorated with paintings of *palaestra* scenes. The connection between the subject and such funerary cycles as those of the 'Tomb of the Two-horsed Chariots' ('Tomba delle Bighe') and the later 'Tomba delle Olimpiadi' is

PLATE 42 – Painted terracotta cinerary urn. About 500 B.C. From Tarquinia. *Museo Archeologico, Tarquinia. Cf. p. 144*

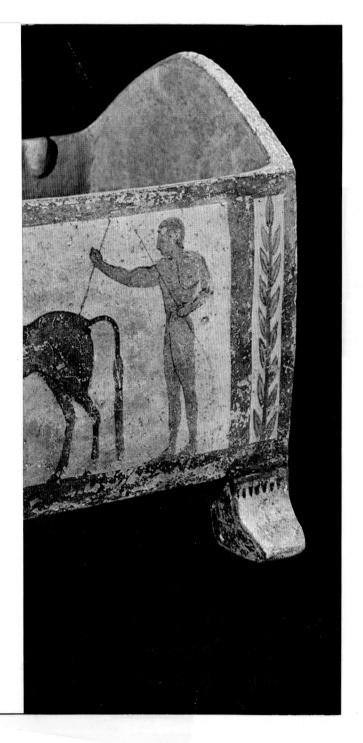

clear; the spacing of figurative elements and the syntactic use of colour are on the lines of the 'Baron's tomb'. For the whole of the 5th century Tarquinia continues to be one of the great centres of funerary painting; several painted tombs are dated over the period between the first and the last quarter-century, all of them manifestations of a retarded archaic style which assimilates from time to time some features of 'modernity'. The oldest is the most meaningful, although it has come down to us in a poor state of conservation, — the 'Tomba delle Bighe' ('Tomb of the Two-horsed Chariots'), which is dated between the first and the second decade. The combat theme inspired a rich variety of attitudes going beyond the subjects usual lay-out of convivial and dance themes; the absence of the conventional partition elements gives the composition both a unity and a liberty which are unusual, in contradiction with the more ample (and therefore, at least in intention, more important) lower frieze showing the woman and the feast, where the partition elements are mechanical and rigid. The dark background from which the figures of the second frieze stand out draws attention to the influence on this tomb of Attic ceramic techniques and the same influence plays a part in the free-and-easy realism of the groups shown under the platform of the small frieze, a realism repeating after a lapse of time that of the erotic groups in the 'Tomb of the Bulls'; the games scenes do not share the Greek athletic ideal, but do objectively reflect the coarse and noisy character of Italic public spectacles. Here I would not separate from the field of painting certain mirrors, engraved and in relief; some indeed (Villa Giulia and the Gregorian Museum, Rome), directly copy the sub-archaic types of the couple on the *kline*, and closely allied to it is the sample in the Bibliothèque Nationale at Paris, with a scene that alludes to the meeting between Helen and Paris. The example in relief from the Gregorian Museum, showing the rape of Cephalus,

'*Tomb of the Two-horsed Chariots*'

FIG. 53

FIG. 53 – '*Tomba delle Bighe*'. *Detail of wall-painting. Early 5th century. Tarquinia. From a drawing*

146

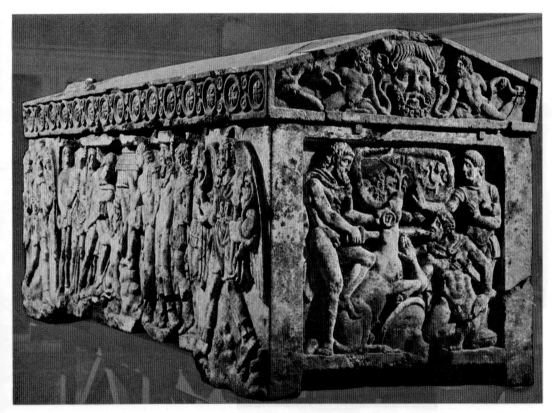

PLATE 43 – Polychrome stone sarcophagus. About 300 B.C. From Torre San Severo. *Museo Archeologico, Florence.* Length 2.10 m. *Cf. p. 143*

derives, however, from Attic ceramics of early classical times; it is perfectly balanced in composition, while the other, of which several copies are known, showing the Etruscan myth of the rape by Hercules of a woman called Mlacuch, has many forced features besides its exaggerated linear character.

Painting at Chiusi, in the centre of Etruria, is independent of that at Tarquinia. *Chiusi* One notes a more popular and provincial style in the 'Tomb of the Monkey', which is a little later (between the second and third decade). The scene presents athletic games mixed with jugglers' 'turns'; in setting out the material, much prominence is given to the well-known group of wrestlers, for which the artist had recourse to a reversible cartoon. The other Chiusi tomb, the 'Tomba del Colle' or 'Casuccini tomb', about half-way through the century, already shows schematized motifs without the bursting vitality of the pictures in the 'Tomb of the Monkey'. The Chiusi 'Tomba del Deposito de' Dei' is of unequal quality, its composition in part incoherent, but it has the interesting episode of the fallen horse, recalling, in a different form, that of the new Tarquinian 'Tomba delle Olimpiadi'.

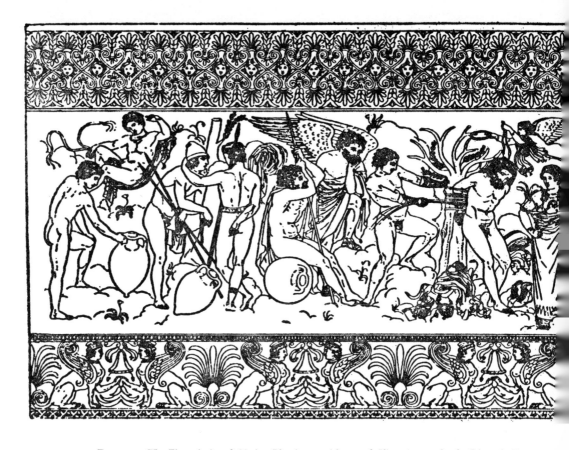

FIG. 54 – *The Ficoroni cist of Novios Plautios: punishment of King Amycus by the Dioscuri. From Palestrina, 3rd century. Museo Nazionale di Villa Giulia, Rome*

PLATE P. 151

Tarquinian tombs

At Tarquinia the themes remain the same in the Tombs of the 'Leopards' and of the 'Triclinium', in the second quarter of the century, but out of the identity of theme there emerges the difference in temperament of the painters. In the first the figures are stumpy, with aggressive profiles and a broad simplicity of planning and an implicit dynamic quality causing the traditional little trees, sketched in outline, to bend and take part in the movement; the drapings are informed by the body shapes, and attention is concentrated on certain details which are given emphasis (for instance, the hands of the player of the double flute). In the 'Tomb of the Triclinium' ('Tomba del Triclinio') movement is more apparent than real, and the drawing inclines to stylistic, recherché complacency, a cultured attitude which attains its greatest success in the female dancer who turns her head. Because of these characteristics, Greek pottery and the painter of Brygos have been recalled. The 'Tomb of the Funeral Couch' is eclectic; in part it echoes the motifs of the 'Tomb of the Leopards', schematiz-

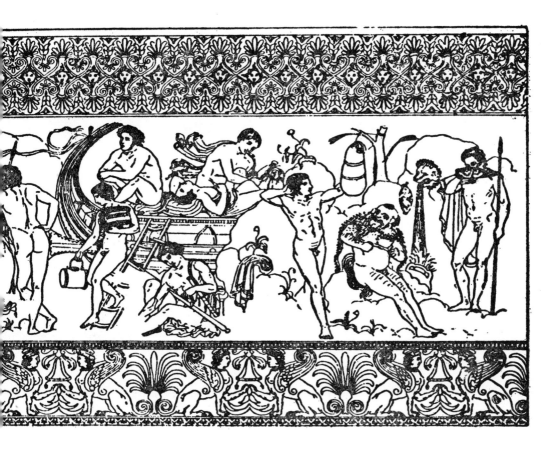

ing them, and in part the small frieze of the 'Tomb of the Two-horsed Chariots'.
The 'Francesca Giustiniani tomb' completes our picture of Tarquinian artistic
tendencies in the 5th century, to some extent on a craftwork note, and with
a violent use of polychrome, and now and then continuing to adopt classical
forms. The last page of the story, for the present, is the recently discovered
'Tomb of the Ship', where the usual convivial scene opens unexpectedly onto a
great marine background, taking up again details from the past which we have
already seen and which were tried out in the 'Tomb of Hunting and Fishing'.
Its novelty and unexpected nature however must not lead us to attach an ex-
cessive value to this tomb, which, in the abundance of its elements and the
usual inconsequent connection between them, is indicative of the possibilities,
and the limitations, of Etruscan painting in a period when inspiration had
grown faint and imitation was the vogue.
Dated about the middle of the 4th century, the Tarquinian 'Sarcophagus of the

PLATE 44 – Mural with dance scene. 'Tomba del Triclinio', Tarquinia. *Cf. p. 148*

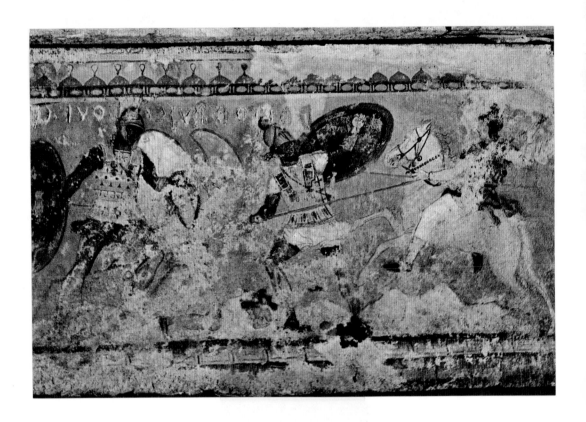

PLATE 45 – Sarcophagus in painted marble with Amazonomachy (detail). From Tarquinia. *Museo Archeologico, Florence. Length 2 m. Cf. p. 152*

'Sarcophagus of the Amazons' Amazons' (Archaeological Museum, Florence) is an isolated case in the Etruscan area, without connections with what went before it and without any real consequences for the works of painting known to us. The funerary inscription of Ramtha Huzcnai was scratched on one of the surfaces when the painting was complete. Balance in composition, a syntactic use of colour, and lastly the discovery that the sarcophagus is in marble from the Greek islands have suggested, with more reason than in many other cases, that the artist might have been a Greek. It has seemed difficult to view this work as the result of a line of copies though that is not impossible when we take into account the discontinuous and inconsequential history of Etruscan art. The 'Sarcophagus of the Amazons' is in fact the only remaining monument of large-scale ancient painting which allows us to study at first hand the problems of painting in the 4th century, before the artistic personality of Apelles made itself felt. It is not so

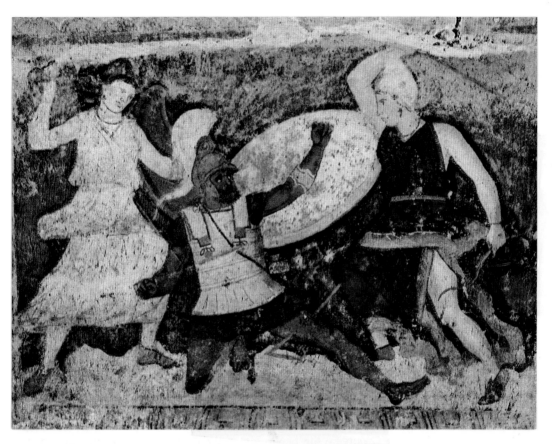

PLATE 46 – Sarcophagus in painted marble with Amazonomachy (detail). From Tarquinia. *Museo Archeologico, Florence. Length 2 m. Cf. p. 152*

much by the designs and attitudes that our interest is quickened as by the dissolution of the contour lines which had already taken place and which already tends to melt away into a plastic light-and-shade, while the palette is enriched with *finesses* and semitones, upon the original basis of the traditional four colours. Comparisons with contemporary painted pottery have also led to the hypothesis of a southern painter working in Etruria, or strong influence from the hellenized south. Without any very high artistic value (many of the designs are rather conventional, the composition is more correct than dramatic, and the rendering reaches fullness rather in the details), the 'Sarcophagus of the Amazons' is the only authoritative voice of painting in the second period of classicism to be heard in the Etruscan area; alongside it, as a copy of a Greek composition, can be put the graffito of the Ficoroni cist, which was somewhat later. Painted pottery in the red-figure technique, produced in Etruria many decades *Vase painting*

later than in Greece, shows surprising creative capacity and great richness of expression. It seems, indeed, to have been the most lively sector of artistic production. At first it follows the Attic model (amphora at Munich with scenes from the Trojan cycle), but takes on independent aspects, especially in the course of the 4th century. The best known is perhaps the group of Faliscan painters, from whom the 'Painter of the Aurora' singles himself out, developing his scenes with deftness of drawing and composing rich decorative themes, making ample use of colour and white. He is near not so much to late Attic painted pottery as to the Italic ceramic artists of the south, but without the exuberance of the latter. The bull assailed by griffins on the neck of his well-known *krater* at Villa Giulia is one of the most solid achievements of Italic ceramic painting. Rather more of a traditionalist is the 'Painter of Nazzano', author of the *krater* portraying the 'Destruction of Troy', which copies schemes of composition from pottery under the influence of the painting of Polygnotus, putting emphasis on elements of drawing and detail. Products not infrequently sink to free drawing, as in the cup showing Bacchus and the Maenad, which is known mainly for its inscription in Faliscan dialect. Other centres of production were recognized many decades ago by Albizzati, who was also the first to discern the worth of the masterpiece of Etruscan pottery painting in the 4th century, the *krater* showing the Argonauts (?), in the Florence Museum. Remains of composition in the Polygnotus tradition are here accompanied by a structure wherein at last the traditional linear drawing plan is superseded, with volumes suggested rather than described, and a fullness of mass and movement, specially in the hair. We have here a master craftsman of highly individual character who blends elements of culture from the past with a clear-sighted choice of the modern.

PLATE P. 157

Krater with Argonauts

In a much more popular vein, but effective, were the painters of the 'Campanian-style Group', at the beginning of the century; some of the painters at Volterra were rather superficial, but competent in drawing and free from classicist preconceptions in ornamentation, and achieve at the end of the century a figurative expression which is successful as caricature, rich in light, shade and colour effects. (*Krater* portraying pigmy and crane; Archaeological Museum, Florence). Ceramic painting at Volterra can also show greater themes on a large scale. (*Krater* showing hero and 'Victory' goddess, in the Guarnacci Museum.) Of a strictly Attic bent, even in technique, is the Vulci painter of the cup in the Gregorian Etruscan Museum, showing the carrying off of a girl by a bearded god (?); there is no recourse to colour, but the ornaments in relief are covered with gold leaf. Highly elaborated in a composition containing manifold examples of foreshortening, the cup from Montepulciano, showing Bacchus playing with the *kottabos*, is notable in particular for the highly convincing quality of the drapings. The cup is thought to be from a Chiusi artistic circle, which also produced other receptacles. The Vulci ceramic artists on the other hand incline to more dramatic effects (*krater* showing the death of Ajax, British Museum; the sacrifice of the Trojan prisoners, Bibliothèque Nationale, Paris), making use of demonic elements (*krater* portraying the myth of Alceste, *ibid.*).

'Campanian-style Group'

154

I give a few examples only, because all the material awaits further working over, after the classification done by Beazley and others. Perugia has a school of its own, among the later ones (the so-called 'Palazzone' vases), whilst the so-called 'Upper Adriatic' ceramics, with the greatest density of finds at Adria and Spina, also occupy a special place. It has neither narrative nor figurative elements and the decoration is carried out with an extremely free technique in which the brush-work no longer has linear values, but is purely painting. Metal engravings cannot be divorced from painted ceramic decoration. The mirror from the Gregorian Etruscan Museum, from a Vulci artist, the engraver METAL ENGRAVING of the 'Calchas', goes back to the classicist style of the Parthenon, if we may so describe it, at the end of the 5th century. The hero of the Homeric myth is seen as the Etruscan genius of haruspication; in what was produced at Vulci, and in Etruscan art generally, there is no example except for the Atlas mirror which is so significant a document of the influence of the Greek world's manner of expression. Mirrors with duel scenes, drawn from Greek myth (duel of Achilles and Penthesilea) and occasionally from Etruscan myth too (Laran and Celsclan, from Populonia; Archaeological Museum, Florence) and the example from Castiglione in Teverina showing the death of Penthesilea (in the same FIG. 56 Museum) are close to local styles and particularly to the bronzes of the 'Mars' type from Todi; they are a little earlier than the work of the engraver of Telephus and other engravers of his circle whose products have been found mainly in the Bomarzo area.

The art of the mirror is closely associated with that of the cists, which nevertheless cannot be called Etruscan. Cist art is Latian art, and the most noble CISTS example, the Ficoroni cist, though found like the rest at Praeneste, bears besides FIG. 54 the signature of the artist, 'Novios Plautios', an indication of the locality of the workshop where it was done, — *med Romai fecid*. It is superfluous to add that

FIG. 55 – *Red-figure krater from a Volterra workshop. End of 4th century. Museo Etrusco Guarnacci, Volterra*

FIGS. 56, 57 – *Engraving on mirror: death of Penthesilea, from Castiglione in Teverina. 4th century. Museo Archeologico, Florence. Engraving on mirror: Semla, Apulu and the young Phuphluns, from Vulci. 4th century. Antikensammlungen, Berlin*

Novius invented nothing new; he merely translated on to the side of the cist a Greek cartoon, varying perhaps the arrangement of the groups, but — it is symptomatic in the work of this Italic artist — there is correctness of drawing and faithfulness to his model, without any indiscipline, without deviations. His de-personalized classicism brings him close to the style of the Faliscans, and this too because of the division of his working surface into zones and his ornamental sequences. The other cist — the Rape of Chrysippus — is perhaps his, but it is less constant and disciplined in the drawing; it is clear that, in cists as in the mirrors, the extreme simplicity of the means of expression must go back to the pure drawing of traditional ceramic painting design; however, Novius's pencilling was meant more to suggest than describe. Nor can we say that the

'Triumph'
iconography

production of cists in general is of interest to the art historian, often not even for its iconography, except for the specific case of the cist at Berlin, which is part of the oldest (if not actually the oldest) Roman iconography on the 'Triumph' theme; in it there is an obvious contrast between the artless representation of the *quadriga* theme, repeating models which were probably only pottery figuration, and the muddled delineation of the rest of the ceremony, where the guidance of the cartoon was absent and the engraver had to fend for himself. Production of the Latian cists, historically interesting for the light

PLATE 47 – Red-figure *crater* by the 'Painter of Nazzano'. From Civita Castellana. *Museo Nazionale di Villa Giulia, Rome. Height 57 cm. Cf. p. 154*

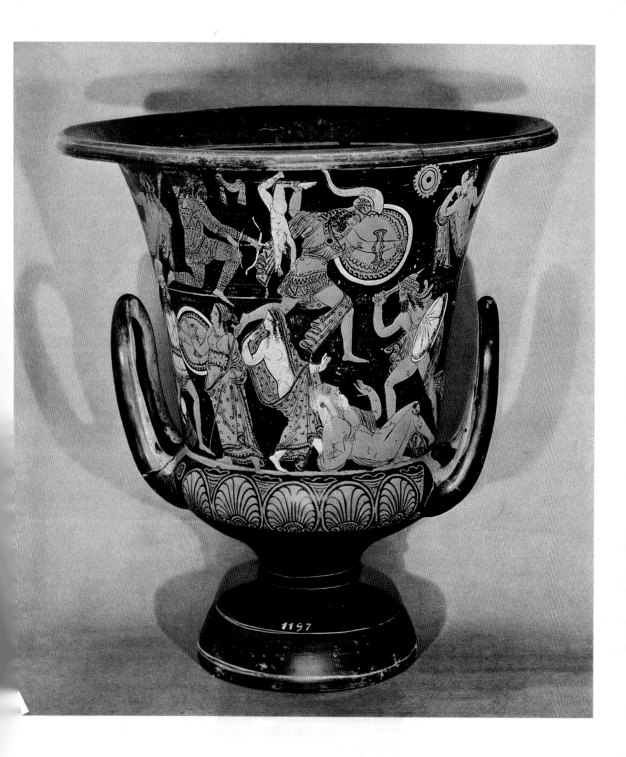

FIG. 58 – *Detail from cist from Palestrina: Rape of Chrysippus. 3rd century. Museo Nazionale di Villa Giulia, Rome*

it throws on Roman taste, independent in at least this case from Etruria, was considerable, but it soon declined, as did the production of mirrors, into hasty and undistinguished work, though not entirely without interest from the point of view of colour.

On one mirror there appears a second name of a Latin engraver, 'Vilis Pilipus', probably very late. If the cists can be compared with pottery for their development of broad figurative themes, mirrors would offer subjects for quite a number of observations too, in that it is during the course of the 4th century that the decoration on them gradually escapes from the *cylix* type to include extracts from large-scale pictorial works; later this happened still more generally in engravings in the Hellenistic period, when even the traditional means of engraving-tool and punch work is enriched with devices directed to suggesting a plastic 'light-and-shade' or to bring out the volumes without complete delineation of details; in their continuation of the arts of the past, now 'outside their time', the engravers, like the ceramic artists, tried to keep abreast of new developments in painting, their common and habitual mainspring.

Engraving went on longer, and mirrors and cists continued to be produced, when vases had long since ceased to be painted. The refined stylism of the engraver of Phuphluns and Semla (mirror at Berlin, Antikensammlungen), who came from Vulci, was enriched with notes of colour in the later mirror (also

FIG. 57

from Vulci and now in the Bibliothèque Nationale, Paris) by the engraver of Epiur, showing two complicated scenes, one Olympian, the other Chthonian, which take up the round space divided into two half circles. In practice these engravers are adherents of classicism, as is their colleague, also from Vulci, who FIG. 59 engraved Usil (mirror with 'conversation-piece', showing Usil standing between Nethuns and Thesan; in the Gregorian Etruscan Museum), whilst more inclined to Italiote influences are the engravers of the Bomarzo group who work on the decorative and 'baroque' lines of the engraver of Telephus. The manners of these craftsmen were taken up, in a more ordinary style, in a mirror found at Arezzo (Museo Civico, Bologna), showing the birth of Menrva. There is particular interest in a mirror from Tarquinia, in which is portrayed the legend of Tarchon the Soothsayer, and which in respect of the drawing of the heads is quite close to the work of the painter of the 'Tomb of Shields'. A landscape detail (the sun rising behind the clouds) is confirmation that this mirror comes from a pictorial archetype, and in fact there are solid reasons for maintaining that it preserves the memory of a large-scale Etruscan painting based on national legend or history, so that it is not out of place to recall the 'historic' pictures of the François tomb. Two mirrors with a mythological subject certainly had a similar origin in large paintings, — that from Perugia showing

FIGS. 59, 60 – *Engraving on mirror: Usil (the sun-god), Nethuns and Thesan. From Vulci. Beginning of 3rd century. Vatican City, Museo Gregoriano Etrusco. Engraving on mirror: Menrva shows Perseus and Turms the head of Medusa reflected in a pool of water. From Perugia. Beginning of 3rd century. British Museum.*

Tyndareus and the Dioscuri and that from Volterra with Hercle being suckled by Uni, an Etruscan version of the myth of the assumption of the hero into Olympus. Both of them, constricted within the round, still preserve an echo of grandiose formal motifs, coming from the circles that produced the large-scale

FIG. 60 paintings of Middle Hellenism; this is also true of the mirror of the Perseus saga, with a reflection effect, from Perugia, now in London.

FIG. 61 – *Ivory laminae from Palestrina. 4th century. Museo di Villa Giulia, Rome*

VII. HELLENISTIC INFLUENCES
AND LATE ETRUSCAN ART

HELLENISTIC
INFLUENCES

When the time came for Hellenistic artistic experience to find a widespread
echo in the cities that had an Etruscan culture and tradition, these cities had
practically ceased to have any independent political power, and had been one
by one drawn into the Roman orbit, in different ways but with the same results.
In the 3rd century, Roman victory in the First Punic War, by eliminating
Carthaginian sea-power, had fully opened up again the high seas of the West
to Mediterranean-wide traffic; in the 2nd, the final defeat of Carthage con-
solidated those results and extended the sphere of Roman interest to the East.
Both wars had been fought and won with the large-scale co-operation of the
Italic peoples, but, of these, it does not seem that the Etruscans were able or
knew how to profit by the consequences. In any case the situation that had
come about was a new one, and Italy in effect took over the mission of being
the centre of Mediterranean life in all its manifold aspects. Old Etruria felt the
consequences of the situation indirectly now, composed as she was of vassal
states of the Romans. The flow of Hellenistic imports affected all parts of the
Italic area and the consequent artistic influences were manifested not in Etruria
alone, that is within the historic boundaries of the Etruscan nation, but also
in Campania and in Latium. In these countries one cannot say that there was
everywhere a real continuity of the old influences which had been felt in the
times of the maximum expansion of Etruscan power; in some zones, and par-
ticularly Campania, contacts had been virtually lost for some time; new forces
were now in play, more or less directly influenced by the civilizing currents
that had had their epicentres in the Greek cities of the Ionic and South
Tyrrhenian shores; some of these in fact had witnessed a mixing of Greek with
Lucanian and Samnite elements. The Romans extended their dominion and
carried out their mission of unification even while those separate processes
of assimilation were still going forward. Upon what was now clearly established
as the centre of Italy and the Mediterranean there converged by now all the
most vital forces of the multiform Italic substratum.

In an historical climate such as this it is doubtful whether it is still permissible
to speak of Etruscan art in the proper sense. That there was an intensified
artistic production from the 3rd century on is clear, in the entire Tyrrhenian
area, from the Tiber to the Magra, indeed an exceptional one if we look at
artisans' products (even though these were for the great part done by mass pro-
duction methods); but there is no longer a really individual character, with
those unmistakable features shown particularly during Archaism and also in
the more recent periods. There is a wider variety of art forms, tending to level
off in a new *koiné*, taking in a great part of central and southern Italy, though
from it the zone to the north of the Apennines remains practically cut off. We

*Break-up of
traditional unity*

can scarcely attribute to the influence of the Etruscan towns alone the geographical spread of homologous artistic responses; it is rather that there were like reactions, at various levels and of the various traditions, to the same influences. Art in the Etruscan cities in the Hellenistic period took a large part of its themes from the Greek repertoire, using them as it needed, but always fully revealing their place of origin. The transmission of cartoons and the movements of teams of craft-workers are actual facts that have to be taken into account. For example, it seems impossible to attribute works like the terracottas

PLATE P. 163 from Civitalba or Luna to local artists or traditions. Etruria's becoming part of the Roman system had moreover the effect of greatly facilitating the freedom of movement in Italy, and the Italic towns, the Etruscan ones included, were destined within it to lose their autonomy and distinctive traditional character.

To keep to our theme, however, and reserving the right to give the term 'Etruscan' now a more exclusively geographical meaning, it is natural to ask what the attitude of the Etruscan artistic world was when confronted by Hellenism. It will have already been seen from the foregoing that the Etruscan reaction to Greek archaic and classic art was not rational, not coherent like the Greek artistic phenomenon it was faced with, but an unbalanced reaction, one of obvious discontinuity, of striking delays and returns to positions formerly held. Thus we must rule out the possibility of any real comprehension by the Etruscans and the Italic peoples, when confronted with Hellenistic art, of the direct and consequential link between the later and the earlier experience of the Greek world, even where Hellenism might have seemed most outspokenly 'deviationist'. They found congenial to their way of feeling and in accord with their own tendencies the freedom and emphases of the 'baroque', the break with the classical canons, the realism, the colour, but they experienced them in their externals, not in their intrinsic substance. Roman taste on the other hand took up the classical inheritance, appreciated it via Atticist experience, offered a favourable common ground for Hellenism's different tendencies, helping to form eclectic academic currents, so that Hellenism continued throughout the Imperial period. Eclectic tendencies were present too in the art of the Etruscan area, but they were more radically changed there because they were worked on by local artists and not exclusively entrusted to Greek workshops and hands, or those trained in the Greek tradition.

ARCHITECTURE The later period includes most of the Etruscan monuments known, though they are still few, and some are the only examples, in certain fields, that we can
City gates examine and evaluate. This is the case with city gates, which only late take on more than a functional and technical interest. The only gates which can be exactly dated (third quarter of the 3rd century) are those of Falerii Novi (Santa Maria di Falléri), built in fact by the Romans along with the wall after the destruction of the old town of the Faliscans; they are simple arched structures in rectangular stone blocks having a solidly constructed outer row for their extrados and considerably projecting topping cornices; sculptured heads dec-
APPX. PL. 2 orate the outer row of hewn stones and the keystone. The stones of the outer row

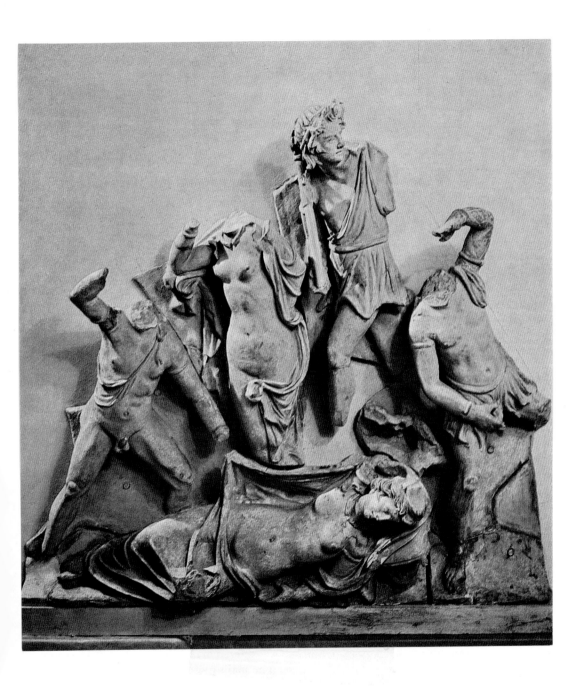

PLATE 48 – Terracotta temple decoration (detail: Ariadne discovered). 2nd century B.C. From Civitalba. *Museo Civico, Bologna. Height 94 cm. Cf. p. 162*

are lost in the Porta all'Arco at Volterra, which is not older, it seems, than the 2nd century. The artistic value of the gateway is very limited; much greater is its antiquarian interest, because of the three sculptured heads in the bearing stones and keystone. The cut of the stones and the setting-up are not so carefully done as in the Falerii gate, and the heads, in baroque style and striking a pathetic note, are irrational in respect of mass and movement compared with the dimensions of the total construction.

These heads illustrate a symbolism connected with the act of passing through, seen as a rite, something which in a different form is found at Rome much earlier, but which has analogies in the Aegean basin. Some very well-known urns show the wide-spread acceptance of the gate-theme in the Etruscan world;

Perugia

APPX. PL. I

one of these is at Volterra, another at Perugia. In both cases the heads stand forth from the strictly functional part of the arch, just as in what has survived in the Marzia gate at Perugia. This gate is non-functional, with its 'door-posts' used as framework for the six-column loggia above. The figurative element is amply introduced into this context, where the loggia is probably a late development of the pseudo-triglyph of the older gate of August in the same town. In the Porta di Augusto the decorative portion harmonizes, in its severity and plastic qualities, with the massive structure of the wall and the functional character which the construction achieves. The upper arch is a relieving arch, not a decorative one, and is framed, like the lower one, which has the functional opening, by gate-posts. The Porta di Augusto, for its presentation of mass, its closely linked framing elements, is perhaps the most completely realized architectural work of the Etruscan area, and coincides with Etruscan taste because of that tendency to emphasize effects, just as the 'Marzia'

Bridge construction

gate is an example of the 'inorganic' aspect of Etruscan feeling, with its incoherent decorative additions. The bridges at Blera and San Nicolò di Viterbo are the work of Roman engineers.

Funerary architecture

If we are to consider the chamber-tombs, funerary architecture does not substantially depart from tradition, except where the chamber becomes, late, a vaulted one (Vaiano near Castiglione del Lago; hypogeum of San Manno near Perugia; Bettona), without reaching a real solution of the problem of space by the use of the new technique, — that is, without transforming the technical process into a means of conscious artistic expression. Thus the so-called 'Pythagorus' Den', or 'Tanella di Pitagora', which is in any case from Roman times, has a purely technical interest. Attention to horizontal spaciousness is shown in the

PLATE P. 113

'Cardinal's tomb' at Tarquinia, and the 'Tomb of the Reliefs' at Caere, which are of the pillar-supported-roof type. In the 'Tomb of the Reliefs', with its super-abundant decoration, whilst an attempt was made to give a realistic reproduction of a room, a sample is also offered of use of colour to give an illusion of space, in a non-figurative sense. The main room of the Perugia tomb of the Velimna family stresses spaces in the vertical direction, exaggerating the slope of the roof and raising the *columen*, and in the horizontal direction by widening the corridors parallel with the end wall; further, the axial principle is strengthened by the presence, in the centre of the end room, of Arnth Velimna's urn, a true

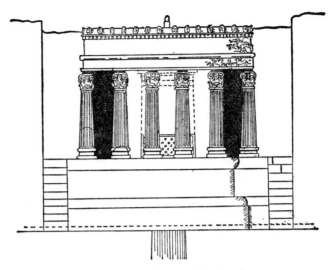

FIG. 62 – *Tomba Ildebranda, Sovana*
(reconstruction)

and proper independent *monumentum*, allusive in fact to a triumphal arch, since the tall base is conceived as being opened up in the middle by an arch, in which there appears a procession, which can still be made out from the traces of paint which remain. The neighbouring urns of the other Velimnas are also erected on bases which are independent of their environment.

The assimilation of Hellenistic forms is quite clear in the rock-hewn façades of the temple type at Sovana ('Tomba Ildebranda', Grotta Pola). This is not a simple 'transposing', but an Italic 'integration' of traditional forms and details which shows a breadth of relationships which in the geographical sense reach as far as Asia Minor and Syria, but more noticeably and frequently to Sicily and Magna Graecia, and in the temporal sense go back at least to the 5th century (the Sardo-Punic capital of Nora). The elaboration, basically Italic rules out

Rock-hewn façades
at Sovana
FIGS. 62, 63

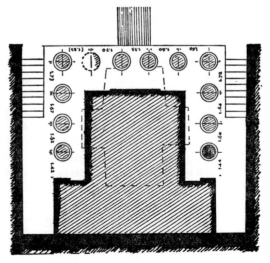

FIG. 63 – *Plan of Tomba Ildebranda,*
Sovana

its being a direct descendant from Hellenism and a direct relationship with the aedicule-type monuments (the mausoleum); the arrangement of the order in the Greek sense is lacking. Formal analogies in the decoration, on Hellenistic archetypes, are to be found in particular with the southern Italian area. To this in particular there belongs the problem of the voluted capital with sculptured heads added at the same time as the volutes, a capital the diffusion and elaboration of which also links Etruria with Campania and Magna Graecia, but which seems to have awakened particular interest in Etruria.

At Sovana the form of the capital, like other details too, now shows the influences of the classicist current, largely operative in Italy from the first decades of the 2nd century B.C. and observable too in the last manifestations of wall-painting. But in general, before these last manifestations, Etruscan decoration sought heavily-laden effects both in respect of colour and plastic form: the tombs of Sovana in fact were covered with white stucco, painted in lively colours, and probably with irrational and violent juxtapositions, as in the interior of the Caere 'Tomb of the Reliefs'. This feature too shows the independent character of the Italic reaction to the commonly diffused and accepted Hellenistic forms.

PLATE P. 113

The vast anthology constituted by decorative terracottas, in their extreme variety of motifs and forms, as these circulated and were repeated, nevertheless does present some common characteristics. With the always striking polychrome feature is often associated *à jour* pierced work which transforms the crowning element into a sort of lacework and confirms the continuing traditional character of temple architecture, always resistant to formal rectilinear definition. This character is possessed by, amongst others, the antepagments from Caere, now at Copenhagen, the Faliscan polychrome *acroterion* at Villa Giulia, of classicist tendencies, and the antepagments of the little temple at Talamon. The terracotta covering-slabs for the rafter ends always present a break-up of lines at their lower edges, interrupting unity of alignment. The decorative repertoire extends from classical motifs, and even 'archaistic' ones in the later times, to moulded additions which were often *recherché*, as in the frieze with protomes in the temple of Belvedere d'Orvieto, and to quite a technical virtuosity, as in the frieze with heads from Caere, now in the Vatican, baroque in taste and south Italian in inspiration.

PLASTIC ART
Terracottas

To the objects mentioned above may be added the very numerous moulded terracottas from frontons and acroteria; we must speak further of some of these. Some of them, even if they have not come down to us complete, are in a condition which makes satisfactory reconstruction possible, and they can be interpreted for the pointers they offer in connection with architectural problems. Colour and a wealth of moulded elements in the facing-tiles are associated

PLATE P. 167

with crowding of frontal decoration, which only at Luna shows the influence of classical architectural principles, with the repetition of the theme of the vertical figure. At Talamon composition is somewhat chaotic and lays most stress on obliques, which are found again, combining with vertical and hori-

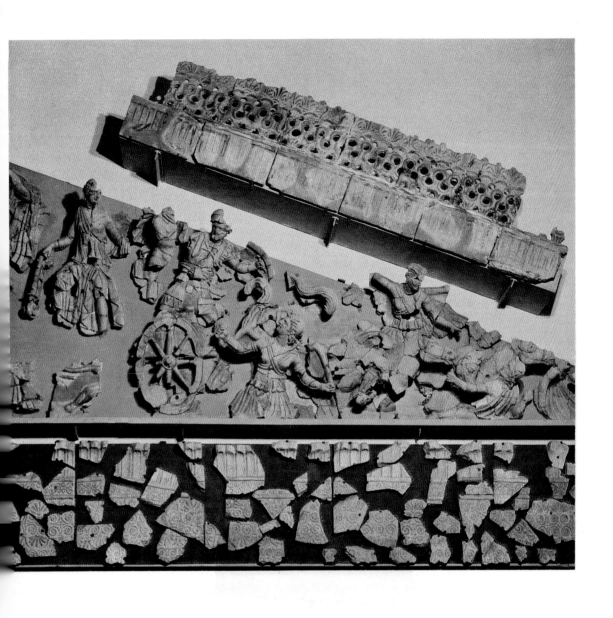

PLATE 49 – Terracotta temple decoration (detail: the death of Amphiaraus). About 200 B.C. From Talamon.
Archaeological Museum, Florence. Cf. p. 166

PLATE P. 163 zontal lines, at Civitalba. A figure which strikes an axial note, in line with the *columen*, is introduced however at Talamon. The groups point constantly to a heightening of the frontons, and therefore also to the persistence of the temple's traditional characteristics — *barycephalae, humiles, latae*, as described by Vitruvius (III, 3, 5). The influence of the classic temple type is not felt in the area of Etruscan civilization until Roman designs are carried out. The version that we to-day see of the temple of Fiesole is of late date; the external walls of the side *cellae* certainly extended to the front, ruling out the hypothesis of lateral colonnades.

Temple at Florence The Florence temple has three *cellae*; as in the case of the Fiesole temple, there were two phases of construction, with succeeding enlargement; it was not earlier however than the times of Roman colonization, even for the temple's first form.

The reference to Hellenistic themes in decorative coroplastics shows once again how foreign to the Italic area was an awareness of problems of form, to which it sought a clearly eclectic solution. The formula of the Scopas tradition, for instance, was not just transferred in its entirety, but only in so far as it was filtered through the baroque experience and could be sympathized with, in its outward appearance, by a personality at the craft worker's level, in search of exaggerated means of expression and inclined to the dramatic. Thus pathos not infrequently becomes truculence, even in urn reliefs. Solidity of structure and thus an intensity of expression that springs in a fairly coherent way from the formal presentation is found in the fictile steles from Arezzo, not only PLATE P. 169 in the pathetic Amazon but also in the Minerva, an intensity achieved in an emotional way by the means of expression available in coroplastics, inserting rapid detail of line and cutting deep to produce shadows. What accompanied this Arezzo decorative work — which would be dated about 150 — is unknown, but we can see clearly by examining other works, comparable even if not exactly contemporary, that the local artists — as the numerous examples offered by the urns confirm — took over entire iconographic schemes, freely modifying them, for scenes which were in origin mainly intended for painters.

Cartoons for It is this fact, together with attributing to them too early a date, which has
pictures led to the mistake of crediting the Etruscans with 'inventions' and 'anticipations' in the successful treatment of space which in reality spring from the translation into plastic terms of cartoons for pictures, or else are the unintended results of a happy improvization. Translated painters' cartoons are the basis PLATES PP. 167, 163 of the frontons and frieze of Civitalba and those of Talamon. The decoration of the fronton is carried out in relief rather than in the group of statues. The fronton of Talamon, if as has been supposed it decorated a temple built in commemoration of the victory of 225, would be an allegorical interpretation of the mythical subject. In this group, balance is lacking between the composition of the left-hand wing, showing the flight of Adrastus, and the rapid scene which, in the right-hand wing, presents the chariot of Amphiaraus sinking into the ground, dynamically resolved in a far-off echo of the Parthenon. The right wing, in fact, apart from the somewhat illogical introduction of the Etruscan

168

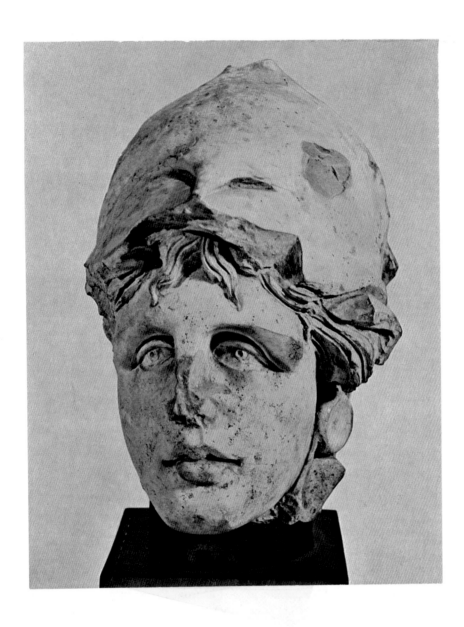

PLATE 50 – Terracotta head of Minerva (fragment of decoration from a fronton). From unknown temple at Arezzo. *Archaeological Museum, Florence. Height 12 cm. Cf. p. 168*

demonic figures, — a sort of note of explanation for local consumption, is undoubtedly successful as representation, specially in the figures of the horses. The positive results, then, are to be found in the details, not in the whole, which, inorganically adapted to use as decoration for a fronton, betrays the difficulty met with in rising to large-scale composition, especially when versions of the same subject on small urns are compared with it. The forced baroque quality would perhaps suggest a rather later date, which would bring the Talamon fronton nearer to the date of the Civitalba decoration.

Civitalba reliefs The latter work shows that there was much uniformity of motifs and taste even outside the Etruscan area proper, the result of the contemporaneous arrival of Hellenistic influences in southern Italy, Campania and Latium, and in all central Italy, and the steady mingling of maturer with newer Italic experiences into an established *koiné*. In the Civitalba reliefs the search for pictorial effects and the unforced technique cannot hide the mechanical
PLATE P. 163 nature of the composition and the recourse to turning back and repeating old types, and the forced attempt at a dynamism more apparent than real in the translation of cartoons in all probability Asiatic. Here too the achievement lies rather in the details, in the pictorial attractiveness of Ariadne unveiled and in the pathetic quality in the heads of certain Gauls, since identity in technique is not sufficient to harmonize the dissonances resulting from the use of different cartoons.

The Luna frontons lack the fresh, impetuous technique of Talamon and Civitalba. They cannot be earlier than 176, the date of the Roman colonization, and the composed and classical note suggests a definitely later date. The Luna works are not a case of copying single cartoons, but, at least in the side showing the gods, rather an anthological assembly of statuary groups from different sources. The very freedom given by coroplastic technique is reduced to a minimum, sacrificed to academic punctiliousness about finish. Not very
Volsinian acroterium different in this respect are the *acroterium* from Volsinii, of Minerva with a woman (which can be dated if we take the woman's clothing as a *terminus post quem*), and still less so the seated female figure from San Gregorio at Rome, now in the Museo dei Conservatori. In many of these terracottas the elongated figures which are a feature of late Hellenistic mannerism are repeated; it is natural to see in this fashion — which was itself sufficient to break up the classical sense of proportion and to open the door to a decorative note — a descendant from Campanian as well as from Etruscan art, which in all its long history had shown a constant absence of sensibility for syntactic relationships and organic composition.

Technical tradition Nor is it to be greatly wondered at if Etruria too surrendered that predilection for a massy quality in forms, beloved of archaism in the Ionic tradition. As compared with Campanian art, however, the master's touch in Etruscan art

PLATE 51 – Statue in bronze. (So-called 'Orator'). About 80 B.C. From Sanguineto on Lake Trasimene. *Archaeological Museum, Florence. Height 1.80 m. Cf. p. 172*

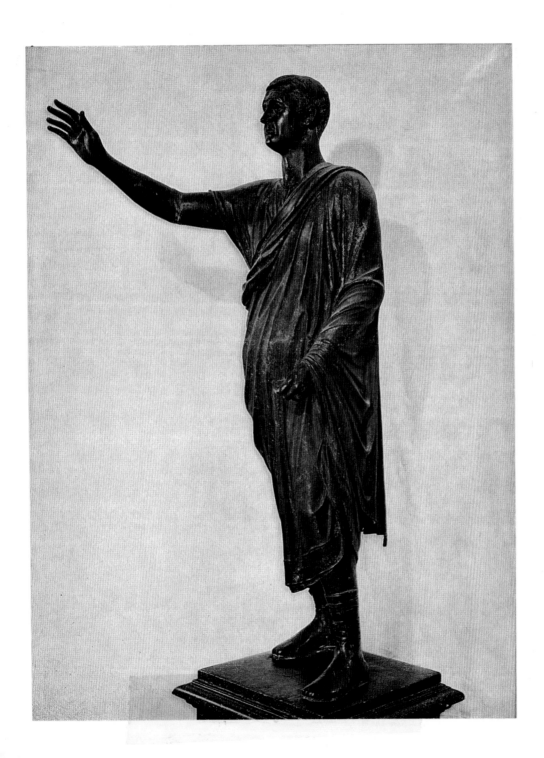

often announces itself still in its constructive ability, whereas in Campania they were content with capricious improvisations which reduced structure to utter disorder (Young man in a cloak, from Pignataro Interamna; Copenhagen, Glyptothek Ny Carlsberg).

STATUARY
Romans in the toga

The structural plan is more obvious, and with good reason, in works produced at Rome, where Hellenistic influence made itself more directly felt. The male fictile figure from San Gregorio, together with the classicism of the seated woman, is in the line of those experiences which led to the formation of the Roman *togatus* type, more cultivated in the formal sense than a celebrated

PLATE P. 171
The 'Orator'

statue, the so-called 'Orator' ('Arringatore') of Florence. The dress of the 'Orator', realistic both in itself and in its being closely modelled on the body which it clothes, is the Italic answer to Hellenistic draperies which by now have predominantly decorative aims. The date of the work — the subject of much argument — is now put in the first half of the 1st century and so becomes a part of the history of the Roman portrait, even though it is not in the absolute sense Roman, as it is not in the absolute sense Etruscan either, having been found in Umbria. It may be classified, following Schweitzer, as in the 'pictorico-pathetic' category. The 'Orator' brings into the situation of the 1st century, via a central Italic route, the sum of those experiences, taking place in somewhat earlier times, which had been brought to maturity by the artists responsible

PLATE P. 173

for the Capitoline 'Brutus' and the head of Bovianum, in which the classical additions (the hair of the 'Brutus') are still very obvious as symptoms of a component element, and individual representation is not yet carried out to the extent of being physiognomically realistic. Italic interpretation of the Hellenistic portrait, in this form, will not repeat itself and in fact the 'Orator' already presupposes some contact with realism. The Etruscan nature of the 'Brutus' lies both in the non-classical character of the model and the lack of concern about analysis.

This poses therefore the problem of Etruscan influence in the formation of the Roman portrait, a point which we must clarify, since the identification of the funeral monument by means of an inscription is not synonymous with a thoroughgoing attempt at physiognomic detail, even though attention is focussed on the head. Putting the recumbent figure on the lid of the sarcophagus goes back to an archaic tradition, represented both in the canopic sculptures of Chiusi and in the sarcophagi of Caere, and it is a non-Hellenic tradition. To recall an 'image' of the deceased is not necessarily to imply that his features are reproduced, and the portrait is therefore intended, yet only hinted at, as in the Tarquinian sarcophagi. Individual representation is thus lost in type generalizations, and odd cases, such as the demonic teeth in a Chiusi funerary figure, are not really part of the representation of the physiognomy and go beyond the limits of realism. What is constant — even though attention con-

FIG. 64 – *Sarcophagus lid: the dead woman as a bacchante. From Tarquinia ('Tomba del Triclinio'). About 250. British Museum*

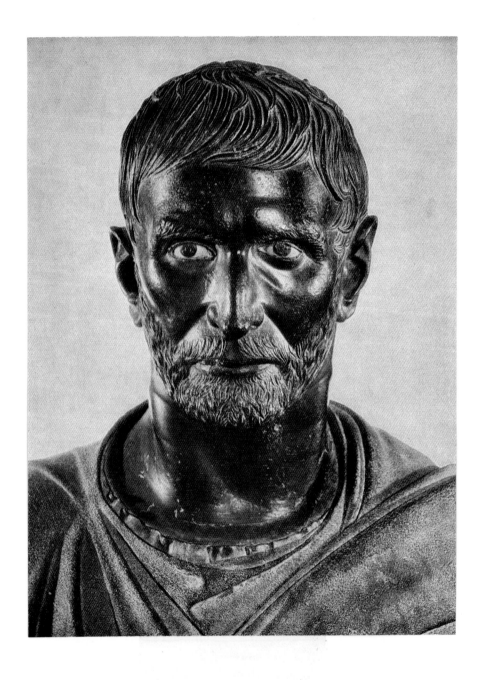

PLATE 52 – Head in bronze. (So-called 'Brutus'). 2nd century B.C. *Capitoline Museum, Rome. Height 37 cm.*
Cf. p. 172

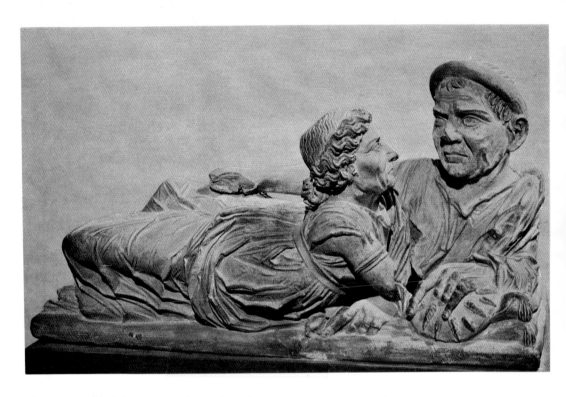

PLATE 53 – Lid of cinerary urn: deceased couple. 1st century B.C. From Volterra. *Guarnacci Museum. Length 47 cm. Cf. p. 177*

tinues to be given to the head — is the total representation of the figure as a whole; this does not mean there is harmony of proportion, because the recumbent figures are in fact always inorganically presented, but the need for this integral rendering is confirmed by the atrophied, but entire, representation of the bodies on small urns, where the size of the head assumes an almost caricatural character. Often quite artificial contortions are resorted to in order to present upright and full-face the heads of the recumbent figures. The well-known late group of the aged couple in the *kline*, which takes up again an archaic and sub-archaic motif, has in the faces what are features of a type rather than of a portrait, though this group has often been quoted as a forerunner of Roman realism. That the process mentioned above should have very commonly led, in the second half of the 2nd century and the first half of the 1st, to the production of heads proper, which are very common particularly as votive offerings in the Etrusco-Latian sanctuaries, is easily understood, and would be a taking up again of a very ancient tradition and a development in the Roman use of *imagines*.

Such heads, often in mass-production and in general reduced to type, present a local style strongly influenced by Hellenism. They include some of the most

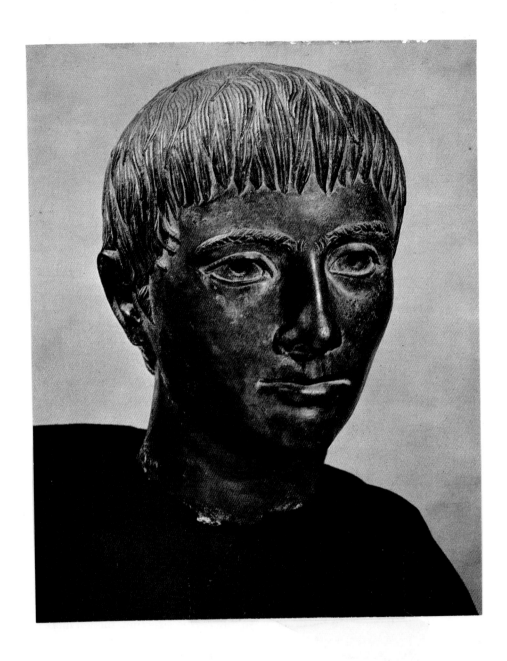

PLATE 54 – Youth's head in bronze. 2nd century B.C. Origin unknown. *Archaeological Museum, Florence.*

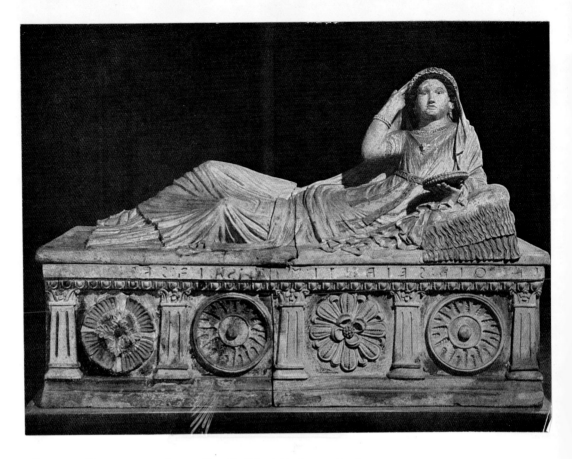

striking creations of Italic art as an autonomous phenomenon, parallel but not converging with the steady progress of Romanization.

Sarcophagi with
figures
PLATE P. 176

The well-known Chiusi sarcophagus of Larthia Seianti is a clear example of this lack of synthesis, accompanied by a purely external descriptive attitude to the details of the lady's *parure* (which has numerous parallels) and a cultivated pretentiousness in the drapery. No different in structure, though more classical in the clothing, is the other sarcophagus, now in the British Museum, of Seianti Thanunia Tlesnasa, where the full curve of the mantle on head and right arm encircles the entire bust, attenuating the effect of the faulty joining of the trunk and legs; the head, however, has the same characteristic of immediacy of expression. The fictile sarcophagi of Tuscania, which can be dated between the end of the 2nd and the middle of the 1st century, attain illusonistic plastic effects, given by rapid touching-up with the spatula; the heads

vary between ordinariness, apparent realism, and abnormal features such as in the deceased with his canine teeth projecting, in the Gregorian Museum, or caricatural features as in the very well-known lid from Volterra, in the Guar- PLATE P. 174 nacci Museum, showing a married couple. Of a portrait in the proper sense we can never, or hardly ever speak; moreover a body of craft-workers such as this was practically incapable, because of its limitations and very qualities, of achieving a naturalistic, true-to-physiognomy portrait, which calls for a considered study of the subject, or, in cases with more modest aims, the patience to use mechanical means of reproduction, such as the mask. If any at all, it would appear that Hellenistic influences were being felt, as in the Barberino urn at Florence, or in a Chiusi sarcophagus portraying a 'celtomachy' on its sides; this is itself a pointer in the naturalistic direction.

There was, however, another way of presentation which had nothing to do at all with the actual person but showed the deceased as a mythological figure (the sarcophagus of Adonis in the Gregorian Museum). More frequently, the tendency was to reduce to type, to draw a sketch, when not an outright 'caricature'. This is the case with the aged pair on the Volterra urn mentioned, with the pensive deceased man in the Chiusi Museum, or, also at Chiusi, in the delightful sketch of the woman in a mantle. However, attention should be drawn to the absence, here, of that popular, episodic character which one finds in the work of the Campanian craftsmen, linked with the somewhat distant Southern Italian tradition. In the Etruscan workshops there is a strength in interpretation, a stubborn insistence, almost, on the concrete data, character-

FIGS. 65, 66 – *Terracotta head of woman. About 100. Gregorian Etruscan Museum, Vatican City. Terracotta votive head, from Caere. 1st century. Gregorian Etruscan Museum, Vatican City*

istics which are undoubtedly original and of value, even though they remained uncrowned by the results that would have followed a conscious working-out of the form. Along with the 'heroic' and then the naturalistic portrait of Hellenism, along with the true-to-physiognomy realism of the Romans, there stand, with their minor importance, the Etruscan figures, substantially independent of one as of the other. The Tuscania fictile sarcophagi are very different from the monuments just mentioned. In them were sought mainly illusionistic plastic effects by means of tracing continuous furrows deeply into the surface. These sarcophagi have a certain originality, which was achieved by the technical media achieving new forms of expression, though these remained in the nature of improvisation.

SMALL URNS
Figured urns

FIG. 67

FIG. 68

FIG. 69

The small urns, multiplied in their hundreds and in some cases produced with the help of a die and then finished with colour, are only rarely of interest to the art historian; most of them were produced by trade-workers, and often they are of an everyday, mediocre standard. Some generalizations apply to all the groups, of which the main ones are those of Chiusi, Volterra and Perugia. The urns are a derivative, and a résumé, of the sarcophagus, which, in accordance with long tradition, was conceived as a couch, with figures stretched out on the lid; in reducing the dimensions to a smaller scale, the head, the focus of interest, as we have seen, does not undergo a proportionate reduction and thus often remains of enormous size as compared with the shortened body. This shortening of the bodies is not the only aspect on which stress must be laid, — there is also the widespread use of figurative themes on the sides. These themes are drawn in the main from the stock of Greek mythology and specially from the forms it took in the tragic poets, and not infrequently the personages depicted wear

FIG. 67 – *Front of cinerary urn from Volterra: the recognition of Paris. First half of 2nd century. Guarnacci Etruscan Museum, Volterra*

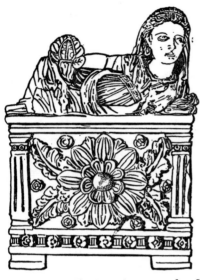
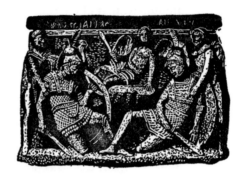

Figs. 68, 69 – *Terracotta cinerary urn, from Volterra. 2nd century. Guarnacci Etruscan Museum, Volterra. Front of Chiusi cinerary urn: death of Eteocles and Polynices. Middle of 2nd century. Archaeological Museum, Florence*

theatrical garments; these tragic subjects had already been given an allegorical and cathartic interpretation. To a less extent subjects were drawn from Etruscan legendary material. All these subjects, and the Greek ones in particular, had clearly gained universal acceptance and, in the Etruscan world, local tradition and elements drawn from Hellenistic culture were found side by side, not without causing perhaps ideological conflicts, as happened at Rome.

We must not pass over in silence the working methods of the decorators of urns — and in part of sarcophagi too — in respect of the Hellenistic cartoons on which they depended. And since it is established that the majority of the cartoons derive from painting, the local reaction is a translation in relief which of the original keeps the iconographic foundation (and therefore the urn material can only to a certain extent be considered as indirect documentation for the Hellenistic painting which is lost), a translation which is an index of a 'baroque' mentality striving to reach out beyond the confines of the classical *genres*. Confronted by the demands of a composition calculated for a certain proportional relationship between the dimensions of the picture-area, the Etruscan decorative artist feels himself quite free to take away or add figures, to adapt his iconography to the space at his disposal, and this has often led to problems of interpretation which are difficult to solve. This absence of interest in the logical construction of the original picture is accompanied by attention focussed purely on the subject, and it is this concentration on content that is the basis of the metaphorical and allegorical interpretation. It should be noted that there are no scenes from daily life apart from those of the *cortège*, which often give rise to revealing transitions between earthly reality and its projection into the after-life, when on the basis of the iconography of the *cortège* the artist

copies that of the journey of the soul, with both sometimes fusing into the same scene.

The urn, like the sarcophagus, is the individual monument, to which are transferred and in which are concentrated those features which in ancient times — and occasionally still — bore reference collectively to the entire family group on the walls of the painted tombs. Such a result comes from very ancient traditions: that of the containers of ashes individualized in the *canopi*, and that of the steles and *cippi* which at Chiusi, in the Fiesole territory and at Felsina gave concrete expression to the figurative and symbological apparatus which was elsewhere reproduced on the painted walls of the chamber-tombs. The extent of the diffusion of cinerary urns therefore is documentation of a wide-spread phenomenon, with repercussions throughout the social and ideological environment, that bespeaks the attribution of a value to the individual within the whole clan and the opening up of this awareness of the individual to a far greater part of the dominating aristocratic class. In fact the very richness of the themes used in the urns, with episodes from rare and sometimes even obscure myths, is a reflection of individual and subjective attitudes, as was to be the case later in Roman sepulchral iconography. The type itself is not found outside the territory where culture and civilization were traditionally and uninterruptedly Etruscan; it is not found where other ethnic and cultural layers — other historical factors, that is, as in Campania and the Po valley — were superimposed on the Etruscan or Etruscoid one.

Consciousness of the individual

Alabaster urns

For urns in alabaster, stone, or terracotta there were differences in technique and sometimes in quality, but they were not substantial, basic ones. The generally more refined technique of sculpture in alabaster was not always matched by excellence in the result, which is more likely to be met with in terracotta plastics, though in a quite casual and unpredictable way, — excellence in the result, I repeat, and immediacy, hall-marks still, as ever, of the irrational character of Etruscan figurative expression, and also signs of tendencies and attitudes, of 'leads' which were not followed up in consequential developments. On the whole the urns fail to justify themselves historically unless

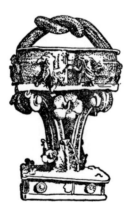

Fig. 70 – *Terracotta vase from Etruria. 2nd century. Louvre, Paris*

180

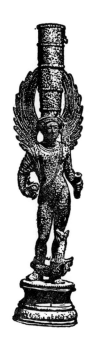

it be as results of the baroque experience, seen from a different viewpoint, in so far as *de façade* compositions *can* be plastic translations of painters' cartoons (itself a baroque phenomenon), yet they are in great part manifestations of late Hellenism (frieze of the temple of Lagina, *c.* 130 B.C.), a link which also explains more ambitious works, such as the frontons of Luna. The tendency to ascribe later dates (some series of urns are at least as late as the beginning of the empire) brings the position historically more up to date, ruling out the 'anticipations' with which Etruscan art and also craft-work were previously credited.

One special feature which we may allow it, and not only in the specific case of alabaster sculpture, is the bringing figures forward from their background, as, indeed, in coroplastics, where they are developed independently of the general scheme; this is a procedure typical of applied art which will for various reasons have its developments later. The application of polychrome is always inorganic and violent, based on the juxtaposition of strident tones, such as often to result, in the mass-produced urns, in complete disharmony. The concept of plastic forms as a base for colour is common, as is known, to a great part of the ancient art-producing civilizations; its persistence in Etruscan art until relatively recent times is not a remarkable fact; what is, on the other hand, remarkable, is the gradual break-up in the Etruscan area of the organic relationship between form and colour, into a 'dissociated coexistence' which has a decided flavour of an artisans' attitude. The gaudy taste of the vases from Canusium is not greatly different, nor is the look of Campanian production any different either; the attitude of the Etruscan artists, in the sense indicated, may therefore have been determined by the influence of other Italic districts, adding a decisive thrust, and not in the right direction, to a traditional tendency.

To give an account of the last manifestations in painting we must refer to the experiences of the end of the 4th century. Painting is in decline, it is true, not so much from the point of view of quality, since some examples are among the most significant in the entire course of Etruscan art's history, but from the point of view of quantity, which has also its meaning. The painted chamber-tombs had belonged exclusively to the aristocratic ruling class, unchanging for centuries, the class which was fundamentally the most seriously affected, it being the only one to wield political and economic power, by the situation which followed upon subjection to the Romans. That came about notwithstanding the fact that Roman politics was everywhere dependent on the aristocracy. It was natural enough that the Etruscan patricians should try to find a niche for themselves in the life of Rome and there seek political and civic prestige and a means of fortune. That quickly led to a new situation in many Etruscan towns, where the loss of influence and power to take the initiative by the ancient ruling class brought about a reduction in artistic enterprises, renewed only

PAINTING

181

later on in the reorganized but relatively obscure existence of the Roman municipalities.

'*Tomb of
Hades*' at
Tarquinia
PLATE P. 182 For Tarquinia it is convenient to begin with the paintings in the oldest room of the 'Tomba dell'Orco', well-known for the head, often reproduced, of the young woman of the Velcha family, the principal fragment that has survived. It is no portrait; the idealization comes from late classical painting, and with it there are heavy outlines and 'rough and ready' approximations betraying the Etruscan fondness for quick and immediate expression. Classical

Golini Tomb I influence can be seen too in the pictures of the Golini Tomb I at Orvieto, but it remained more a matter of externals than at Tarquinia; with its free planning and perspective, the lines of the drawing are not co-ordinated, and express irrationally the anatomic detail of the nude bodies. There is a materialistic, hedonistic character in the scenes of preparation for the banquet which bring

FIG. 72 these to the same level as other examples of a 'rhopography' whose invention by the Etruscans is still a matter for discussion. Idealization can be seen in the profiles of certain banqueters, whilst the head of the cup-bearer with the scanty beard is realistic, though not a portrait. The figures of the deities of the underworld, Aita and Persipnei, are classical additions, almost extraneous to the rest of the composition. In the more recent room of the 'Tomb of Hades', which is at least as late as well on in the 3rd century, as an example of an eclectic attitude, personages from Greek themes (the pair of infernal deities and the heroes Theseus and Pirithous undergoing punishment) are mixed with those from Etruscan demonology, like the 'frightful' Charun (echoes from Polygnotos?); and even the classicist Persipnei has serpents in her hair. Clear drawing of outlines persists beside the chiaroscuro. From its draughtsman's tradition Tarquinian painting found it hard to tear itself away.

'*Tomba degli Scudi*' The second tomb of the Velcha family, called the 'Tomb of the Shields', to be put chronologically between the two rooms of the 'Tomb of Hades', shows a receptiveness for the methods of early Hellenism; the head of Ravnthu Aprthnai, the wife of Velthur Velcha, is without doubt one of the most impressive pages of pictured art in antiquity, achieved as it is entirely in terms of colour, but the figure of Velthur, who lies beside her on the couch, is expressed purely in the language of drawing, as is indeed the lower part of the female figure. The same duality of treatment is found in the second couple, Larth Velcha and his wife, where the survivals of a linear attitude are to be seen in the woman's face, but with the dress in part rendered with a technique different again, in a rapid, popular style, as in the foodstuffs shown on the tables. The figures of servants and musicians are from the technical point of view compromises, testimony to the non-awareness of the meaning and values of the new tendencies, of the congenital inconsequentiality of Etruscan art, but also of a profound crisis not limited to the Etruscan world but which left its traces

PLATE 65 – Wall-painting (detail: woman of the Velcha family). About 300 B.C. 'Tomb of Hades', Tarquinia. *Cf. p.* 182

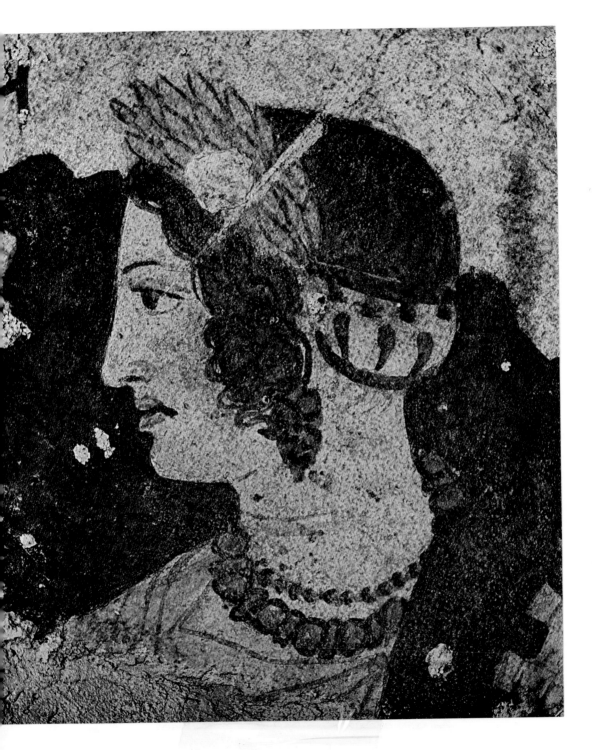

in the doctrinaire polemics of Hellenism. One can also perceive in these pictures a clearly anti-traditional content, both for the much-discussed pessimistic turn expressed by the demons and the material presence of the inescapable deities of the nether world and by the displaying of the pains of the 'damned' along with the happiness — no longer so complete as in the days of archaism — of the 'elect', and also for the heights achieved by the deceased couples, who, brought into contact with deities, seem not to be their inferiors; this is a repercussion — which would justify a somewhat later dating — of the affirmation of individual personality, something felt in Rome and throughout Italy with the acquisition of Hellenic culture. The long and in its context tasteless inscription which lists the offices held by Larth Velcha is a sort of funeral *elogium*, comparable to that on the Roman tomb of the Scipios.

'Change and decay' Much is changed in the Etruscan world. The untroubled thoughtlessness of the archaic age gives way to a lugubrious preoccupation with death, and with this were mixed considerations of personal and political prestige, whilst the story of the Etruscan cities, now virtually subject to the Roman power, came ingloriously to its end. The clan of the Velcha was probably a part of that aristocracy on which the Romans based their control of the community of their allies and subject peoples.

Political resistance as a theme: the 'François tomb' The historical situation at the end of the 3rd century might well justify the inclusion at this time of the 'François tomb' at Vulci too. We find in it, along with the recall of mythological themes, in tragic and sanguinary episodes, those of struggles of the Etruscans against the Romans; the heroes Avle and Caile Vipina, from Vulci, are shown being freed by Macstrna; and a Roman, Cneve Tarchunies, falls in a duel with the Etruscan Marke Camitlna. In the fastness of a noble's tomb there could be given eternal form, in works of art, to sentiments of Etruscan ideological 'resistance' to their conquerors. The choice of theme is backward-looking, and the scenes, copied in part from Greek

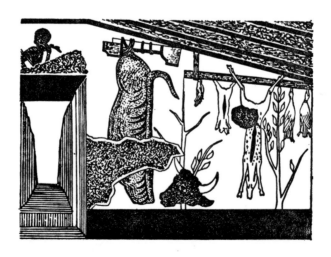

Fig. 72 – *Orvieto, no. 1 Golini Tomb. Detail of frieze. 4th century. Archaeological Museum, Florence*

184

cartoons of the 4th century, present the killing of the Trojan prisoners and the duel between Eteocles and Polynices. The eclecticism is evident in the first of the pictures, one of the biggest in Etruscan painting which remain: colour and drawing coexist without fusing together, a *lasa* is in the type of Nike, the Greek 'Victory', and alongside the classical composure of the Greek warriors there is the physical terror of the prisoners being sacrificed. There is no unity, of style or of inspiration, no organic wholeness in the scene of savage battle, broken up into so many duels. From a world of myth, and of history seen as myth and legend, there emerges the individual reality of the noble Vel Saties, clad in the embroidered *tebennos* and accompanied by his fool Arnza, one of the last representatives of the old Etruscan noble class. The figure of Vel Saties is one of the key-points in the problem of the history of the Italic portrait, but is not itself a portrait, but only an allusive likeness of an actual person outside the world of myth. Classicism of a more coherent sort may have been visible in the 'Campanari tomb', now lost, but we may be misled by the neo-classic drawings which reproduce the pictures it contained. Classicism however there undoubtedly is in the dimensions of the figures taking up almost the entire height of the walls, while the 'François tomb' takes up again the division into horizontal bands, keeping a decorative frieze above.

Among the last of the Tarquinian tombs are those of the 'Cardinal' and the 'Typhon', practically of the Roman age, even if we do not wish to bring them down to the middle of the 1st century. *Last tombs*

The 'Tomb of the Typhon' is important for its use of plastic chiaroscuro and its snakefoot baroque forms which gave it its name, and particularly for the wall showing the procession of members of the Pumpu family, a pictorial episode which characterizes the realistic crowding of the figures with the intentional individualization of the single personages, in whose faces however there are clear echoes of classicist idealization. The procession of figures dressed in white togas has for good reasons been linked with Campanian and Roman folk-style painting. A similar concourse, or *frequentia*, to use Pliny's term, was painted in a reduced version in the 'arch' at the base of Arnth Velimna's urn, in the family hypogeum at Perugia.

The paintings of the 'Cardinal's tomb' are too far perished, and the drawings made from them in too modern a style, for us to make a judgment about their value. Their interest lies only in the theme, in the episodes portraying punishment in the Life Beyond or at any rate of souls coming into contact with terrifying demons, and above all in the detailed allusions to the Rite of the Last Journey, where the souls are taken by demons on carts, through arches, which, among other things, are the first hint of viewing in perspective and with a sense of spatial relationships. *Iconography of the nether world*

VIII. ART IN THE ROMAN REPUBLIC
AND ITS
ETRUSCO-ITALIC ELEMENTS

THE EXPANSION
OF ROMAN
CIVILIZATION It has been one of the prejudices of the past to consider the Etruscan artistic experience as the main factor determining the growth of Roman art; this has been the source of many serious misconceptions. Roman civilization, taken as a whole, is indeed Roman from the institutional, juridical, ethical and linguistic points of view, but at the time when the problem is posed, that is the 2nd and 1st centuries B.C., the city of the Roman people of the Quirites no longer acted so much of itself, but as the centre and the guide of the whole Italic complex, and did so long before the political settlement of Augustus. Roman Italy, as an effective reality, taking in Latins and Etruscans, Italiotes, Campanians and Samnites, and by this time the Veneti and Cisalpine Gauls too, was now in its turn the centre of convergence (and leading centre too in at least the politico-economic sense) of the *oikouméne*, of all that great world, interested, in whatever fashion, in the growth of the Roman political initiative. From the cultural point of view the Romano-Italic area had been subject to powerful Greek influence, at least since the times of the Pyrrhic War, without a break in continuity, Italiote first, then Siceliote, and then Asiatic, Rhodian and Attic. Yet to accept again the idea from the classicist Horace that conquered Greece brought the arts to a rustic Latium would be to adopt a one-sided attitude.

Literature The literary culture of the Romans, much earlier than the artistic, had been nourished by Greek imports, but had received them as fruitful suggestions, opening wide its doors to varied combinations of the borrowed with what it already possessed: acceptance of the new comedy led to no disengagement from the Italic impetuosity of Plautus before it had been reformulated by the 'intellectualistic' Terence; first the Homeric poem was translated into Saturnian Latin, but soon afterwards Ennius modelled his Homeric-type hexameter wherewith to set in verse the Roman annals. Thought, at first vaguely Pythagorean, then found philosophical and historiographic justification for the Roman concepts of *civis* and *virtus*, and Epicureanism came, antinomically, into being, whilst Latin culture at last, thanks to Cicero, discovered Platonic idealism and Aristotelian rationalism. Natural and impulsive eloquence acquired

Rhetoric discipline in the Hellenistic styles of rhetoric, giving rise, like grammar, to lively polemics, a sign that they were taken seriously; then Cicero imposed the Rhodian style as a compromise between opposing tendencies.

Crisis in political institutions All this happened while the aristocratic republic approached a crisis. The crisis came in the middle of the 1st century, under economic and social pressures even before political ones, forces indeed released by the process of the assimilation of Italy and the subjugation of the *oikouméne*: the old senatorial formula was no longer equal to the enormous demands made upon it, and Rome moved towards the solution offered by a principate. It was a crisis in institutions, but

also the crisis of *libertas*, which had never been a democratic liberty, so that the masses recognized unitary power as the only way in which to manifest themselves in the life of the Roman world, and unitary power made common cause — though more in appearances than in reality, at least in the beginning — with the tendency to manifest the individual personality within the equalitarianism of caste, a phenomenon obvious since at least the 'century of the Scipios' and which in the end turned against the state and finally brought its dissolution. In this process too the influence and actual practice of the Hellenistic monarchies had played their part, at the very time that the old senatorial nobility which originated in high republican days was exhausting itself faced by the *homines novi* now emerging, men prevalently Italic in origin, and by the consolidation of the equestrian order as a new political force.

Phenomena of such complexity make it impossible from the start to explain the artistic situation in isolation and in simple terms; the truth is that the positions taken by those who insist on an independence in the Romano-Latin territory, and those who see prevailing now the Hellenistic, now the Campanian, now the Etruscan element, have both a certain validity, so long as they are not taken in any absolute and final sense and that one is balanced against the other. *Romano-Latin artistic independence*

The fact is that from the 7th century Latium and Rome itself became part of the Etruscan artistic civilization, and only the complete loss of evidence from Rome of the Kings and the early republic prevent our apprehending the phenomenon to its full extent. We have referred to this several times in our earlier chapters. But it is only quite late that a more open acceptance of classical influence in the Faliscan territory and at Rome itself makes itself evident, when we consider the 'Praenestine' cists, — 'Praenestine', but still in the tradition of Etruscan technical experience. On the other hand, judging from literary testimony, it seems clear that in the very category which is more properly considered a specially 'Roman' form of original expression, that is, the portrait, the artists passed from the traditional and probably only allusive three-foot-high statue to that of life-dimensions through the influence and perhaps actual participation of Italiote craftsmen. Similar influences are seen even in the aniconic statues, the sarcophagus of L. Cornelius Scipio Barbatus in the 1st half of the 3rd century being a typical example (Vatican City, Museum). The casket ornamented at the upper edge by Doric triglyphs and the two-faced voluted lid recall the type of the altar, not that of the *kline* (even if an adaptation, in the Etruscan area, was later made by combining the two elements, as in the sarcophagus of Larthia Seianti). The personality of the deceased is described in a metrical inscription, where the words *forma uirtutei parisuma fuit* is obviously a translation of the Hellenic concept of *kalós kagathós*. *Effects of the Etruscan tradition*

The tendency towards self-assertion led to such a multiplication of honorary statues as to become something of a public scandal. They were associated, as the contents of the dedicatory inscriptions precisely show, exclusively with the individual person of the subject, and often, in older tradition, celebrated in detail a specific incident. The antiquity of our examples, in this latter respect, shows the individualization of the honorary statue to be a specially Roman *Statues of individuals*

phenomenon, so that the appearance of genealogical inscriptions or individual references in Etruscan sarcophagi (and particularly Tarquinian ones) from the end of the 4th century onward allows us to suppose that this happened because of Roman mediation, which in this case would act as a carrier for Hellenistic influences. The problem of the relationship between the Hellenistic tendency towards the individual portrait and Roman 'physiognomic' realism is not yet completely solved, chiefly because older Roman portraits have not survived and because, even in what was produced in the first half of the 1st century, the effect of Hellenistic formal influences was often decisive, even though portraits of Roman personages such as Pompey and Cicero were not carried out by

PLATE P. 171 Greek sculptors. The Florence 'Orator' cannot easily be placed within the narrower ambit of physiognomic realism, which is not a mere resolving of problems of form from outside without psychological introspection and without a particular anatomical structure, but an insistence on the particulars revealed by analysis, an individualization of the subject through the accidental feature, that is the abnormality. Thus the remote Etruscan tradition of the *canopus* or the isolated head, though it may form part of the pre-history of the bust or of the portrait-head, does not constitute an ancestor which we can critically evaluate as part of the formation of the Roman portrait; it never seizes upon the physiognomic detail as such, but always remains at the stage of the 'pre-portrait', the 'portrait-only-in-intention', even adding sub-human details, as we have shown in the preceding chapter.

Campanian realism One cannot very usefully invoke Campanian realism either, notwithstanding its very many common features in respect of taste and technique with the Latian and Etruscan lands. Campanian realism, outside Roman influence, is sketchy, episodic, inclined to revert to type, and its role within the Italic *koiné* of the Hellenistic epoch and in the growth of particular forms of expression in Roman art, in the widest sense, was rather in the field of solutions to technical problems, in view of its lack of sensitivity for the internal elements of structure and its illusionistic tendencies, which it had in common with later 'Etruscan' art.

Roman art collectors From the times of the wars in Greece and Asia, Rome had become a museum of masterpieces of Greek art, classic and Hellenistic, collected according to various but uncritical criteria, for their material value, for their celebrity, accepted not so much from personal conviction as because of the assertions of others, and according to the tradition of making their own the gods of their enemies by carrying away their holy images. Then came the desire for luxury, and snobbery, and only to a small extent the sincere passion and personal conviction of the cultured to strengthen the flow; Cicero himself, of his contemporaries certainly the most alert to artistic problems, collected only for the content or decorative value of the objects. The accumulation of works of art went on however, and the enormous demand brought to Rome artists and specialized craftsmen of the most varied nationalities and traditions so as to make it, far more than Alexandria or Rhodes, the ideal meeting-ground where eclectic and academic currents might form.

Such a situation had its repercussions further afield, and in this perhaps ar-

chitecture had precedence. If what had gone before, in the city gates of Volterra and Perugia, can be quoted in explanation of analogous events in Roman architecture, one can scarcely escape attributing to tenacious Hellenic influences the harmonious use of the order in the Tabularium or the scenographic setting of the temple complex at Praeneste (Palestrina), one of the most grandiose architectural works in the ancient world. That is not to say that the sanctuary of Praeneste is not an original work, and the work of an artist of exceptional capacity at that. Indeed here is clearly a case where vague terms like 'Italic features' or 'Hellenism' had best be abandoned, and where we are justified in speaking rather of personalities and independent creation, of personal culture and the ability to re-experience it and transfuse it in original and entirely fresh invention. Certainly the addition to the landscape not of a town-planning scheme, but of a plan for a unified complex is something new, with which Italic traditions, as far as we know, have little or nothing to do, — but we know them too little to be able to base discussion on them, particularly *as* traditions, that is, precedents. *Praeneste*

The connection at one time generally admitted to exist between Etruscan and Roman town-planning, according to which the latter was seen as dependent on the former, must now be re-examined, in view of the further studies carried out in either field. The Roman city, where it was created, that is where it was the result of a new plan, and even elsewhere, where it was superimposed on town-structures or agglomerations of houses already in existence, is not so much a consequence of the Etruscan rules, as the combination with them, if it indeed occurred, of rationalized rectangular plans, a marriage of details of outside influences with practical contingencies as they arose. A constant factor in Roman town-planning was centralization — practical and end-determined rather than for artistic reasons — of all that was necessary for life in association, in respect of religion, politics and economics; thus the Roman city has of necessity a *forum* on which must stand the official religious centre (the *capitolium* in the colonies), the building for the meetings of the local assembly (the *curia*) and that for the administration of justice (the *basilica*), then the public offices, and often also those necessary for commercial activities (the shops or *tabernae*). The space of the *forum* itself was used for religious and political gatherings and as the market, and in early times for public spectacles too. Because of its many purposes the *forum* approaches the Greek *agora*, but the parallel is not strictly correct, the *forum* being much more widely used. We do not know if the Etruscan towns had something of the sort, but it is certain that there was a place of its own for the religious life, unconnected with other activities. The town walls, in their most ancient form, presented no aesthetic problem, but were essentially practical, and the primitive character of some structures in polygon masonry (Segni, Alatri, Ferentino) has sometimes led to their being given an early and not always justifiable date. It is clear that at Rimini in the first half of the 3rd century polygonal masonry was still in use, whereas at Rome in the 4th the so-called 'Walls of Servius' were in square-faced stones.

The adoption of the Ionic and then the spread of the Italo-Corinthian capital

Roman town-planning

Roman capitals

are also new facts, but in the establishment of the second we do see, in this case, a mingling of Italiote, Campanian and Etruscan experience and precedents, on a plan suggested by the dominant classical influence, in the formation of an architectural element which in its compactness could serve the need for functional expression which seems exclusively Roman. And while discussing architecture, it is worth while referring here to the problem, conceptual if not formal, of the monumental gate and the arch, where in fact we find common ground with Etruscan culture, — the figurative apparatus which stresses the sacred nature of the gate, the connection that the 'Triumph' had from ancestral times with the ceremonies of the solemn *cortège* documented in Etruscan reliefs, the concept of the archway as outward expression of the idea of 'limits' which we find in the pictures with scenes of the Life Beyond in the 'Tomb of the Cardinal'.

Roman tombs
It is scarcely necessary now to refer to the connection with Etruscan tradition in funerary architecture, formal and true-to-type in the tumulus and in its direct derivative, the monument on a plinth, except that to the Roman mentality the sepulchral chamber is not conceived exclusively as a dwelling, and the tendency towards organic solutions leads to structural arrangements of the series of chambers inside to fit the monument's outside form. The Roman funerary building has in common with the Etruscan that front-facing aspect, which for the Etruscans was determined by the fact that the 'aedicules' were the fronts of rock-tombs, whilst in the Roman world the same front-facing aspect was determined by a town-planning concept insistent on the views of the tomb constructions being visible from the road at whose verges they were set.

The Roman temple
The Etruscan tradition was of vital effect on the Roman conception of the temple, always built on a high podium with a flight of steps before it, and vital was the frontality (which influenced the idea of funerary edifices taking the forms of temple and aedicule), a fact which is reinforced in Roman architecture because the temple is never thought of as something isolated, but as part of the urban whole. These considerations still apply whether one accepts or not the thesis according to which the tripartite temple is not of necessity Etruscan, but only a re-interpretation of the Etruscan temple type to suit the needs of Latin cult and ritual.

Arches and vaults
Something which is still not clear is the earliest use of the arch and the vault, which according to tradition the Romans learnt from the Etruscans, but the presence of this technical feature is found at about the same time in both areas and no very ancient examples are known which might lead to a solution. All that is certain is that the oldest Roman architecture directly known to us and in a sufficiently complete state shows strongly Hellenicized features. This is the case with the most ancient forms of the basilica and with some funerary monuments like the front of the hypogeum of the Scipios.

Artistic house decoration
It is in southern Italy (in Campania), not Rome, that we have the most ancient examples of private architecture with artistic aims (the houses of the Samnite period at Pompei); from at least the beginning of the 1st century B.C.

interior decoration is amply documented, with schemes that are clearly based on Hellenistic patterns. This feature of taste, with that for decorated pavements (according to Pliny's assertion that 'they began with mosaic floors as early as Sulla's time', — *lithostrata coeptavere iam sub Sulla*), leads the way to schemes for matching colours in the various parts of the room, a direct precedent for the concept of 'coloured space', that is of the idea of coherent relations between the definition of space in the sense of volumes and areas of coloured surfaces that bound it. This would lead us to the vexed question — and we cannot take it up now — of the Italic share in Romano-Campanian painting, or Hellenistico-Roman, as it would be more correct to call it from the historical point of view, and even more so in that the problem itself, in concrete terms, arises only later. Wall decoration in the republican age, as far as we know, is a Hellenistic transplantation. Nor perhaps did things happen differently in the case of the lost works of the painters who worked in the Romano-Latian environment and of whose activity we know from literary tradition. One of them was certainly an Asiatic, as is shown by the epigrammatic poem written in an archaic alphabet beside a picture in the Temple of Juno at Ardea (Pliny, *Nat. Hist.* 35, 115: *Plautiu' Marcu', cluet Asia lata esse oriundus*), whilst it was certainly from an Italiote culture that Pacuvius came, the tragic poet, who painted in the Temple of Hercules in the Forum Boarium (cattle market). The individual most difficult to identify would thus be the earliest, a member of the *gens Fabia* from whom his descendants took the surname *Pictor*. Fabius had painted and signed his work in the Temple of Health, dedicated in 304 B.C. by C. Iunius Bubulcus; we must assume him deeply influenced by Hellenism if Dionysius of Halicarnassus (XVI, 6) deemed his paintings perfect in the drawing and pleasant for the laying-on of colour, endowed with a splendour quite other 'than that which is called ῥῶπος'. We have too a series of painted and graphic works on the Ficoroni cist from the 'François tomb' to tell us of the direction painting took in Italy from the 4th century till Hellenism.

It is difficult, on the other hand, to believe that the painting, portraying Atlanta and Helen nude, mentioned by Pliny (*Nat. Hist.* 35, 17), as existing in a temple at Lanuvium, was any earlier. Atlanta and Helen were the work of one painter. The nude heroine type does not appear before the beginning of the 3rd century, as is proved by an entire series of Etruscan mirrors, when indeed nudity became a specific allusion and the badge of goddesses and heroines (Turan and Helen) famous for their beauty. In the mirrors it is a simple graphic translation of pictorial cartoons, since the female nude had been the special subject of the colourists, from Apelles onwards, as indeed in every period noteworthy for colour. Pliny records that Atlanta was represented particularly as a virgin, and the pair thus become a sort of 'Sacred and Profane Love' though this is not of course a classical concept and even less an archaic one. But perhaps in the Pliny text the connection is merely topographical, since the writer had recorded, immediately before, the very ancient pictures, in a temple at Ardea, works that he admired above all others.

Contrasting with the Etruscan painting of the Hellenic age, devoted in part to

modifying and copying Greek cartoons, and in part to reconstructing the semi-legendary world of past history, there was the 'Triumph' and 'historical' painting of the passing event, in part episodic, and in part descriptive and topographic, of which there is a record as early as 265, when M. Valerius Messalla Maximus set up outside the Curia Hostilia a picture on the subject of his victory over the Carthaginians and King Hieron. Scipio Asiaticus did the same later, with a picture posted on the Capitol in 194, and so also, clearly for propaganda purposes, L. Hostilius Mancinus in 146. Valid testimony of the existence of the same *genre* is given by the celebrated fragment, showing military scenes, from the Esquiline (Museo dei Conservatori); venerable as it is, it is practically incapable of classification artistically and its chief value is as a document of a taste for purely objective representation, with no attempt at interpretation, done only so that all might read. The powerful Hellenistic cultural influence and its consequent figurative suggestions could not cancel these traditions, and in fact in the relief on the altar of Domitius Aenobarbus one can see an open dualism between the figurative work copied from a Greek cartoon and that which is unsupported by an equally cultured figurative tradition; this last is in the same case as the Praenestine cist with the Triumph scene and the many reliefs with a mainly gladiatorial subject frequent in central Italy and on the Campanian coast.

At base, leaving out of account the difference in chronology, the case of the Aenobarbus relief is analogous with that of the picture from the 'François tomb', where the picture with a classical, epic subject, and those with an historical or legendary Etruscan subject, are quite different, technically and in quality, except that Roman art could continue to develop its own way of expressing itself, amalgamating from time to time disparate traditions and experiences in its own factual history. Etruscan art, in the proper sense, went no further than the beginnings of this process, and was not able to find in the realities of history its own *raison d'être*, as Roman art could, and it is perhaps here that we draw the decisive dividing line between the two points of view, taking into account too the fact that artistic personalities were converging upon and manifesting themselves in Rome and other great Romanized centres, personalities such as Etruria now could scarcely produce, and finding motivation (particularly outside 'official' life and later even within it) in new forms of inspiration rendered possible only by the breadth and multiplicity of forms and aspects which Roman society took.

The Italic artistic *koiné* which came into being because of subjection to Rome and the consequent internal traffic did not remain shut up within itself, but was in fact, one may say, of brief duration, because of its rapidly assimilating the local experiences which remained — in Etruria till its virtual extinction — into the forms and taste of a new Italian *koiné*, which in turn was synchronized and culturally conditioned — at least to as great an extent as Italy conditioned *them* politically, by the remaining parts of the conquered world, by the Hellenistic East first, then also — and not much later — by the West which the energies of the Italic peoples had helped to Romanize. And so it comes about

that the flowing together of the Italic elements — and thus of the Etruscan — in the life of Roman Italy is much easier to determine in the historico-political sense than it is to bring out, from the documents which remain to us of life and artistic production. Research into this is really in its very beginnings, and it is something much needed, urgently so, in studies dedicated to the rediscovery of the past.

APPENDIXES

	HISTORY		GREEK ART	CHRONOLOGICAL DETAILS ETRURIA ITALY	Architecture
	Asia and Egypt	*Greece and Italy*			
I	II	III	IV	V	VI
800	Kingdom of Phrygia		Late Dipylon		
790					
780					
770					
760		754 Foundation of Rome			
750			Late Orientalizing Geometric	750–675 Villanovan III 750–690 First Etruscan 'facies' on coast	
740		736 Foundation of Corcyra 734 Foundation of Syracuse and Naxos	Ancient Proto-Corinthian	Importation of proto-Corinthian pottery	
730	730–12. 24th Dynasty (Tefanacht Bokenranf)	729 Foundation of Catana 728 Foundation of Megara Hyblaea 721 Foundation	Final Late Geometric		
720	Reign of Bokenranf	of Sybaris		Vase of Bokenranf (?)	First city wall of Rusellae (Roselle) (?)
710		710 Foundation of Croton 706 Foundation of Tarentum Foundation of Poseidonia and Metapontum	Proto-Attic		
700			Middle Proto-Corinthian		
690		Foundation of Messana 688 Foundation of Gela			

ETRUSCAN ART				ROME AND LATIUM			
Sculpture Bronzes Coroplastics		Painting Pottery Engraving	Goldsmiths' and craftwork	Architecture	Sculpture	Painting	
I		VIII	IX	X	XI	XII	XIII
			(8th century) The Monterozzi cart (Tarquinia)				800
							790
							780
							770
							760
							750
							740
							730
							720
							710
							700
							690

	HISTORY		GREEK ART	CHRONOLOGICAL DETAILS ETRURIA ITALY	
	Asia and Egypt	*Greece and Italy*			*Architecture*
I	II	III	IV	V	VI
680	Invasion of the Cimmerians		Apollo of Mantiklos Middle Proto-Attic Proto-Daedalic	675–50 Spread of orientalizing products	'Regolini-Galassi tomb', Caere 'Poggio Gaiella tomb',
670	668–26 Reign of Ashurnazirpal 664 Occupation of Tyre 663–09 Reign of Psammetichus I	675 Foundation of Regium (Reggio Calabria) 663 Laws of Zaleucus	670–60 Daedalic I	(675) 'Regolini-Galassi tomb', Caere, Niche D	'Della Pietrera tomb', 'dei Lebeti tomb', Vetulonia
660	652–10 Crisis and end of Phrygian kingdom	657 End of the Bacchiadae 654 Carthaginian occupation of Balearic Islands			
650			Late Proto-Corinthian Middle Daedalic		
640			Reliefs by Priniàs		
630		Laws of Charondas 627 Ionic voyages to Tartessos (Spain)	Archaic Corinthian Late Proto-Attic Late Daedalic	630–10 Importation of Palaeo-Corinthian pottery	
	625–585 Empire of the Medes	625 (?) Foundation of Selinunte		Chigi pitcher, 'Tomb of the Tripod' Villanovan IV, I	
620	612 Destruction of Nineveh	616 c. Dynasty of the Tarquins		Local imitations, oriental importations Alphabetarium of Corinth	
610			*Kouros* of the Dipylon	610–590 Importation of 'Phoenician' objects; sheet bronzes in relief, *buccheri*, goldsmiths' work with granulation. Importation of Corinthian vases End of Italo-Siceliote Late Daedalic	(End 7th–6th cent.) Casalmarittimo tombs, Volterra
		The Phocaeans at the mouth of the Tiber			

ETRUSCAN ART			ROME AND LATIUM			
culpture Bronzes oroplastics	Painting Pottery Engraving	Goldsmiths' and craftwork	Architecture	Sculpture	Painting	
II	VIII	IX	X	XI	XII	XIII
						680
7th century) ripod, etulonia						670
culptures of he 'Pietrera omb'						
						660
after 650) egolini- alassi bes, Caere						650
						640
						630
		(After 625) Corsini fibula, Marsiliana, fibula of 'Tomba del Littore', at Vetulonia. Ecphantos of Corinth		? Statues of the Seven Kings from Titus Tatius to Attus Navius	? Painting at Lanuvium	620
Last decades th cent.) arberini ivory roup, Praeneste						
	(From c. 610) Bucchero ware (End of 7th cent.) Impasto stands for lebetes					610
End 7th cent.) arberini basin, raeneste						

600	Scythian invasion	Foundation of Massalia *(c.)*	*Kouros* of Sunion	(610–590) Marsiliana, Tombs 1–24. 'Tomba del Duce 4', Vetulonia; 'Tomba dei Rasoi', Populonia; Tombe 'Barberini' and 'Bernardini', Praeneste. Scarab of Psammetichus ('Tomb of Isis')?	(610–490) Regolini-Galassi tomb, Montecalvario tomb (Between 600 and 570) Fictile statuettes (Caere)
	593–588 Reign of Psammetichus II		Middle Corinthian Post-Daedalic		
590			Treasure of the Geloi		
	585 End of the Urartian Kingdom		585 Corfú frontons		
580		Foundation of Agrigentum Battle of Selinunte	Late Corinthian 575 Olympieum (Temple of Zeus) of Syracuse		
	573 Nebuchadnezzar II conquers Tyre				(First half 6th cent.) The 'Goddesses' of Chiusi
570		(570–54) Phalaris Tyrant of Agrigentum	Temple C at Selinunte The Sele *Thesauros* 565 The Basilica, Paestum. *Kouros* from Tenea		(Before 550) 'Tomba degli Scudi e delle Sedie', Caere
560	560–46 Reign of Croesus 559–30 Reign of Cyprus the Great	Carthaginian successes in Sicily; the Massaliotes in Corsica	Temples D and F, Selinunte Sele Temple of Hera *c.* 555 Aphrodite of Marseilles		
550	546 Cyrus conquers Lydia	Foundation of Emporium	Geneleos	'Protofelsinean' style	(After 550) 'Aedicule' tomb at San Cerbone, Populonia
540					
		535 Battle of Alalia 533 Polycrates Tyrant of Samos Victory of Sybaris over Siris	The Apollonion of Corinth		

ETRUSCAN ART

ROME AND LATIUM

Sculpture Bronzes Coroplastics	Painting Pottery Engraving	Goldsmiths' and craftwork	Architecture	Sculpture	Painting	
VII	VIII	IX	X	XI	XII	XIII
Isis', Vulci	(After 600) Tomba Campana, Veii	Praeneste goldsmiths' work; Bernardini sheet metal work		? Wooden image of Diana		600
Beginning of 5th century) Montescudaio cinerary, Volterra						
						590
						580
	(575–500) 'Tyrrhenic' amphorae					570
						560
ntefix of the 'iazza d'Armi' eii. oeb tripods	Boccanera tiles, Caere					
	(550–530) 'Tomb of the Inscriptions'; Campana tiles, Caere					550
Centaur', Vulci	(550–530) 'Tomb of the Bulls', Tarquinia; Tiles with Gorgons, Caere					540
astel San Mariano bronzes	(540–30) 'Pontic' vases 'Painter of Paris'					

	HISTORY		GREEK ART	CHRONOLOGICAL DETAILS ETRURIA ITALY	Architecture
	Asia and Egypt	*Greece and Italy*			
I	II	III	IV	V	VI
				Last decades of 6th cent.: development of Etruscan Po Valley, Adria, Spina, Felsina, Marzabotto	
530					
	525. 27th Dynasty (Egypt under Persian control) 522–486 Reign of Darius I	525 Foundation of Pythagorean sect 524 Defeat of Etruscans by Aristodemos of Cumae	Treasure of the Cnidians at Delphi Treasure of the Syphnians at Delphi		
520					
		516–12 Persian conquest of Ionia			
		511 Exploits of Dorieus; destruction of Sybaris			
510		509 (?) The Tarquins expelled from Rome War of Porsenna 506 Battle of Aricia			
500		499 Battle of Lake Regillus	The Heraium of Samos		
		c. 493 Cassian League with Latins	Canachus		
490		Battle of Marathon	The *Kore* by Antenor Temples A and E, Selinunte		Aule Tite's stele
		485 Gelon Tyrant of Syracuse			Town-planning at Marzabotto
480		Battle of Salamis Battle of Himera 478 Hieron I Tyrant of Syracuse 477 Attico-Delian League 474 Victory of Hieron at Cumae	*Kore* by Euthydikos Critius Group, 'The Tyrannicides'		
			Olympian fictile group		
470			Calamis (Athenian sculptor)		

ulpture Bronzes roplastics	Painting Pottery Engraving	Goldsmiths' and craftwork	Architecture	Sculpture	Painting	
I	VIII	IX	X	XI	XI	XIII
						530
ast quarter century) ctile tile m Poggio co	(530–20) Tombs of the 'Auguri', 'Dead man' 'Lionesses' at Tarquinia					
	(520–500) Tombs of 'the Bacchantes', 'Old Man', 'Painted vases', 'Dying Man', at Tarquinia					520
olio Stipe	(520–490) 'Tomb of Hunting and Fishing', Tarquinia (End of 6th cent.) Painter Micali		(510–500) Capitoline Temple			510
ere sarcophagi	(510–500) 'Baron's tomb', Tarquinia			(?) Statues of Porsenna, Horatius Cocles and Cloelia		
ılca of Veii			(501–493) Temple of Saturn, Rome. Dedication of the Temple of the Capitoline Jove	The 'Magistrates' Tile, Velletri. Vulca of Veii at Rome		500
o–490) Veii oteria and racottas					493 Damophilos and Gorgasos painting in the Temple of Ceres	
o–480) Censer h ephebus; ıdelabrum with ncer, Vulci ınteguragazza e	(490–470) Tombs of the 'Bighe' and 'Citaredo', at Tarquinia; of the 'Monkey', and of 'Orpheus and Eurydyce' at Chiusi		484 Temple of the Castors at Rome	484 Bronze statue of Ceres		490
rgi terracottas rst half century) ıerary statue Chianciano	(475–55) 'Tomba dei Leopardi', Tarquinia					480
	(470–400) 'Triclinio', 'Letto funebre', 'Francesca Giustiniani', 'Pulcella' tombs, at Tarquinia					470

	HISTORY		GREEK ART	CHRONOLOGICAL DETAILS ETRURIA ITALY	Architecture
	Asia and Egypt	*Greece and Italy*			
I	II	III	IV	V	VI
460			Myron		
		456 End of the Demomenides			
450		Defeat of the Siculi. Decemvirate (450–400) Territorial expansion of Carthage 448 Peace of Callias 443 Foundation of Turii	Phidias and Polycletus Kresilas The Parthenon		(After 450) Travignoli *stele*
440		(438–25) 2nd war, Rome and Veii Fall of Capua (431–404) Peloponnesian War	Temple of Athena Parthenos		
430		427 Sicilian expedition 425	Temple of Athena Nike ('Victory')		
420		Fall of Cumae			
410		413 Battle of the Assinaros 409–8 Fall of Himera and Selinunte 405 Siege of Veii Defeat of Athenians at Aegos-Potamos by Lysander. Dionysius I Tyrant			(End of 5th–4th cent.) 'Tomba dei Sarcofagi', Caere
400		of Syracuse 395 Veii taken The Gauls in Central Italy Dionysius I in Italy			
390		Battle of the Allia 387–6 'Peace of the Great King' 387 Roman expansion in Etruria 384 Attacks by Dionysius I on Pyrgi, Elba and Corsica			

ETRUSCAN ART			ROME AND LATIUM			
Sculpture Bronzes Coroplastics	Painting Pottery Engraving	Goldsmiths' and craftwork	Architecture	Sculpture	Painting	
VII	VIII	IX	X	XI	XII	XIII
	'Tomba del Colle', Paolozzi, Chiusi					460
450–400 The Arezzo Chimæra	Mirror with Thesan and Kephalos					450
Malavolta head				438 Statues of the ambassadors killed at Fidenae 434 The Minucian Column		440
Cortona candelabrum (?)						430
						420
Terracottas from San Leonardo, Orvieto Falerii 'Zeus'	(End 5th cent.) 'Tomb of the Ship', Tarquinia					410
						400
Youth, Veii						390

205

	HISTORY		GREEK ART	CHRONOLOGICAL DETAILS ETRURIA ITALY	Architecture
	Asia and Egypt	*Greece and Italy*			
I	II	III	IV	V	VI
380	380–43. 30th Dynasty				
370		Apogaeum of Thebes			
		367 Death of Dionysius I			
360			Praxiteles and Scopas		
		359 Philip II King of Macedonia			
	Phoenician revolt	353 Peace between Rome and Caere 351 Peace between Rome and Tarquinia			
350		(*c.*) Fall of Felsina			
		342 Archidamus in Italy 341 Battle of the Crimisus			
340		338 Battle of Chaeronea 336 End of Latin League	Leochares and Bryaxis		
330	332 Foundation of Alexandria	331 Alexander King of Macedonia	Lysippus		
		327 Treaty between Rome and Carthage Voyage of Pytheas 326 Roman-Apulian alliance			
320					
310					
	Reign of Ptolemy I	(309–6) Campaigns of Agathocles 306 The Diadochi take the royal title 303 Cleonymus in Italy			

ETRUSCAN ART			ROME AND LATIUM			
pture Bronzes *plastics*	*Painting Pottery* *Engraving*	*Goldsmiths'* *and craftwork*	*Architecture*	*Sculpture*	*Painting*	
	VIII	IX	X	XI	XII	XIII
				Removal of the statue of Jove from Praeneste		380
						370
rst half of century) ltomachy' e, Bologna			367 Temple of Concord, Rome			360
vedere terra-tas, Orvieto	'Sarcophagus of the Amazons', Tarquinia					350
			344 Temple of Juno Moneta, Rome			
	(340–280) 'Golini' and 'dell'Orco I' tombs, Tarquinia			338 Statues of the consuls of the year		340
				? Statues of Pythagoras and Alcibiades	Novios Plautios Ficoroni cist	
o–25) narzo sarco-gi, Vulci						330
	The painter of Hesione					
h–3rd cent.) rtunus sarco-gi, Tarquinia	(End of 4th–beginning of 3rd cent.) 'François tomb', Vulci					320
						310
				305 Equestrian statue of Marcius Tremulus		

HISTORY			GREEK ART	CHRONOLOGICAL DETAILS ETRURIA ITALY	Architecture
	Asia and Egypt	Greece and Italy			
I	II	III	IV	V	VI
300			Philoxenus of Eretria		
		295 Battle of Sentinum 294 Peace between Rome and Volsinii			
290		291 Surrender of the Samnites			
		283 Battle of Lake Vadimonis (Lake Bassano) 282 Defeat of the Boii and Etruscans 281 Pyrrhus in Italy			(3rd cent.) Temple at Faesula (Fiesole)
280					
		275 Alliance between Rome and Carthage Sack of Delphi 274 Battle of Beneventum 272 Tarentum taken			
270		Regium taken			
		268 Reign of Hieron II Reign of Eumenes I (of Pergamus) (264–41) 1st Punic War 264 Sack of Volsinii			
260					
250			Doidalses of Bithynia		
		241 Destruction of Falerii			
240					
		238 Roman occupation of Sardinia, Corsica and Luna	235 Great donarium of Pergamum		(Latter half of 3rd cent.) Inghirami tomb, Volterra
230					
		226 Treaty of the Ebro 225 Battle of Talamon 222 Roman conquest of the Po valley 221 Philip V King of Macedonia			

ETRUSCAN ART			ROME AND LATIUM			
Sculpture Bronzes Coroplastics	*Painting Pottery Engraving*	*Goldsmiths' and craftwork*	*Architecture*	*Sculpture*	*Painting*	
VII	VIII	IX	X	XI	XII	XIII
						300
				296 Ex-voto offerings of Ogulni family 293 Dedication of statue of Jove by Spurius Carvilius 285 and 282 Statues to C. Aelius and Fabricius Luscinus by the citizens of Thurii	283 Fabius Pictor paints in the 'Aedes Salutis'	290
	(After 280) Tombs of 'the Shields', 'Bruschi', 'dell'Orco II', 'of the Cardinal', at Tarquinia. Campanari tomb at Vulci					280
					272–64 Pictures in the Temple of Vertumnus, — M. Fulvius Flaccus and T. Papirius Cursor, in the 'habitus triumphalis'	270
Sarcophagus of Torre San Severo				264 Removal of 2000 statues from Volsinii	264 Painting put on show by M. Valerius Messalla Maximus in the Curia Hostilia	260
First Chiusi urns			260 Column to C. Duilius	251 Statue of Caecilius Metellus		250
				241 Removal from Falerii of the Minerva and the Janus Quadrifrons		240
				230 Dedication of the statues of the Muses		230

HISTORY		GREEK ART	CHRONOLOGICAL DETAILS ETRURIA ITALY	Architecture	
Asia and Egypt	*Greece and Italy*				
I	II	III	IV	V	VI

I	II	III	IV	V	VI
220		219 Saguntum taken (218–1) Second Punic War			
210					
200	197 Sidon under the Seleucids		201 Small donarium		
190		191 Defeat of the Boii 189 Roman colony of Bononia			
180		176 Roman colony at Luna			

ETRUSCAN ART

ROME AND LATIUM

...pture Bronzes ...oplastics	Painting Pottery Engraving	Goldsmiths' and craftwork	Architecture	Sculpture	Painting	
	VIII	IX	X	XI	XII	XIII
				220 Removal of works from Capua ? Statue of Juno Matrona 216 The 'Victory' given by the Syracus- ans. Statues of M. Anicius and others at Praeneste	(After 220) Pacuvius paints in the Temple of Hercules	220
				212 Removal of statues from Syracuse— the 'Honos' and 'Virtus'	Painting in the Atrium Libertatis to commemorate events at Beneventum	
...d of 3rd ...t.) The ...itoline ...tus'						210
				209 Removal from Tarentum of the Herakles of Lysippus		
...Scasato ...ollo', ...rii				204 Statue of Claudia Quinta		
						200
			197 Statues of Ceres, Liber and Libera 196 Triumphal arch (fornix) of L. Stertinius 193 The 'Porticus Aemilia' at Rome			
			190 Triumphal arch (fornix) of Scipio Africanus	189 Religious statue of Hercules 188 'Congregati per Asiam artifices', — pictures of the Asiatic 'triumph' of Cnaeus Scipio 186 Greek artists present at games of M. Fulvius Nobilior		190
			184 Basilica Porcia, Rome			
			180 Monument to Scipio at Liternum	181 Gilded statue of Acilius Glabrio		180
				Statues of the Scipios and of Ennius	174 Painting of the Sardinian War of Ti. Sempronius Gracchus	

	HISTORY		GREEK ART	CHRONOLOGICAL DETAILS ETRURIA ITALY	Architecture
	Asia and Egypt	Greece and Italy			
	II	III	IV	V	VI
170					
		167 Polybius the historian at Rome			
160		159 Reign of Attalus II, King of Pergamus	Altar of Pergamus		
150					Tomb of the Volumnii, Perugi
			146 Destruction of Carthage and Corinth		
140					
130			Hecateum of Lagina 128 Ofellius statue at Delos		
		125 Destruction of Fregellae (Ceprano)			
120					
110					
100					
		91 Social War			
90		89 Roman citizenship for Etruscans			

ETRUSCAN ART			ROME AND LATIUM			
Sculpture Bronzes Coroplastics	Painting Pottery Engraving	Goldsmiths' and craftwork	Architecture	Sculpture	Painting	
II	VIII	IX	X	XI	XII	XIII
					172 (151) Gladiatorial pictures put on show by Terence Lucanus	170
					168 Metrodorus at Rome	
				164 Removal of an 'Atena' by Phidias		
				162 Statue of Cn. Octavius		
The Seianti sarcophagi, Chiusi						160
					154 Demetrius of Alexandria	150
Bronze head, Bovianum	(After 150) François tomb, Vulci. Typhon tomb, Tarquinia		147 Porticus Metelli	146 Removal of statues from Carthage and Corinth	Picture of exploits of Hostilius Mancinus	
Arezzo terracottas					(After 140) Pictures in the Forum	140
						130
(After 130) Tuscania tile sarcophagi						
			121 Fabianus Triumphal arch (fornix)			120
End of 2nd cent.) Head in bronze, Faesulae						110
1st cent.) Volterra urns the married couple group, Volterra			109 Pons Milvius (Reconstruction)			
			100 Temple of Hercules at Cora			100
			90 (?) M. Plautius paints at Ardea			90

	HISTORY		GREEK ART	CHRONOLOGICAL DETRILS ETRURIA ITALY	Architecture
	Asia and Egypt	*Greece and Italy*			
I	II	III	IV	V	VI
80		82 Dictatorship of Sulla 81–80 Sulla's repressive measures in Etruria. Colonies at Arretium and Faesulae			
70			Apollonius of Nestor		
60	64 Syria a Roman province				
		1st Triumvirate			
50		49 The Civil War			
40		44 Assassination of Caesar 43–33 2nd Triumvirate. Perugian War			
30		31 Battle of Actium			
		27 Octavian given the title of Augustus			
20					

Sculpture Bronzes plastics	Painting Pottery Engraving	Goldsmiths' and craftwork	Architecture	Sculpture	Painting	
ETRUSCAN ART			*ROME AND LATIUM*			
	VIII	IX	X	XI	XII	XIII
'Orator'			80 Curia Cornelia, Rome 78 Tabularium at Rome (Age of Sulla) Temple of Fortune, Praeneste	(From 81) Honorary statues of Sulla		80
				Honorary statues of Marius (67–49) Cicero's art importations (61) The *ex margaritis* portrait of Pompey		70
			55 Theatre of Pompey			60
				Avianus Euander Pasiteles, Arcesilas, Possis, Componius, Stephanus	Timomachos of Byzantium	50
			46 The Julian Basilica	46–44 Honorary statues of Caesar and Cicero (B)	Arellius	
				(39–27) The Monuments of Pollio		40
			31–29 Temple of the Deified Julius 29 Arch of Octavian in the Forum			30
			17 The arch of Augustus at Ariminum (Rimini)			20

CAPTIONS TO APPENDIX OF PLATES

1 – Perugia, 'Porta Marzia' Gate. Ancient part built into the Sangallo Renaissance bastion. 2nd century B.C. (?). (Photo. Alinari)

2 – Volterra, 'Porta dell'Arco', outer face. 2nd century B.C. (?) (Photo. Alinari)

3 – Caere, Tumulus II of the Banditaccia Necropolis

4 – Populonia, sepulchral aedicule, San Cerbone Necropolis. Latter half of 6th century B.C. (Photo. Superintendency of Antiquities for Etruria)

5 – Quinto Fiorentino, Montagnola chamber-tomb, interior. 7th century B.C. (Photo. Superintendency of Antiquities for Etruria)

6 – Casal Marittimo, interior of chamber-tomb. Beginning of 6th century B.C. (Photo. Alinari)

7 – Tarquinia, Tomba degli Auguri, interior. 6th century B.C. (Photo. Anderson)

8 – Marzabotto, detail of Etruscan house. (Photo. Superintendency of Antiquities for Emilia)

9 – San Valentino di Marsciano (Perugia). Sheet bronze *repoussé*. Antikensammlungen, Munich

10 – Veii, female figure from acroterion, in terracotta. Villa Giulia, Rome. (Photo. Superintendency of Antiquities for Southern Etruria)

11 – Caere, fragments of painted tiles with myth of Medusa. Villa Giulia, Rome. 6th century B.C. (Photo. Superintendency of Antiquities for Southern Etruria)

12 – Pyrgi (Santa Severa). Part of fronton decoration: gigantomachy. First decades of 5th century B.C. Villa Giulia, Rome. (Photo. Superintendency of Antiquities for Southern Etruria)

13 – Chiusi. Cinerary statue. 540–520 B.C. Casuccini Collection, National Museum, Palermo. (Photo. Superintendency of Antiquities, Palermo)

14 – Marzabotto. Bronze crowning decoration for candelabrum. Beginning of 4th century B.C. – Bologna, property of Countess Avia Castelli. (Photo. Superintendency of Antiquities for – Emilia)

15 – Vulci, François tomb. Detail: head of Trojan prisoner. Torlonia Collection, Rome. (Photo. Istituto Archeologico Germanico)

1

2

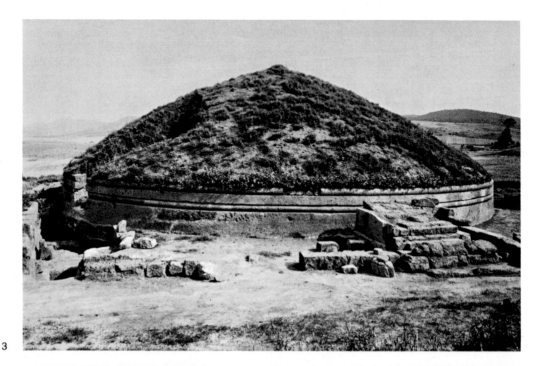

3

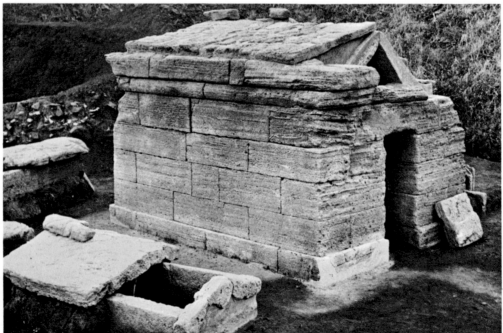

4

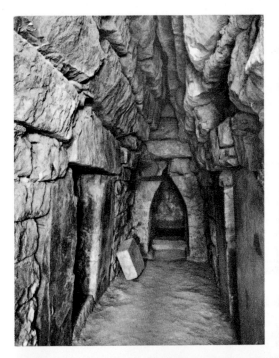

5

6

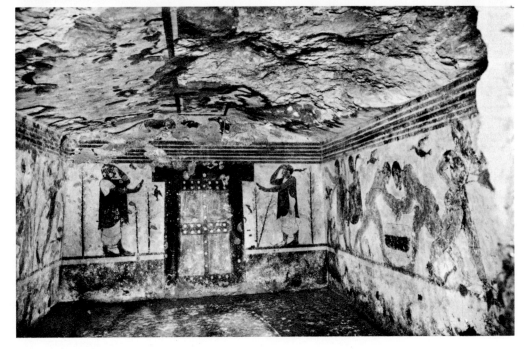

7

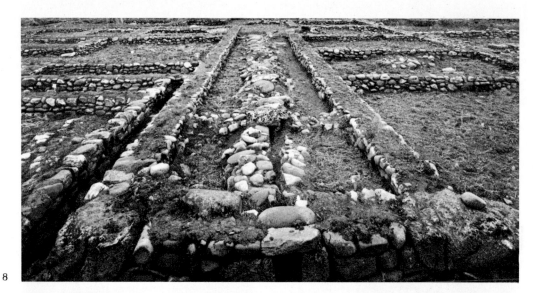

8

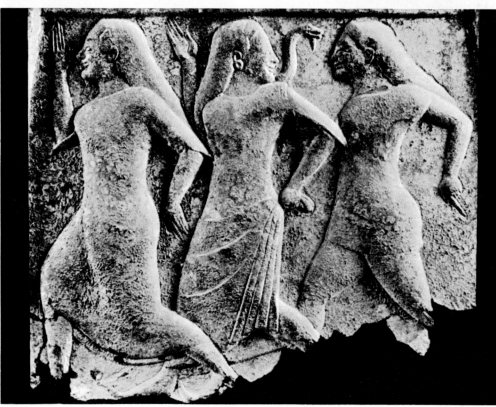

9

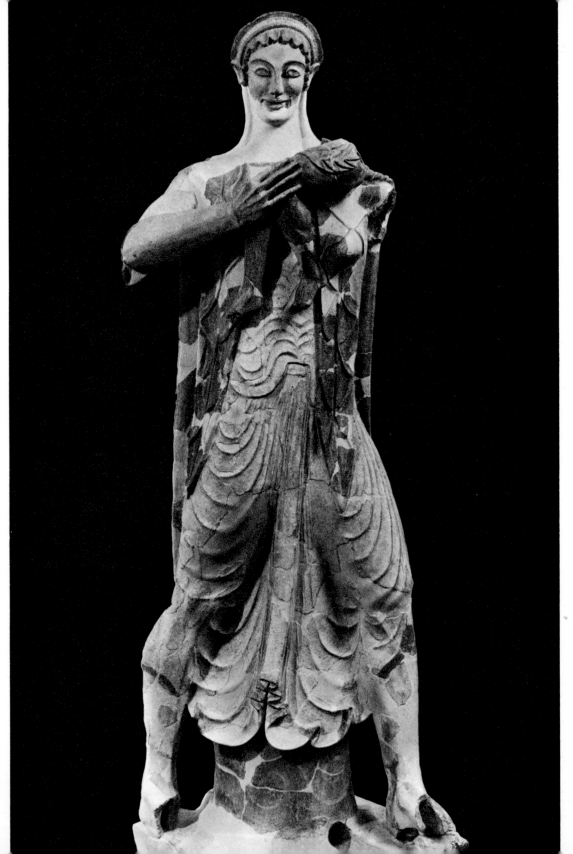

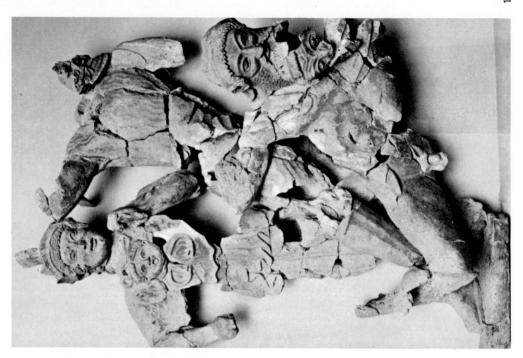

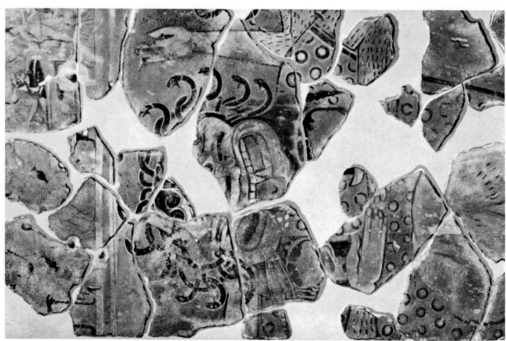

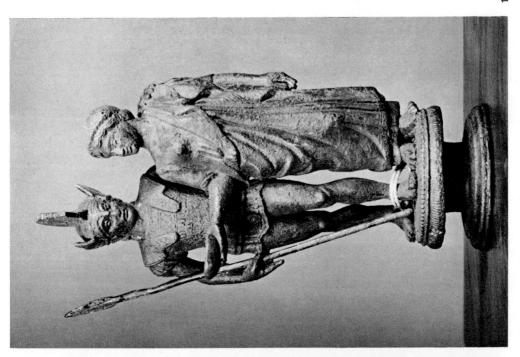

14

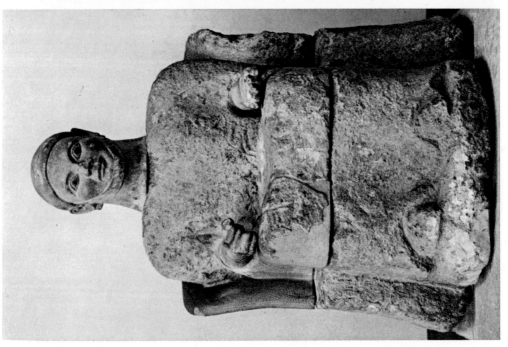

13

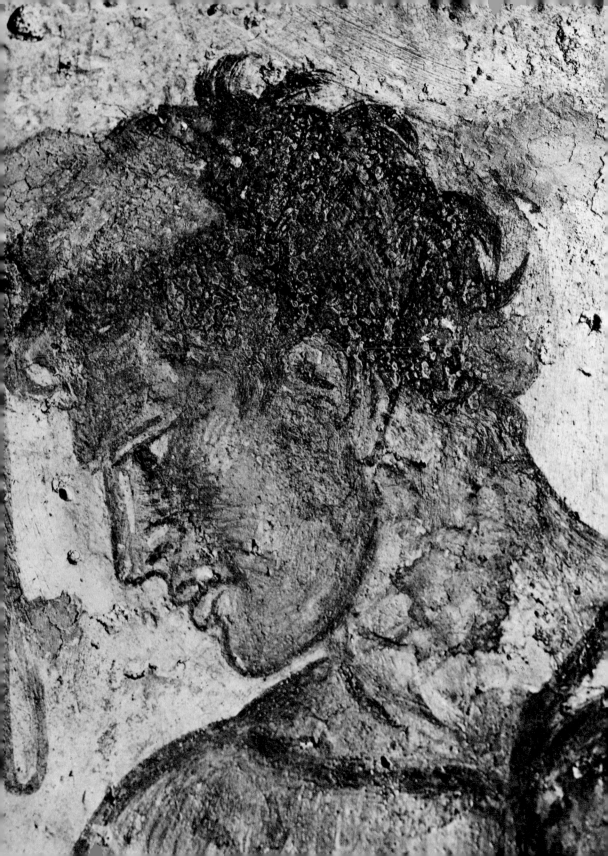

THE ETRUSCAN TOWNS

In the introduction to this book I referred to my double aim of tracing an historical outline and putting in a clear light the characteristics of the several localities. Of necessity certain particular aspects have been only in part brought out in the preceding pages; I therefore add in this append-ix brief references to the monuments and the character of the principal centres, with the warning, however, that many of the cultural exchanges, importations and influences suggested are far from being certain facts. The indeterminate, episodic and inconsequential nature of Etruscan art is itself such that it is difficult to define the true and proper character of the art of a particular town. One is aware of individuality without always being able to demonstrate it. Even inventories showing where objects were found do not always allow us to go much beyond making statements about topography, and even between centres with a character clearly their own, like Caere, Tarquinia and Vulci, there are relationships which are not clear to us, and they become still vaguer when we examine exported materials.

To facilitate reference, entries are in the alphabetical order of the ancient names (or the modern ones where the correspondence between ancient and modern is not certain); I have added in any case the modern name where it might be useful.

ADRIA *(v. Atria)*

ARRETIUM *(Arezzo)* – Hill-town in the Chiana valley, of rather late development. The remains of the walls, built of brick, probably date from Roman times. There is architectural documenta-tion, however, from the 5th century, including 'strigilated' terracotta tiles with figures applied almost in full relief, of classicist character, the only example of its kind in Etruria; the large bronzes (p. 128) are not a local product. The architectural terracottas (p. 169), classicist and Hellenized, from a temple building, belong to the middle of the 2nd century, i.e. after the area came under the Romans.

ATRIA *(Adria, Hatria, Hadria)* – The town is chiefly known for its necropolis in which have been found the most ancient Greek potteries (prevalently Attic) in the Upper Adriatic. Greek settle-ment and use of the town therefore appear to be slightly earlier than of Spina, but as was not the case with the latter, Adria did not pass materials and forms on to the interior. Like Spina it had no artistic production of its own, unless the so-called 'Upper Adriatic ceramics' are so con-sidered.

BISENTIUM, BISENZIO *(v. Visentium)*

BLERA *(Bieda)* – Town in the Tarquinian (?) territory, of which remains the important necropolis with cubic rock-cut tombs and architecturally faced tombs.

BOLOGNA, BONONIA *(v. Felsina)*

BOLSENA *(v. Volsinii)*

CAERE *(Cere, Cerveteri)* – The city took up a long terrace between the channels of the Mola and the Manganello, which separate it from two other parallel elevations which are occupied by the cemeteries (the Banditaccia and the Monte Abatone); a third necropolis area (the Sorbo) was where the two streams meet. The oldest monumental tomb, of the 'corridor-under-a-tumu-lus' type, the Tomba Regolini-Galassi (p. 47) is in the last-named. The necropolis which has been most thoroughly explored is the 'Banditaccia', with chamber-tombs hewn out of the rock, under tumuli on plinths and, later, with architectural rock fronts. The growth of the cemetery led to a thorough-going, 'town-planning'-type rationalization, with streets and squares, without the later constructions leading to any noticeable changes in the substantially uniform appearance. Importation from Greek lands and the Orient goes back to at least the 7th century, with parallel local production, determined by and developing hand in hand with it, — bronze reliefs, painted and plastic ceramics, ivory intaglios, and a great local growth in fine orientalizing goldsmiths' work (pp. 42–45). There is ancient documentation of moulded fictile products in the seated fig-urines (p. 51) and later in the recumbent-figure sarcophagi of the 6th century (pp. 94–97), which

qualify Caere style as clearly Ionicized, with softened modelling and broad definition of surfaces. The bronze reliefs found in Umbria have consequently been attributed to Caere workshops (p. 92). On the other hand Archaic evidence of sculpture in stone is exceedingly scarce. Caere was one of the most ancient centres for painting (Tombs of the Painted Lions—p. 73—and of the Painted Animals), and Pliny includes it with the towns which had pictures 'more ancient than Rome'. Surviving as evidence of painting at Caere are the Boccanera and Campana tiles and those portraying the Gorgons (pp. 81–84). A direct graft of the Ionic is shown by the 'Caere' *hydriae* (pp. 72, 74–77). The production of figured terracottas diminishes in the 5th century, later tomb architecture changes, but only in the interior arrangement of the tombs which show supporting columns and at the end strongly polychrome plastic details (Tomb of the Reliefs, pp. 112–13). Architectural plastic art resumes in the Hellenistic age, but without connections with local tradition and having relations rather with the South of Italy and Magna Graecia (friezes with heads and plant ornamentation). Likewise independent of local tradition are the votive heads of the Hellenistic age; these belong by this date to Italic art, or even to the history of the Roman portrait, like the naturalistic head in the Vatican Museum.

CAPENA – A Faliscan town which had from very ancient times its own forms of ceramic decoration and, later, considerable importations of *buccheri* and goldsmiths' work, but no Attic pottery. Main development from the 7th to the 5th century.

CAPODIMONTE *(v. Bisentium)*

CAPUA *(Santa Maria di Capua Vetere)* – The rectangular town plan is regarded as a mark of the Etruscan character of the city, rebuilt in accord with pre-existing topographical features. Of its art the main aspects to be studied are the antefixes and details of architectural plastic art in an Ionicized style, votive statues and bronzes (temple area, on the Patturelli property) showing parallels with southern Latium and Etruria, and also considerable borrowings from the Italiote world.

CASAL MARITTIMO – Pseudo-cupola tomb with central pylon, reconstructed in the Archaeological Museum at Florence.

CASTEL D'ASSO – Necropolis with architectural tombs of the 3rd century, with inscriptions including those of the Alethna family.

CASTELLINA IN CHIANTI – Tumulus tomb of 6th century, with considerable tomb furniture.

CHIUSI *(v. Clusium)*

CIVITACASTELLANA *(v. Falerii)*

CLUSIUM *(Chiusi)* – Capital of the Chiana valley, a hill-town on the site of the modern town and with a wide expanse of necropolises, it is one of the towns best endowed with a character of its own. Being a long way from the sea, imports and influences reached Chiusi via other areas, which explains its conservative character and the delay with which it took up new attitudes. The great Villanovan cemeteries have contents from which were descended the typical forms of the art of Chiusi and in the first place the *canopi* (pp. 48–50), which are the descendants of the Villanovan cinerary urns. Tarquinian influences have been found; and in its turn Chiusi exerted a powerful influence over a vast territory whose extreme points extend from Visentium on the one hand to the entire valley of the Arno and 'Etruria Padana' and Umbrian territory on the other. There were considerable importations in the 6th century, particularly in the field of Attic pottery ('François Vase' by the potter Ergotimos and the painter Klitias), but earlier than this great quantities of goldsmiths' work and ivory intaglios came to Chiusi from southern Etruria. It has been supposed that Vulci influence accounts for the funerary sculptures (lions and sphinxes). As early as the 6th century there was a production of *signacola*, in relief, for use outside the tombs, at Chiusi (p. 100–04), under the influence of Ionic and Attic types and stylistic formulas, whilst cinerary statues took the place of *canopi*, assuming in the 5th century forms which had a tendency to the 'severe' style (pp. 130–31). Painting comes episodically (p. 147), but reliefs, flat and with draughtman's and polychromatic features, are really more pictorial than plastic. Still in the 6th century, heavy *buccheri* with rich plastic decoration — and so not matching, in taste, the sense of measure and correctness shown in the reliefs — are characteristic of Chiusi. From the end of the 5th century ceramographic artists of high ability had their workshops here, though, in respect of some, this fact has been called into question. (Compare what is said under Volterra). In the Hellenistic age Chiusi was one of the producing centres for small urns in relief, and the great sar-

cophagi with recumbent figures were well estabished (pp. 172–78). For the latter, Tarquinian influences have been suggested, but the link with the horizontal cinerary statue is also obvious. In fictile sarcophagi the style of Chiusi tends to heaviness and a superabundance of forms and colour (pp. 177–78). The small urns with mythological subject-matter are often like miniature sarcophagi; in them, composition is generally sober and balanced, even to becoming schematized, with sudden intensification of expression, particularly in the fictile examples. Late funerary architecture (Tomb of the Grand Duke) goes back to the central-pilaster type.

COLONNA DI BURIANO (v. Vetulonia)

CORNETO (v. Tarquinia)

CORTONA – The part of the town on the hill has no remains, apart from the walls, earlier than the Roman occupation. The main interest lies in the tumulus tombs with internal chambers with false vaulting, in the surrounding territory (Camucia, Melone del Sodo), to which also the late funerary building known as 'Pythagoras' Den' ('Tanella di Pitagora') also belongs. Otherwise this was a receiving rather than a producing town. It is difficult to fit in to this local environment the bronze candelabrum (pp. 129–30) and the archaic stone sculptures (pp. 55, 57, 90), which are in any case not numerous.

FAESULAE (Fiesole) – The town, on the top of a hill, is rather late and it is therefore incorrect to speak of a very ancient urban development of the middle Arno valley. The principal Etruscan monument, a temple of the in antis type with a single cella, dates in its earliest form from the 3rd century. Within the Fiesole territory are the Mula and Montagnola orientalizing tumulus tombs of the 7th and 6th century and later the steles in relief, partly influenced — but only in the iconography — by Chiusi, and signacola like the Settimello cippus and the stele of Panzano in Chianti.

FALERII (Civitacastellana) – Faliscan centre, topographically like the Etruscan towns, on a hill between the Maggia and Vicino streamlets and the Treia, and surrounded by other high ground occupied by necropolises; these show progressive development from the end of the 7th century to the end of the 5th, with a great wealth of bucchero ware and goldsmith' work in granulation and filigree, later with a notable importation of Attic vases. Several temples are known ('Fosse Cappuccini', 'Sassi Caduti', 'Scasato', 'Vignale'), the coroplastic decoration of which extends from the beginning of the 5th to the end of the 2nd century, even after the complete evacuation of the city imposed by the Romans. In spite of discontinuity in the 'finds', adherence to classical types is a fairly constant characteristic of Faliscan plastic art, even though with considerable delays in acceptance (pp. 124, 132–34), and little inventive capacity. Faliscan classicism is seen too in the blooming ceramics school in the 4th century, which has connections with late Attic pottery and with Greek Italy (pp. 153–54). What we find here, specially in coroplastics, is local versions remarkable more from the technical than the stylistic point of view, and a current of taste which went on fairly constantly for more than two centuries.

FELSINA (Bononia, Bologna) – With the Villanovan urban development — the major concentration of population in northern Italy — came a large-scale flowering in art, in terms of geometric decoration, which spread from pottery to work in bronze (sheet metal engraving and repoussé and bronze casting). Contacts with Tyrrhenian Etruria, during the Villanovan IV (Arnoaldi), are marked by imports of goldsmiths' ware from Vetulonia, whilst contacts with the East, independent of the Tyrrhenian route, are revealed in the themes of the funerary signacola, which are chronologically intermediate between the Villanovan style and the full taking-shape of Etruscoid forms. To take the place of these themes and the late orientalizing style, there came in about 500, in rapid substitution, a double stream of influence, that from an Etruscan conceptual heritage, and powerful and continuing Attic influences, through which the former takes as its exclusive form of expression the big funerary steles in relief, which from the first decades of the 5th century sometimes united inscriptions with the figurative presentation, — the journey to the Underworld on a chariot, funeral games, and farewell scenes being the main subjects, together with survivals from the orientalizing style, symbolically treated. Later, war scenes appear, and in the steles of the last decades there are the most ancient celtomachies in Western art, copying the types of Attic iconographic schemes. The art of the Felsinean steles, the only artistic expression unquestionably associated with Etruscan civilization north of the Apennines, does not seem to be under the influence of other Etruscan centres, unless perhaps from the basin of the Arno, and

then only in respect of content. Felsinean steles in their typical form are emphatic drawings rather than true sculptures, in accord with the training received by their creators, who had before them pottery as models.Plastic art production, in small bronzes, is late, and a great part of the figured bronzes is imported. No Etruscan architectural monuments have been preserved at Bologna and even the extent of the city is unknown. There are fairly convincing indications that the necropolises were in part governed by a 'town-planning' scheme.

FIESOLE *(v. Faesulae)*

HADRIA, HATRIA *(v. Atria)*

MARSILIANA – Necropolis for an unknown town in the valley of the Albegna, receptive to various influences, and very rich and economically well-developed. Its time limits extend from the 7th to the 6th century, and the tombs are circular and chamber-tombs. Greek pottery is absent.

MARZABOTTO – The town was built, it seems, on virgin soil, according to the plan discussed on pp. 107–09. Its closest links were with the Chiusi territory, via the middle Arno valley. There was no very remarkable artistic development, though architectural terracottas with a Greek flavour, archaic and classicist, were locally produced and votive figurines in bronze were cast. The most significant bronzes from the artistic point of view were importations. There was the most important find of a Greek sub-archaic *kouros* head. Attic pottery, which is very common, is artistically on a modest level. The goldsmiths' work is of high quality, all imported. The *cippi*, fig-shaped, in the Chiusi or 'Fiesole', styles are typical. The entire town plan, temple buildings on the acropolis, and two necropolises with coffin-shaped, stone-slab tombs, surmounted by *signacola*, often column-shaped, have all survived.

NORCHIA – Necropolis of architecturally-fronted rock tombs.

ORVIETO *(?Salpinum)* – Identification of this town is doubtful, that with Volsinii not being acceptable. The built-up area was on a hill, on which the mediaeval and modern towns have continued to grow. The necropolises contain evidence going back to at least the 7th century (Cannicella); the most important and recent is that of the Crocifisso del Tufo, which had an overall plan, worked out, it seems, in advance, and was composed of chamber-tombs, cube-shaped outside, and with interior ceilings in false vaulting. Important archaic sculptures have been found here (pp. 57, 60). Several temples have been identified, – those of San Giovanni, San Leonardo, and Belvedere, with important evidence of fictile plastics, fundamentally classicist in inspiration, but with the addition of elements in accord with local taste (p. 125).The Belvedere temple has three *cellae*, with a high podium and flight of steps in front. The Settecamini necropolis is the most recent, with chamber-tombs corresponding in style with the second period of Tarquinian funerary painting, but without any roots, it would appear, in local tradition. Orvieto has been credited with a ceramographic school in the 4th century (the Vanth group), but even before this, painted pottery was produced. The Torre di San Severo sarcophagus (pp. 143 and 147) is from Orvietan territory, but stands alone.

PERUGIA *(v. Perusia)*

PERUSIA *(Perugia)* – This is an Etruscanized town of late development, but its origins are referred to in the considerable amount of legendary material connecting it with the beginnings of Felsina. There is no direct evidence before the 5th century. Etruscanization appears to have come about mainly from Chiusi. There were importations from Volterra in the 4th century, then local production also developed (the Palazzone ceramics). Perugia is one of the producing centres for funerary urns from the 3rd century on, marked by a scenographic presentation in which the figures stand out completely from the base, with strongly polychromatic character. The only great funerary group is the late Velimna tomb (pp. 112 and 164–65) in use right down to the early days of the Empire. The gates are very late (Porta Marzia and Porta d'Augusto, p. 164), the most complex in Etruscan public architecture.

PIRGI *(v. Pyrgi)*

POGGIO BUCO – A town on the Fiora, possibly to be identified with Statonia, with documentation which runs from the 7th century. A temple with Ionicized sub-archaic terracotta decoration goes back to the 6th. A late monument dates from the 3rd century.

POPULONIA *(Porto Baratti)* – The only maritime city on the Tyrrhenian side, marked first by imposing Villanovan necropolises (Poggio Granate, San Cerbone, Porcareccia, Costone della Fredda) with well-type, then trench-type and also chamber-tombs. Chambers under a

tumulus, with plinth, begin very early, as also funerary building in *opera quadrata* masonry with rectangular plan and pseudocupola, partly substituted in the 6th and 5th centuries by funerary aedicules in temple shape, unique in the Etrurian area, some with architectural terracotta decorations. Steles are frequently found, in sandstone, left smooth but with palmetted cymas. Of importance is the well-ascertained fact of gradual progress, shown by additions to the tomb furniture from Villanovan times onward. In the 7th and 6th centuries there was modest importation of proto-Corinthian vases, *bucchero* ware, then Attic vases in great quantities up to the end of the 5th century. There are many Italo-Corinthian imitations, but they are not local. We cannot speak of a 'Populonian art', though there is a craft specialization of inlays in iron on bronze, in the High Archaic. Populonia was, in art, exclusively a receiver, not an original creator. The imposing town walls have survived.

PYRGI, PIRGI *(Santa Severa)* – A port between Tarquinia and Caere, perhaps belonging to the latter. Recent excavations have brought to light considerable temple remains from the beginning of the 5th century (pp. 122 and 124), with figured plastic decoration.

QUINTO (AND SESTO) FIORENTINO – Necropolises with tumulus tombs (the Mula and the Montagnola) with pseudo-cupolas and central pillars. The orientalizing tomb furniture of the Montagnola, to some extent independent of southern Etruria, dates it as the 7th century.

RUSELLAE *(Roselle)* – A town of Villanovan formation, with archaic defences of the earthwork type; recently some parts in rough brick have also been found, contemporaneous with town planning elements in course of excavation. Nothing has so far been found to suggest any special local artistic character.

SAN GIULIANO – Necropolis with architectural rock tombs.

SANTA MARIA DI CAPUA VETERE *(v. Capua)*

SANTA SEVERA *(v. Pyrgi)*

SOVANA – Town in the Vulci hinterland; little is known of the town-plan. It occupies the Sparne hill between the Fiora and the Bavoso and Rubbiano water-courses. The main monuments of Sovana are the rock tombs with architectural fronts (pp. 109, 165–66), the most important of which are of the Hellenistic age.

SPINA *(near Comacchio)* – Port on the Spina branch of the Po, according to tradition founded by the Pelasgians (or the Thessalians), and then abandoned under pressure from the Gauls. Other sources of information about the ethnic origins of Spina also mention the Umbrians. There are however many references to Spina as an important Greek city; she ruled the Adriatic (repression of piracy?) and had her own treasury at the sanctuary of Delphi. According to research carried out both by aerial photography and on the surface, Spina was a special case in Italian, pre-Roman town-planning, the city being constructed on islets and criss-crossed by canals, the main one of which was the port channel. The inhabited part was probably moved as a result of changes in the delta itself. It was certainly constructed in part on piles. There do not appear to have been architectural monuments; none at any rate have so far been discovered. The city is known chiefly through the extensive necropolises, rich in Attic pottery, in general of exceptionally high quality, and in more modest bronzes; Etruscan, and perhaps Italiote, goldsmiths' ware is not uncommon. There are also articles imported from Carthaginian territory. Spina does not seem to have had an art of its own: it seems to have been above all else a receiving centre, and to have had great purchasing power as an *entrepôt*, supplying the interior with the flood of Attic ware which continued throughout the 5th and for part of the 4th century. Attic painted pottery was succeeded by black Attic, 'Campanian' and the so-called 'Upper Adriatic pottery', which it had in common with Adria.

TALAMON *(Talamone)* – A town whose principal contribution is the temple building to which belonged the well-known decorative terracottas (pp. 166–8, 170) perhaps commemorating the battle of 225.

TARQUINII *(Tarquinia, and formerly Corneto)* – This city, linked with ancient traditions, particularly of a religious nature, is certainly one of the most important in the Etruscan area; it was sited on the Civita plateau, on the left bank of the Marta, between the San Savino and Albacci waterways. It had an uncompleted city wall, at least in the 4th century. In front of it there developed the necropolises (Monterozzi, Selciatello, Poggio dell'Impiccato). Excavation, of the urban area, so far only in parts, has offered documentation mainly of the 4th–3rd centuries, while the

necropolises bear witness to uninterrupted occupation from a prosperous Villanovan stratum, rich in tomb remains with geometrical decoration, and then from tombs of the orientalizing period, with sheet bronzes, goldsmiths' work, and *buccheri* (less fine in quality, generally, than at Caere). Tradition bears witness to an immigration of Corinthians at the end of the 7th century, under the leadership of Damaratos, but there does not seem to be evidence of direct Corinthian influence to the extent found elsewhere; probably the city's fame and local repetition of the story led to Tarquinia's being credited as the venue of legendary journeys which allude to something of a general nature affecting nearby centres of ancient Etruria. The chamber-tombs typical of Tarquinia begin in the 6th century, but only from the 4th do they link up to form complex plans. Tarquinia is the only city where one can trace a history of painting, almost without a break from archaism (pp. 77–81) to sub-archaism and the 4th century (pp. 144–7, 148–153) and the Hellenistic age (pp. 182, 185), steadily in the first two phases and in outstanding disconnected episodes in the others. And it is at Tarquinia that there can be observed that change, which has often been remarked upon, from the hedonistic subject matter which prevailed in archaic and sub-archaic painting to the meditative and pessimistic turn shown in later chthonic figurative representation. This is a phenomenon which cannot be explained by Etruscan subjection to the Romans alone, but has certainly wider ideological reasons. In the 4th century Tarquinia cultivated the 'historical' painting of which evidence remains in works of applied art (p. 159). To this same time is to be attributed the big temple to which belonged the *acroteria* with winged horses, classically influenced, but of particular power in their modelling. Tarquinian plastic art, only slightly documented during archaism (p. 60), is very highly developed in the 4th and 3rd centuries, with the great sarcophagi of the Partenu and Pulena families, with recumbent figures and reliefs on the sides, from which certain consequences derived for the Romano-Italic *koiné* in late Hellenism.

TUSCANIA *(Tuscania)* – A town which came artistically to life only from the 3rd century. The art of Tuscania, which found expression mainly in sarcophagi, in stone and particularly in terracotta (pp. 176–78), seems to have derived from Tarquinian artistic experience, and then developed in an illusionistic direction.

VEII *(near Isola Farnese)* – The site of the Etruscan town was on a gently undulating terrace almost completely surrounded by watercourses. Some of the monumental zones have been explored (the Piazza d'Armi, the Campetti and Portonaccio) and the necropolis only in part. The most ancient document of Etruscan art at Veii is the Campana Tomb, in sub-orientalizing style, with Cretan influences coming via pottery; importation of painted vases is not very considerable; from as early as the 6th century, on the other hand, *buccheri* of particular fineness and simplicity were in very active production. A particular feature of Veii was the development of coroplastics, at first perhaps under the influence of Vulci and parallel in form with the products of other centres over a wide area (Velitrae, Caere, Tarquinia, Rome). It was here that there grew up at the end of the 6th century, without clear evidence of how it came about, the greatest known artistic school in the whole of Etruria, conditioning too the artistic life of the last years of Rome of the Kings and the early years of the republic; Vulca di Veii, the only Etruscan artist whose name is known, was actively engaged at Rome in the oldest parts of the decoration of the major temple of the Capitol. The terracotta statues and antefixes of the Portonaccio group, belonging to temple buildings of which the foundations and parts of the elevation survive, are the most original manifestations of all Etruscan art (pp. 122, 124, 126). Some decades later the Malavolta head (pp. 132 and 136) reveals an individual interpretation of Polyclitan antecedents.

VETULONIA *(Colonna di Buriano)* – The Etruscan town developed from a considerable Villanovan nucleus, with its greatest growth in the 7th and 6th centuries and a re-awakening from the 3rd. A guide to the process is given in the so-called 'ripostigli stranieri' [('foreigners' caches')], which were really trench-type tombs with greater wealth and variety than usual in tomb-contents. There followed circular tombs and probably also tumulus forms, which are documented in the Vetulonian territory. Vetulonia has special cultural features even in the High Archaic period, with few pottery importations and great quantities of bronzes besides *buccheri* and vases in *impasto;* in particular, the bronzes present unusual types, developments from the geometric style. Vetulonian goldsmiths' work (pp. 45 and 46) has a character of its own, based on tone values showing complete respect for the article's design. Documentation for sculpture dates

principally from a very ancient period, in the Pietrera sculptures (p. 53), then in the steles (pp. 51–53) which are indeed almost an exclusive possession of the north of Etruria. It cannot be claimed that Vetulonia had a full art of its own because of the lack of continuity in the evidence and because of a loss of interest in the plastic aspects.

VISENTIUM *(Bisentium, Bisenzio, Capodimonte)* – Our documentation comes mainly from the High Archaism period, developing from a solid Villanovan basis, with importation on a large scale. The town centre was redeveloped in Roman times.

VOLATERRAE *(Volterra)* – A hill town with a double wall of which parts are perhaps from the 5th century; the later gates (Porte Diana and Dell'Arco, pp. 162–64) are well-known. As the town grew it took in the older Villanovan necropolis, the Guerruccia, with well-type, barrel-vase type and chamber-type tombs. A definite orientalizing local *facies* is lacking, and there were importations of *buccheri* (from Caere?) and Attic pottery. The period of greatest development is in the 4th century, when there is notable evidence of the presence of and commerce in red-figure painted pottery, with the production of which, however, Chiusi too has been credited. Certainly of Volterran origin are the urns, from the 4th century to the Hellenistic period, with their lids plain and later with recumbent figures, mythological and narrative scenes on the sides, with spacing of the figures, first in low relief, then almost in full round, with architectural elements in the framing details (pp. 174, 178–81), which illustrate a local tendency, completely absent in the archaic period and the 5th century.

VOLSINII *(Bolsena)* – The identification of the unknown capital of the Volsinians with Bolsena, on the lake of that name, has of late years been again put forward, and persuasively, since it is supported by weighty finds; at Bolsena there have come to light parts of a great wall complex in *quadratum opus*, two sanctuaries, Mercatello and Poggio Casetta (3rd century), and necropolises, started in Villanovan times and then developed from the 7th century. A very important religious centre, Volsinii must have known great artistic development if the Romans, after conquering it, were able to carry off two thousand statues. The pottery in relief of late Hellenistic times, with surfaces silvered in imitation of relief metal vases, is described as Volsinian.

VOLTERRA *(v. Volaterrae)*

VULCI – The town grew up on a terrace on the right bank of the Fiora; the necropolises were to the north and, particularly, east (Mandrione, Ponte Rosso, Polledrara), all showing an early development of Villanovan forms on a vast scale. Although it was a very rich town, the tombs were for a long time of a more modest appearance than those of Caere and Tarquinia in respect of monuments and decoration; the tomb contents however are particularly abundant, though they suffered from unplanned exploration in the 18th and 19th centuries. There was an imposing amount of Greek pottery and oriental products imported; the proportion of Attic ceramics is greater, and that of Corinthian less, than elsewhere. Stone sculpture began very early at Vulci, combining Ionic and Sub-Daedalic influences (pp. 53, 55, 84), and there was a thriving funerary plastic art, with echoes from the orientalizing repertoire. The question of attributing to Vulci several types of bronzes ('rod'-legged tripods, candelabra, and ex-voto figurines) is still debated; they can be dated from the end of the 6th century onwards and do not constitute homogeneous series. Though it is certain that Vulci was a great centre of metal work, exporting on a very wide scale, attribution can not always be certain, in the lack of explicit evidence of where articles came from. The salient characteristics would appear to be a substantially Ionic quality, with which go great delicacy of execution and retouching. Similarly the attribution to Vulci of the 'Pontic' vases (p. 77) has been contested, whilst we seem to be on safer ground in supposing the Painter Micali to be from Vulci (p. 77). A Vulci school of pottery, about which one can be sure, strongly classicist in style, came only in the late 5th and the 4th century. Thus to describe Vulci's artistic character and set down a history of its art would be difficult. Plastic art is taken up again in the 4th century (sarcophagi at Boston, p. 143), and there are, later, great painted tombs (p. 185), with paintings with high aims and wall-schemes different from those of the Tarquinians.

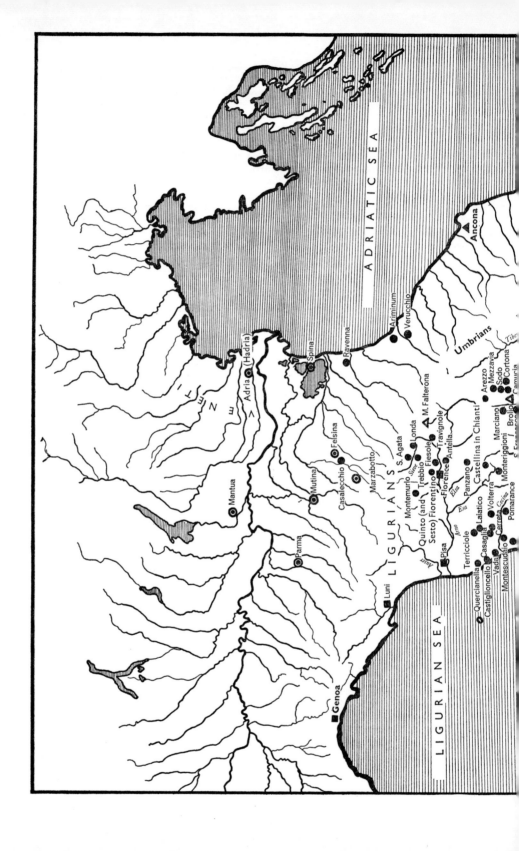

ADRIATIC SEA

LIGURIAN SEA

VENETI

LIGURIANS

Umbrians

Genoa

Luni

Quercianella
Castiglioncello
Terricciole
Casaglia
Vada
Montescudáio
Pomarance

Casalia
Lalatico
Cerreta
Volterra

Pisa

Parma

Mantua

Casalecchio
Mutina

Marzabotto
Felsina
S. Agata
Londa
Fiesole
Montemurlo
Quinto (and
Sesto) Florence
Trebbio
Travignole
Antella
Panzano
Castellina in Chianti
Marciano
Monteriggioni
Brolio

Arezzo
Mezzavia
Sodo
Cortona
Camucia
S. Francesco

M. Falterona

Spina
Ravenna
Ariminum
Verucchio
Ancona

Adria (Hadria)

Arno
Auser
Era
Elsa
Cecina
Sieve
Tiber

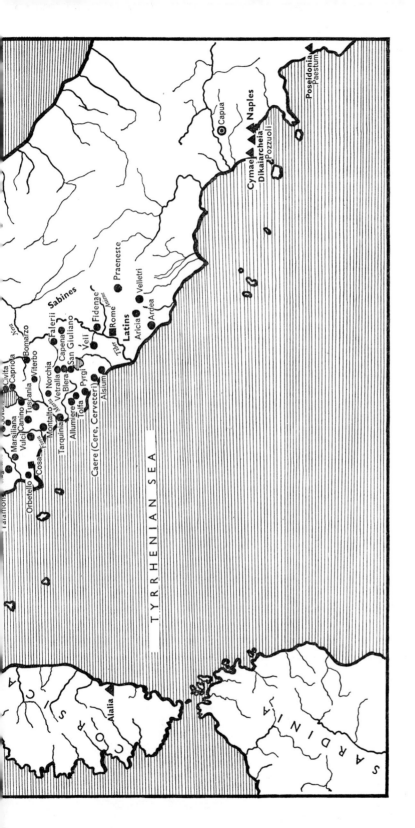

CORSICA

SARDINIA

TYRRHENIAN SEA

Alalia

Talamone
Orbetello
Cosa
Marsiliana
Vulci
Canino
Tuscania
Montalto
Tarquinia
Toscania
Bonarzo
Capriola
Civita
Viterbo
Norchia
Vetralla
Falerii
Allumiere
Blera
Tolfa
Pyrgi
San Giuliano
Capena
Caere (Cere, Cerveteri)
Alsium
Veii
Fidenae
Falerii
Rome
Latins
Aricia
Ardea
Velletri
Praeneste

Sabines

Capua
Cymae
Dikaiarcheia
Pozzuoli
Naples
Poseidonia
Paestum

● Etruscan and Roman towns; chief places where remains are found

△ Remains found in strata

▲ Greek colonies

◉ Etruscan towns in the periphery

■ Roman towns

THE ETRUSCAN TOWNS

GLOSSARY

Acroterion, acroterium (plur. *acroteria*)
Plastic detail, figurative or decorative, at the top of the temple building and at the angles formed by rain-courses of roofing.

Aedicule
Small temple. Aedicule-type tomb: a tomb in the shape of an aedicule (*v.* Appendix plate 4).

Aita (or *Eita*)
Etruscan transcription of 'Hades'.

À jour
With openings letting light through.

Akríbeia
In Greek the word can mean meticulous precision of finish; it is used in this sense in works on art.

Alabastron
Long-shaped vessel with broad rim, for perfumes. Often of alabaster (whence its name), but also in precious metals, glass or pottery.

Anta, pl. *antae*
In a building, the parts of the side walls projecting beyond the front. Also architectural element in the form of a pilaster attached to the masonry. *In antis* temple, one having construction of first definition above.

Antefixes
Terminal elements for the rows of curved tiles, with plastic or painted decoration, often consisting of isolated figures or plastic groups.

Antepagments
Terracotta tiles or slabs, in relief or painted, attached externally to the wooden structure of the elevation of the Etruscan temple.

Anthemion
In the Ionic capital the decoration of the *collarino* (q.v.) below the double volute (q.v.).

Antica (*v. pars*)

Aplu, Apulu
Etruscan transcription of 'Apollo'.

Artumes
Etruscan transcription of 'Artemis', later = Latin 'Diana'.

Askós
Literally, 'bag'. The term is used for a type of small vessel, generally animal-shaped.

Asyntactic (*v. Syntactic*)

Atrium (Latin. The Etruscan *cavaedium*).
In houses, the central room, with opening in roof; the other rooms opened on to it.

Augur
In the Etruscan and Roman priestly hierarchy the Augurs, together forming a 'college', were the experts in the interpretation of the will of the gods from the flight of birds and, in general, from celestial signs.

Bar-tripod (*v. Tripod*)

Bract, bractea
Thin leaf of metal, generally gold, cut, and decorated in repoussé, to be attached to cloth.

Búcchero
Pottery typical of Etruscan archaism and subarchaism, and generally imitating forms from metal receptacles, with thin walls (*bucchero sottile*) or thick (*bucchero pesante*). It was made of black *impasto* (q.v.), with glossy-black finish. The technique appears to have included mixing with powdered carbon, and there was some special way of baking.

Bucrane, bucranium
Plastic representation, in decorative friezes or metopes (q.v.), of the skull of the ox, used in isolation or as a support for festoons.

Bulla
Lenticular pendant, generally in lamina of precious metal, in relief. *Bullae* were used in series to form necklaces, or isolated in the middle of a necklace. In the latter form the *bulla* became the mark of free-born Roman youths.

Candelabrum
Conventional designation of an object very common in the Etruscan area and consisting of a verticle shaft on a tripod, terminating in arms coming to a point on which torches were put. Between the arms there was generally placed a decorative top.

Canopus
Term common to Egyptology designating a vase with lid in the shape of a divine image, to contain the organs of the mummified dead. This term has been extended to archaic funerary urns from Chiusi, with masks and lids in the shape of human heads.

Capitol
The principal temple at Rome, on the Capitoline hill; it had a triple *cella* (q.v.) on a *podium* (q.v.); the term is extended, as *capitolia*, to temples with three *cellae* having official cult purposes in Roman colonies.

Cavaedium (*v. Atrium*)

Cella

The closed part of the temple building destined to house the image of the god. The Etruscan temple had a single *cella* between two *alae* or three *cellae* side by side in the *pars postica (q.v.)*.

Charu

In the Etruscan world of the dead the affinity with the Greek Charon is nominal only. Of frightful appearance, he is a tormenting demon (generally carrying a hammer), not the ferryman of souls.

Cinerary urn

In general the equivalent of the urn *(q.v.)*, to indicate receptacles in which were placed the remains after cremation. The term can be extended to plastic objects having the same purpose.

Cippus

An exterior funerary monument in stone, generally a parallelepiped or cylindrical in shape, with or without a base, and generally having plastic figurative decoration.

Cist

Cylindrical receptacle in sheet-metal or wood with metal facing, always with lid, three added feet, cast handles, sometimes with holder like that of the *situlae (q.v.)*, and decoration by *repoussé* or engraving. Common in the northern Etruscan area are the so-called 'cordon'-type cists, in sheet metal with horizontal wavy lines.

Collarino

Strip separating main column from capital.

Columen

('That which is raised on high', and not = *columna*). In the Etruscan temple, the horizontal beam at the highest point of the roof, and corresponding to the 'watershed'. By extension, any other element of like function, even in buildings other than temples. In the temple the front end of the *columen*, at the highpoint of the temple *fronton*, is generally decorated with a terracotta slab, plastic or painted.

Coroplastic(s)

Statuary and architectural decoration in terracotta.

Cylix, *v. Kylix*

Dædalic

From the name of the mythical Greek artist Daidalos; it is applied to the sculpture of the beginnings of Greek Archaism.

Dipylon

Necropolis of the city of Athens, near the gate of the same name (= 'double gate'). In 'Dipylon style' the name indicates Attic Geometric at the beginning of the first millenium.

Dodecapolis

Federation of twelve cities, which in Etruria was probably of a religious character. According to the traditions in ancient historical writings there were three such Etruscan federations, one in Etruria proper, one in Campania, and one in the Po valley, but the actual composition of all three is not at all certain.

Dromos

Corridor, open to the sky, giving access to sepulchre-tombs, tumulus *(q.v.)* or rock-face.

Engraving

Technique consisting of tracing figures or decorative detail on the surface of objects, generally in bronze, by means of a metal point (the *bulino* or graver or engraving tool). Also used in finishing detail on cast bronzes.

Entasis

The swelling of the shaft of the Doric column.

Ephebus, plur. *Ephebi*

Strictly, Greek youth between adulthood and the age of twenty, in his years of military service; a representation of a young male.

Extispicium

Ritual interpretation of divine will by examination of organs of sacrificial victims.

Facies

A Latin term in general use in writings about pre-history, meaning cultural 'look' or aspect.

False vaulting

Form of vaulting resulting from progressive projection of blocks laid horizontally on each other, and not — as in true vaulting — built of conical stones or conically laid mortar. Mainly used in chamber-tombs of the 7th and 6th centuries. The *pseudo-cupola* was constructed in the same manner.

Favissa

In the temple building or its sacred precincts, a ditch to contain votive offerings.

Fibula

Fastener for clothing, consisting of a main part (the fibula proper, or 'bow'), a spring and a pin, held in a 'stirrup. The bow and stirrup are often decorated.

Fictile

Moulded clays, including terra cotta.

Filigree

A technique often used in orientalized and archaic jewelry, and also later; it consists in the application, hot, of gold, silver or bronze filament, to form ornamental motifs, or in the composition of *à jour (q.v.)* motifs.

Fornix

In Latin technical terminology, an opening, fully arched, on simple pilasters, freestanding or in an

architectural context. Sometimes loosely translated as the honorary, 'triumphal' arch, it is more correctly the forerunner of this.

Front, fronton

'Front', as used in this book, is the face or side from which the building or object is being looked at, generally the entrance side. Where 'fronton' is used the reference is generally to the 'pediment' or triangular part at the top of the front.

Gorgoneion

'Horrific' mask of the Gorgon, i.e. Medusa, largely used as a decorative element.

Graffito

The technique of tracing figures or parts of figures or decorative motifs, generally on stone or ceramics, by means of a metal point; allied to engraving.

Granulation

Technique common in the orientalizing and archaic jewelry, but continued in later periods, consisting of the application whilst hot of minute spheroidal grains of gold, in 'zones' or rows.

Graver (v. Engraving)

Haruspication

Doctrine and ritual practice for the ascertaining of the divine will, by means of examination of the entrails of sacrificial victims, particularly of the liver.

Hathoric, Hatoric

Appertaining to the goddess Hathor. In 'hatoric (hathoric) heads' the word indicates a decorative type of the 'Orientalizing' style, with the hair falling in volutes.

Hercle

Etruscan transcription of Herakles/Hercules.

Hydria

Spheroid or ovoid receptacle for liquids, with cylindrical neck, two arched handles at sides, with a third attached to the neck.

Impasto

Ceramic technique characteristic of hand-worked vases. By 'impasto pottery' is generally meant that of prehistoric times, of the Iron Age or later, made of impure clay with silica content. In painting, the thick laying on of colour.

Incrustation

In ceramic technique, ornaments and designs hollowed out and then filled in with white and coloured materials. In Hellenistic wall painting the term 'incrustation decoration' is used for that imitating polychrome marble slabs applied to the walls.

Intaglio

Technique for working 'semi-hard' materials such as wood, ivory and amber.

Isocephaly

Principle observed in some ancient painting or relief of presenting the heads of all figures at the same level.

Kantharos

Drinking vessel in sheet metal or pottery, with or without a stem, conical body and with handles generally higher than the rim.

Knurling

Beads, ridges, as an ornament on metal surfaces.

Koiné

Greek word originally meaning the common language (κοινή διαλεκτος) used in Greece in the 4th century B.C. Here a culture common to different people.

Kore (v. Kouros)

Kottabos

Instrument used in a party game, apparently of Siceliote origin, consisting of a metal upright, with feet like a candelabrum *(q.v.)*. At the top was balanced a small metal plate, which the players had to dislodge by throwing small amounts of wine from their wine cups *(kylix) (q.v.)*.

Kouros and Kore

Types from Greek archaic statuary, representation of the nude youth (in the Ionian area also clothed) and of the girl, clothed, both standing and facing forward. They were used entirely as votive offerings, and frequently returned to popularity during Etruscan archaism.

Krater

Large receptacle in sheet metal or pottery, ovoidal, with cylindrical neck and high handles, or bell-shaped (bell *krater*). The bell-shaped type is only found in terracotta.

Kriophoros

Votive figure carrying a small goat.

Kylix

Pottery drinking-cup, broad and rather shallow, with stem, and two handles placed beneath the rim.

Lasa, plur. lasae

Minor female divinities of the aphrodisiac and funerary cycles, shown winged, almost always nude or half-nude, often with individual names (Racuneta, Sitmica, etc.).

Lebes, plur. lebetes

Large hemispherical receptacle, particularly common in the orientalizing period, of Asian origin, in bronze sheet metal, with handles in relief, or cast. Without feet, being supported on a tripod or conical stand.

Lituus

Short stick, curved at the top; the crook, the mark of priestly (particularly of the augurs) and

perhaps political functions in the Etruscan world, whence it was taken by the Romans.

Menrva (and *Menerva*)

The Etruscan equivalent of the Latin Minerva, and identified with the Greek Athena.

Metope

In the Doric temple, the space between the triglyphs *(q.v.)*, occupied by a stone or terracotta slab, with plastic or painted decoration. By extension the Doric frieze with triglyphs and metopes is used in the Hellenistic age, in Italy also, as a decorative detail, without any functional purpose.

Monumentum

Connected with the verb *monere*, the word stood in general for any durable witness to the past —architectural, statuary, or in written history. In a narrower sense, an architectural unit with epigraphic, symbolic and figurative elements which have a commemorative purpose, honorary or funerary.

Mundus

Later taking the meaning of 'world', was originally a well, sacred to the cult of the infernal deities of Etrusco-Roman religion.

Necropolis

Area reserved for burials of whatever type: simple grave or trench, tumulus *(q.v.)*, constructed chamber or chambers hollowed out of the rock, with or without rock faces.

Nenfro

A soft stone, of volcanic origin, used in archaic Etruscan sculpture.

Nethuns

Etruscan equivalent of Poseidon/Neptune.

Oinochoe

Jug to serve liquids, spheroidal in shape, high-necked, with tri-lobed lip, one holder, in cast metal, ceramics, impasto or *bucchero*.

Opus, opera (v. quadratum)

Orientation

Ritual practice in founding cities (and in the case of the Romans also in surveying for census and tax purposes), in which axial roads were drawn between the cardinal points. In temple building the orientation consisted of making the façade face a cardinal point.

Orthostat

Known by this name are the rectangular slabs of stone, standing on their short edges, used as structural, covering or fencing elements.

Palliata

Latin comedy with a Greek subject, derived from Hellenistic comedy.

Parasyntactic (v. Syntactic)

Pars antica

The front half in an Etruscan temple, generally occupied by the colonnade.

Pars postica

The rear half of the temple, taken up by the *cella (q.v.)* or the group of three *cellae*

Pediment (v. fronton)

Pendentives, pennacchi (v. Pseudo-cupola, squinch)

Peribolos

Any continuous passage continuing for the entire external perimeter of a building.

Peristasis (also *Ptéroma*)

In a Greek temple the continuous external portico.

Peristyle

Columned portico around a closed space.

Phersipnei

Etruscan transcription of Persephone.

Phersu

In the Tarquinian Tomb of the Augurs, personage with mask and tall, pointed cap, seen egging on a dog against a man with his head in a sack and armed with a stick; later he is seen in flight. This is a representation of a public spectacle, presumably associated with funeral rites, and has been linked with gladiatorial spectacles. The name is connected with the Latin 'persona' (=mask).

Phupluns

Etruscan divinity identified with the Greek Dionysus.

Podium

A part of temple or funerary buildings, a continuous projecting base, outlined externally by continuous mouldings.

Promachos

Term used of an effigy in a fighting attitude.

Prothesis

Laying-out of the dead on the funeral couch, the first part of the funerary ceremonial. The Greek term is commonly used for scenes representing such laying-out.

Proto-historic

Conventional indication of the period which in general corresponds to the Second Iron Age.

Protome

'Upper part'; half-length figure or bust.

Pseudo-cupola

Ceiling or roofs in rows of stones progressively overlapping, in chambers either with a circular or a square ground-plan; in the latter case the pseudo-cupola is mounted on *squinches*, or corner elements, to permit passage from a rectangular plan to a circular culmination.

Pulviscule

Technique much used in orientalized and archaic goldsmiths' work, less frequently so later. It con-

sists in covering a surface with diminutive grains of gold. Also called 'fine granulation'.

Pyxis

Small cylindrical, or globular vase, with a lid, in ivory, metal, pottery or other materials.

Quadratum opus

Latin term equivalent to the Greek isodome masonry. It is used to indicate any structure in regularly cut and keyed stones.

Rhopography

'Still-life' or *genre* painting, representing restricted scenes or small portions of a larger whole.

Rhyton

Drinking vessel, in *repoussé* metal, without a stem, generally decorated, in the shape of a horn or a human or animal head.

Rod-tripod (v. Tripod)

Scarab, scarabaeus

In Egyptian hieroglyphics, the representation of the scarab beetle stands for 'becoming, standing forth'. Scarabs, in various materials, generally semi-precious stones, served as seals and amulets. The centre bore inscriptions or figurative representation. The type was widely diffused outside Egypt and continued in use for a long period, also as part of a necklace or the stone of a ring.

Schnabelkanne

Receptacle having the same purpose as the *oinochoe (q.v.)*, generally in bronze, sometimes also in pottery, marked by the very long, slanting 'lip', exceedingly common in northern Etruria and in proto-historic continental Europe.

Segnacolo

Sign or notice, particularly a memorial, generally on stone; a tombstone.

Sethlans

Etruscan equivalent of Hephaistos/Vulcan.

Signacolum (v. Segnacolo)

Situla

Receptacle in sheet metal, cast metal, terracotta or wood faced with layers of silver, bronze or ivory, with plastic or *graffito* decoration. Conical, cylindrical or spheroidal in shape, *situlae* (other than terracotta ones) have one or two holders, bent to an arc to form a ring-shaped handle, and sometimes have a lid. Their primary purpose was to hold liquids. Sometimes confused with the cist *(q.v.)*.

Socle

In this book, a low plain plinth serving as base for a wall or wall-like surface; generally the commoner word 'plinth' has been used.

Sphyrelaton, plur. sphyrelata

Name given to figures composed of sheet metal in relief and linked one to another. Also, by exten-

sion, simple pieces of sheet metal with decorative reliefs.

Squinch

An arch across the internal angle of walling to support roofing elements.

Stamnos

Receptacle with same functions as the *crater*, normally in sheet metal, with arched handles in cast metal, put on at the sides.

Stampiglia

Impress or die-work. Technique proper to ceramics, consisting of rough reproduction of figurative or decorative detail by means of positive or negative punches.

Stele (pl. steles)

Exterior funerary *signacolum (q.v.)*, generally in stone, taller than it is wide, with plastic decoration, or with inscriptions.

Stipe

Sacred container of votive objects, closed or not in a *favissa (q.v.)*.

Stratigraphy

'Lay' of archaeological strata, determining their whereabouts and relationship one to another, especially from the chronological point of view.

Syntactic

Arrangement of decorative and ornamental elements in accordance with a particular system in which certain elements are dominant, with dependent elements subordinated to them. In the absence of such characteristics an artistic manner is described as 'asyntactic'. Where elements of equal value confront one another and coexist independently the manner is called 'paratactic' (*Cf.* corresponding grammatical terms.)

Tébennos

Usual overgarment of Etruscan male costume, equivalent in use with the Roman *toga*, but shorter; in pictures the *tébennos* is purple, but later also white or with embroidered decorations.

Templum

Ritual division of the face of the sky carried out by the Augur *(q.v.)* after a preliminary 'orientation' *(q.v.)*. The sky was divided into (favourable or less favourable) regions prior to taking the auspices. Determining the 'templum' accordingly laid the foundation for castrametation (camp layout) and town-planning.

Tholos

Chamber with circular ground-plan and ceiling with false-vaulting *(q.v.)*.

Thrénoi

Poetic mourning compositions. The term is also used for the representation of the rhythmic dance which is connected with them.

Tinia

Male divinity in the Etruscan pantheon, of the type of the Greek Zeus and the Latin Jupiter.

Torques

Necklace made from heavy metal rod (gold, silver, bronze, iron) in the form of an open ring, with the metal turned back or with two small spheres at the ends; typical of Celtic costume.

Triglyph

In the Doric frieze the member or ornament, consisting of a block or tablet, originally a supporting element, with three vertical grooves or glyphs.

Tripod

Three-footed stand, for large metal vessels *(lebetes)* in repoussé sheet-metal, composed of bars (bar-tripod) or rods (rod-tripod); characteristic of the archaic age.

Tuchulcha

Tormenting demon of frightful appearance in late Etruscan funerary representation.

Tumulus

A mound, subconic in shape, composed of earth, rocks or loose stones, covering the underground funerary chamber, with access via the *dromos (q.v.)*. In the Etruscan and Roman area generally surrounded by a stone plinth with mouldings.

Turan

Etruscan female deity identified with Aphrodite/Venus.

Turms

Etruscan equivalent of Hermes/Mercurius.

Typhon

Giant of Greek mythology, but in the Etruscan context = Orcus, god of the underworld.

Uni

Female deity in the Etruscan pantheon, companion of Tinia, identified with the Greek Hera and the Latin Juno.

Urartian

Original or derived from the art of Urartu.

Urn

Receptacle for the bones and ashes of the dead in the rite of cremation; in the Iron Age the shape is biconical, or reproduces the home ('hut' urn), later taking on the appearance of a small sarcophagus. The *canopus (q.v.)* developed from the Iron Age biconic urn.

Usil

Etruscan name of the sun-god (Helios/Sol), and not, at least in origin, identified with Apollo.

Vanth

Minor female deity from the Etruscan funerary cycle, often with 'gorgonic' attributes (serpents for hair), generally shown winged, and dressed as an Amazon.

Voltumna (also *Veltune* and *Veltha*, Latin *Vertumnus*)

The principal deity, according to a tradition, of the Etruscan pantheon, and having contradictory characteristics and attributes, being god both of war and of vegetation.

Volute

A spiral scroll, the chief ornament of the Ionic capital; also used in the Corinthian and 'Composite' orders.

Zonal, zonate

In this book generally meaning arranged in 'zones', or 'belts' or 'bands'.

BIBLIOGRAPHY

LIST OF FREQUENTLY USED ABBREVIATIONS

Arch. Class Archeologia Classica
Atti Pont. Acc. Atti della Pontificale Accademia di Archeologia
Boll. Ist. Centr. Restauro Bollettino dell'Istituto Centrale del Restauro
Boll. Paletn. Bollettino di Paletnologia italiana
Dissert. Pont. Acc. Dissertazioni della Pontif. Accademia di Archeologia
Journ. Rom. St. Journal of Roman Studies
Mél. Arch. Hist. Mélanges d'archéologie et d'histoire de l'Ecole française
Mem. Am. Ac. Rome Memoirs of the American Academy, Rome
Rend. Acc. Lincei Rendiconti dell'Accademia Lincei
Rend. Pont. Acc. Rendiconti Pontif. Accademia Archeologia
Riv. Ist. Arch. St. Arte Rivista dell'Istituto di Archeologia e Storia dell'Arte
Jahrbuch Inst. Jahrbuch des deutschen Archäologischen Instituts
Arch. Class. Archeologia Classica

PREHISTORY AND 'THE ETRUSCAN PROBLEM',
GENERAL WORKS

O. *Montelius*, La civilisation primitive en Italie depuis l'introduction des métaux. Stockholm I (1896), II (1904).

A. *Pinza*, Materiali per l'etnologia antica toscano-laziale. Milan, 1914.

D. *Randall McIver*, Villanovians and Early Etruscans. A Study of the Early Iron Age in Italy. Oxford, 1924.

L. A. *Holland*, The Faliscan in Prehistoric Times. Rome, 1925.

C. *Schuchhardt*, Die Etrusker als altitalisches Volk, in: Praeh. Zeitschrift XVI (1925).

L. *Pareti*, Le origini etrusche. (Le leggende e i dati della scienza). Florence, 1926.

A. *della Seta*, Italia Antica. Bergamo, 1928, p. 62 ff.

F. S. *Schachermayer*, Etruskische Frühgeschichte. Berlin–Leipzig, 1929.

J. *Sundwall*, Zur Vorgeschichte Etruriens, in: Acta Acad. Aboensis, Humanoria VIII, 3 (1932) p. 1 ff.

N. *Aberg*, Bronzezeitliche und früheisenzeitliche Chronologie, in: Mnemosyne III (1936) p. 181 ff.

W. *Brandestein*, Die Herkunft der Etrusker. Leipzig, 1937.

P. *Ducati*, Le problème étrusque. Paris, 1938.

M. *Pallottino*, Sulle facies culturali arcaiche dell'Etruria, in: St. Etr. XIII (1939) p. 85 ff.

M. *Renard*, La question étrusque, in: L'antiquité classique IX (1940).

M. *Pallottino*, Appunti di protostoria etrusca e latina, in St. Etr. XIV (1940) p. 27 ff.

P. *Barocelli*, L'ultimo trentennio di studi paletnologici in Italia, in: Boll. Paletn. N.S. V–VI (1941–2) p 3 ff.

A. *Ackerström*, Der geometrische Stil in Italien. Lund-Leipzig, 1943.

P. E. *Arias*, Problemi sui Siculi e sugli Etruschi. Catania, 1943.

M. *Pallottino*, Nuovi orientamenti sulla cronologia dell'Etruria protostorica, in: Rend. Pont. Acc. XXII (1946–7) p. 31 ff.

G. *Devoto*, Agli inizi della storia etrusca, in: St. Etr. XIX (1946–7) p. 285 ff.

M. *Pallottino*, L'origine degli Etruschi. Rome, 1947.

L. *Pareti*, La tomba Regolini-Galassi del Museo Gregoriano Etrusco e la civiltà dell'Italia centrale nel VII sec. a. C. Città del Vaticano 1947.

G. *Patroni*, Preistoria d'Italia. Milan, 1949.

G. *von Kaschnitz-Weinberg*, Italien mit Sardinien, Sizilien und Malta, in: Handb. der Arch. IV 2. München, 1950. p. 364 ff.

P. E. *Arias*, Aspetti del problema della civiltà etrusca, in: Sicul. Gymnasium (1954) p. 155 ff.

G. *de Beer*, Sur l'Origine des Etrusques, in: La Revue des Arts V (1955) p. 139 ff.

M. *Pallottino*, Le origini storiche dei popoli italici, in: X Congresso internaz. di Scienze Storiche, Relazioni II (1955) p. 3 ff.

J. *Bayet*, Etrusques et Italiques: position de quelques problèmes, in: St Etr. XXIV (1955–6) p. 3 ff.

G. *Devoto*, Gli Etruschi nel quadro dei popoli italici antichi, in: Historia VI (1957) p. 23 ff.

L. *Pareti*, A proposito di una recente ipotesi sulle

origini del popolo etrusco, in: Studi Etr. xxv
(1957) p. 573 ff.

G. Saeflund, Über den Ursprung der Etrusker, in:
Historia vi (1957) 10 ff.

Civiltà del Ferro, Studi pubblicati in occasione del
1 centenario della scoperta di Villanova. Bologna,
1959.

M. Pallottino, Sulla cronologia dell'età del bronzo
finale e dell'età del ferro in Italia, in: St. Etr.
xxviii (1960) p. 11 ff.

ETRUSCAN CIVILIZATION, GENERAL WORKS

C. O. Müller–W. Deecke, Die Etrusker (2 vols.). Stutt-
gart, 1877.

C. Hülsen–G. Körte, in: Pauly-Wissowa, Real-Enzy-
klopädie vi (1909) fasc. 730, Art. Etrusker.

P. Ducati, Etruria antica (2 vols.). Turin, 1925.

A. Solari, La vita pubblica e privata degli Etruschi.
Florence, 1928. (2nd ed. with app. by A. Neppi,
Modena, 1931).

B. Nogara, Gli Etruschi e la loro civiltà. Milan, 1934.

G. Buonamici, Fonti di storia etrusca. Florence, 1939.

M. Pallottino, Gli Etruschi. Rome, 1940.

M. Renard, Initiation à l'Etruscologie. Brussels, 1941.

E. Colozier, Les Etrusques et Carthage, in: Mél.
Arch. Hist. lxv (1953) p. 63 ff.

R. Bloch, L'art et la civilisation étrusque. Paris, 1955.

M. Pallottino, Mostra dell'arte e della civiltà degli
etruschi. Milan, 1955.

M. Pallottino, Introduzione alla civiltà degli Etru-
schi, in: Historia vi (1957) p. 1 ff.

S. Mazzarino, Sociologia del mondo etrusco, in: Hi-
storia vi (1957) p. 98 ff.

Tyrrenica, Saggi di studi etruschi. Milan, 1957.

L. Banti, Il mondo degli Etruschi. Rome, 1960. (Die
Welt der Etrusker, Stuttgart, 1960).

M. Pallottino, Etruscologia. Milan, 1960.

J. Heurgon, La vie quotidienne chez les Etrusques.
Paris, 1961.

ETRUSCAN ART, GENERAL WORKS

G. Martha, L'Art étrusque. Paris, 1889.

A. della Seta, Antica arte etrusca, in: Dedalo i (1921)
p. 559 ff.

W. Hausenstein, Die Bildnerei der Etrusker. Munich,
1922.

P. Ducati, Storia dell'arte Etrusca (2 vols.). Floren-
ce, 1927.

A. Loukomski, L'Art étrusque. Paris, n.d.

R. Bianchi Bandinelli, La posizione dell'Etruria nel-
l'arte dell'Italia antica, in: Nuova Antologia lxiii
(1928) fasc. 1355.

R. Bianchi Bandinelli, Actualité de l'Art étrusque, in:
Formes (1930).

D. Levi, L'arte etrusca ed il ritratto, in: Dedalo
xxiv (1933).

G. Q. Giglioli, L'arte etrusca. Milan, 1935.

R. Bianchi Bandinelli, Palinodia, in: La Critica d'Arte
vii (1942), id., Storicità dell'arte classica (2nd
ed.). Florence, 1950, ch. 6.

M. Pallottino, 'Partecipazione' e senso drammatico
del mondo figurativo degli Etruschi, in: Arti figu-
rative ii (1946) p. 149 ff.

M. Pallottino, Sul problema delle correlazioni artisti-
che tra Grecia ed Etruria, in: La Parola del Pas-
sato xiii (1950) p. 5 ff.

P. J. Riis, An Introduction to Etruscan Art. Copen-
hagen, 1953.

C. Hopkins, Oriental Evidence for Early Etruscan
Chronology, in: Berytus xi (1955) p. 75 ff. Kunst
und Leben der Etrusker. Cologne, 1956 (Mostra
dell'arte e della civiltà etrusca. Milan, 1955).

M. Pallottino, H. Jucker, Etruskische Kunst. Zurich,
1955.

A. Frova, L'arte etrusca. Milan, 1957.

R. Bloch, L'art étrusque et son arrière-plan histori-
que, in: Historia Zt. vi (1957) p. 53 ff.

T. Dohrn, Grundzüge etruskischer Kunst, in: Deut-
sche Beiträge z. Altertumswiss. viii. Baden-Baden,
1958.

G. A. Camporeale, La prospettiva dall'alto nell'arte
etrusca, in: Arch. Class. xii (1960) p. 139 ff.

R. Bianchi Bandinelli, in: Enciclopedia dell'arte an-
tica. Rome, 1961 (Art.: Etrusca, arte).

M. Pallottino, in: Enciclopedia universale dell'arte,
Rome, 1962 (Art.: Etrusco-italiche correnti e tra-
dizioni).

THE ORIENTALIZING STYLE AND
THE GROWTH OF ETRUSCAN ART

C. Densmore Curtis, The Bernardini-Tomb, in: Mem.
Am. Acc. Rome iii (1919).

C. Densmore Curtis, The Barberini-Tomb, in: Mem.
Am. Acc. Rome v (1921).

H. Mühlestein, Die Kunst der Etrusker: Die Ur-
sprünge. Berlin, 1929.

S. Ferri, Osservazioni ad alcuni monumenti arcaici
felsinei, in: Rendic. Accad. Lincei S. viii, vi,
p. 387.

L. Polacco, Rapporti artistici di tre sculture villano-
viane di Bologna, in: St. Etr. xxi (1950–51) p.
59 ff.

M. Zuffa, Osservazioni sulla testa felsinea di Via S.
Petronio Vecchio, in: St. Etr. xxi (1950–51) p.
107 ff.

M. Zuffa, Una nuova stele villanoviana, in: Emilia
preromana iii (1951–52) (1953) p. 32 ff.

M. Zuffa, Una nuova stele villanoviana e gli ultimi
studi sulla plastica arcaica felsinea, in: Actes du

iv. Congrès Internat. de Sciences Anthropol. et Ethnolog. Wien 1952 iii (1953) p. 32 ff.

K. R. Maxwell-Hyslop, Urartian Bronzes in Etruscan Tombs, in: Iraq xvii (1956) p. 150 ff.

G. A. Mansuelli, Una stele felsinea di tradizione villanoviana, in: Riv. Ist. Arch. St. Arte v–vi (1956–7) p. 1 ff.

M. Pallottino, Urartu, Greece and Etruria, in: East and West ix (1958) p. 29 ff.

Ž. G. Szilagyi, Italo-corinthiaca, in: St. Etr. xxvi (1958) p. 273 ff.

M. Zuffa, Osservazioni sull'arte villanoviana e protofelsinea, in: Cisalpina i. Milan, 1959 p. 247 ff.

Arte delle situle dal Po al Danubio (di *M. Pallottino, J. Kaselic, S. Gabrovec, G. dei Fogolari, K. Kromer*). Florence, 1960.

G. Colonna, La ceramica etrusco-corinzia e la problematica storica dell'orientalizzante recente in Etruria, in: Arch. Class. xiii, (1961) p. 9 ff.

G. Bermond Montanari, Nuova stele villanoviana rinvenuta a Bologna, in: Arte antica e moderna 17. (1962) p. 41 ff.

G. Caputo, Gli athyrmata della Montagnola di Quinto Fiorentino, in: Arte antica e moderna. Bologna 1962, p. 58 ff.

G. A. Mansuelli, Arte delle Situle, in: Arte antica e moderna xviii (1962).

J. Lucke (†) – *O. H. Frey,* Die Situla in Providence. Berlin, 1962.

ARCHITECTURE AND ARCHITECTURAL PLASTIC ART

G. Patroni, L'origine della domus, in: Rendic. Acc. Lincei (1902) p. 467.

G. Körte, Das Volumniergrab bei Perugia, in: Abhandlungen d. Gesellschaft d. Wissenschaften zu Göttingen, NF xii, 1 (1909).

F. v. Stryk, Studien über die etruskischen Kammergräber. Dorpat, 1910.

J. Durm, Die Baukunst der Etrusker und der Römer (3. Aufl.). Leipzig, 1910.

G. Rosi, Sepulchral Architecture as Illustrated by the Rock Façades of Central Etruria, in: Journ. Rom. St. xv (1925) p. 1 ff; xviii (1927) p. 96 ff.

F. Studniczka, Das Wesen des Tuskanischen Tempelbaus, in: Die Antike iv (1928) p. 178 ff.

A. Minto, La tomba a camera di Casal Marittimo, in: St. Etr. iv (1930) p. 54 ff.

A. Åkerström, Studien über die Etruskischen Gräber. Uppsala, 1934.

A. Gargana, La casa etrusca, in: Historia viii (1934).

P. Mingazzini, La tomba a tholos di Casaglia, in: St. Etr. viii (1934) p. 59 ff.

G. Patroni, Tablino e cella triplice nell'architettura etrusca, in: Rend. Acc. Lincei xi–xii (1936) p. 808 ff.

G. Patroni, L'architettura tombale etrusca dopo gli studi di Åkerström, in: Rend. Acc. Lincei xi–xii (1936) p. 792 ff.

R. Mengarelli, L'evoluzione delle forme architettoniche nelle tombe etrusche di Cere, in: Atti ii Conv. Naz. Storia Architettura (1938).

A. Minto, Pseudocupole e pseudovolte nell'architettura etrusca delle origini, in: Palladio iii (1939) p. 1 ff.

A. Andrén, Architectural Terracottas from Etrusco-italic temples. Lund, 1940.

G. Patroni. Architettura preistorica generale ed italica: Architettura etrusca. Bergamo, 1941.

E. H. Dohan, Italic Tomb-Groups. Philadelphia 1942.

A. v. Gerkan und *F. Messerschmidt,* Das Grab der Volumnier bei Perugia, in: Römische Mitteilungen lvii (1942).

G. M. A. Hanfmann, Etruscan Doors and Windows, in: Journ. Am. Soc. Archit. Hist. ii (1942).

A. v. Gerkan, Die angeblich etruskischen Pfeilerkapitelle in Pompeji, in: Römische Mitteilungen lviii (1943) p. 157 ff.

L. Polacco, Tuscanicae dispositiones. Padua, 1952.

M. Santangelo, Veio, Santuario di Apollo (Scavi tra il 1948 e il 1949), in: Boll. d'arte (1952) p. 172 ff.

A. Minto, Problemi sulla decorazione coroplastica nell'architettura del tempio etrusco, in St. Etr. xxii (1952–3) p. 9 ff.

G. A. Mansuelli, Fornices etruschi, in: St. Etr. xxiii (1954) p. 435 ff.

A. Åkerström, Untersuchungen über die figürlichen Terrakottafriese aus Etrurien und Latium, in: Opuscula Romana i (1954) p. 191 ff.

A. v. Buren, Some observations on the Tomb of Lars Porsena near Clusium, in: Anthemion (in onore di C. Anti). Florence, 1955.

G. Maetzke, Il nuovo tempio tuscanico di Fiesole, in: St. Etr. xxiv (1955–6) p. 227.

R. Enking, Zur Orientierung der etruskischen Tempel, in: St. Etr. xxv (1957) p. 541 ff.

M. Demus-Quatember, Etruskische Grabarchitektur. Baden-Baden, 1958.

M. Pallottino, Scavi nel santuario etrusco di Pyrgi, in: Archeol. classica (1958) p. 315 ff.

G. Caputo, Nuova tomba etrusca a Quinto Fiorentino, in: St. Etr. xxvii (1959) p. 269 ff. Id. in: Bollettino d'Arte ii–iii (1962).

A. Ciasca, Il capitello detto eolico in Etruria. Rome, 1962.

WALL-PAINTINGS

G. Körte, Wandgemälde aus Vulci: Document zur römischen Königsgeschichte, in: Jahrbuch Inst. xii (1897) p. 57 ff.

A. *Rumpf*, Die Wandmalereien in Veji. Leipzig
1915.

Fr. *Weege*, Etruskische Gräber mit Gemälden in
Corneto, in: Jahrbuch Inst. XXXI (1916) p. 105 ff.

F. *Weege*, Etruskische Malerei. Halle, 1921.

F. *Poulsen*, Etruscan Tomb-Painting. Oxford, 1922.

F. *Poulsen*, Etruscan Tomb-Paintings, their Subjects
and their Significance. Oxford, 1922.

P. *Duell*, The 'Tomba del Triclinio' at Tarquinia,
in: Mem. Am. Acad. Rome VII (1927) p. 47 ff.

R. *Bianchi Bandinelli*, Le Tombe dei Calinii Sepus,
in: St. Etr. II (1928).

F. *Messerschmidt*, Beiträge zur Chronologie der etrus-
kischen Wandmalerei: I. Die archaische Zeit.
Rome, 1928.

C. C. *van Essen*, La Tomba del Cardinale, in: St.
Etr. II (1928) p. 83 ff.

J. *de Witt*, Die Vorritzungen der etruskischen Grab-
malerei, in: Jahrbuch Inst. XLIV (1929) p. 42 ff.

F. *Messerschmidt*, Probleme der etruskischen Malerei
des Hellenismus, in: Jahrbuch Inst. XLV (1930)
p. 62 ff.

F. *Messerschmidt* und A. v. *Gerkan*, Die Nekropolen
von Vulci. Berlin, 1930.
(Cfr. A. v. Gerkan, in: Römische Mitteilungen
LVII [1942] p. 146 ff.)

P. *Ducati*, Le Pitture della Tomba delle Leonesse e
dei Vasi Dipinti. Rome, 1937.

F. *Messerschmidt*, La Tomba Querciola, in: Scritti in
onore di B. Nogara. Città del Vaticano, 1937, p.
289 ff.

P. *Romanelli*, Pitture della Tomba della Caccia e
della Pesca. Rome, 1938.

R. *Bianchi Bandinelli*, Le pitture delle tombe arcaiche
a Chiusi. Rome, 1939.

A. *Bovini*, La pittura etrusca del periodo orientaliz-
zante (Siglos VII y VI ante de J. C.), in Ampurias
XI (1949) p. 63 ff.

M. *Cagiano de Azevedo*, Il distacco delle pitture della
'tomba delle bighe', in: Boll. Ist. Centr. Restauro
I (1950) p. 11 ff.

M. *Cagiano de Azevedo*, Alcuni punti oscuri della
nostra critica circa la pittura etrusca del VI e V
secolo, in Arch. Class. II (1950) p. 59 ff.

E. *Stefani*, Une serie di lastre fittili dipinte del san-
tuario etrusco di Veio, in: Arch. Class. III (1951)
p. 138 ff.

M. *Pallottino*, La peinture étrusque. Geneva, 1952.

H. *Leisiger*, Malerei der Etrusker. Zurich–Stuttgart,
1953.

A. *Rumpf*, Malerei und Zeichnung, in: Handb. der
Arch. II 6. Munich, 1953.

R. *Bartoccini*, Pitture Etrusche di Tarquinia. Milan,
1955.

L. *Banti*, Problemi della pittura arcaica etrusca. La

Tomba dei Tori a Tarquinia. St. Etr. XXIV
(1955–6) p. 143 ff.

G. *Becatti–F. Magi*, Le Pitture delle Tombe degli
Auguri e del Pulcinella. Rome, 1956.

M. *Moretti*, Lastre dipinte inedite di Caere, in:
Arch. Class. Rom. IX (1957) p. 18 ff.

R. *Bartoccini*, La Tomba delle Olimpiadi. Rome,
1958.

R. *Bartoccini*, C. M. *Lerici*, M. *Moretti*, Tarquinia, la
tomba delle Olimpiadi. Milan–Rome, 1959.

M. *Moretti*, La tomba della Nave. Milan–Rome, 1960.

VASE-PAINTING

C. *Albizzati*, Due fabbriche etrusche di vasi a fig.
rosse, in: Röm. Mitt. (1915), p. 132 ff.

P. *Ducati*, Pontische Vasen. Berlin, 1932.

T. *Dohrn*, Die schwarzfigurigen etruskischen Vasen
aus der zweiten Hälfte des VI. Jahrhunderts. Ber-
lin, 1937.

B. M. *Felletti Maj*, La cronologia della necropoli di
Spina e la ceramica alto-adriatica, in: St. Etr.
XIV (1940) p. 43 ff.

J. D. *Beazley*, Etruscan Vase-Painting. Oxford 1947.

M. *del Chiaro*, The Genucilia Group. Los Angeles,
1956.

ENGRAVING AND STONE-CUTTING

E. *Gerhard*, K. *Klugmann*, H. *Körte*, Etruskische Spie-
gel (5 vols.). Berlin, 1840–97.

G. *Karo*, Le oreficerie di Vetulonia, in: Studi e ma-
teriali di archeologia e numismatica I–II (1901–2)
p. 235 ff.; 97 f.

F. H. *Marshall*, Catalogue of the Jewellery in the
British Museum. London, 1911.

J. D. *Beazley*, The Lewes House Collection of An-
cient Gems. Oxford, 1920, p. 31.

G. A. *Mansuelli*, Gli specchi figurati etruschi, in:
Stud. Etr. XIX (1946) p. 9 ff. und XX (1948–9) p.
59 ff.

J. D. *Beazley*, The World of Etruscan Mirrors, in:
Journal Hell. Studies LXIX–LXX (1949–50) p. 1 ff.

G. A. *Mansuelli*, L'incisore Novios Plautios, in: St.
Etr. XIX (1946) p. 9 ff. and XX (1948–49) p. 59 ff.

G. *Becatti*, Oreficerie antiche. Rome, 1955.

Y. *Huls*, Ivoires d'Etrurie. Brussels–Rome, 1957.

M. V. *Giuliani Pomes*, Cronologia delle situle rinve-
nute in Etruria, in: St. Etr. XXV (1957) p. 39 f.

ITALIC AND ROMAN REPUBLICAN ART

F. *Weege*, Oskische Grabmalerei, in: Jahrbuch Inst.
XXIV (1909) p. 105 ff.

G. *Kaschnitz-Weinberg*, Ritratti fittili etruschi e ro-
mani, in: Rend. Pont. Acc. III (1925).

C. *Anti*, Il problema dell'arte italica, in: St. Etr. IV
(1930) p. 153 ff.

G. *Kaschnitz-Weinberg*, Das Italische als Grundlage der Formstrukturen der italienischen Renaissance und des italienischen Barock, in: xɪv Congr. internat. d'hist. de l'art (1936) p. 24 ff.

T. *Dohrn*, Zur Geschichte des italisch-etruskischen Porträts, in: Römische Mitteilungen xlvɪɪ (1937) p. 119.

O. *Vessberg*, Studien zur Kunstgeschichte der römischen Republik. Lund–Leipzig, 1941.

G. *Kaschnitz-Weinberg*, Vergleichende Studien zur italisch-römischen Struktur, in: Römische Mitteilungen lɪx (1944) p. 89 ff.

S. *Mazzarino*, Dalla monarchia allo stato repubblicano. Catania 1945.

B. *Schweitzer*, Bildniskunst der römischen Republik. Leipzig, 1948.

G. *Kaschnitz-Weinberg*, Über die Grundformen der italisch-römischen Struktur (Plastik), in: Mitt. d. Inst. ɪɪɪ (1950) p. 148.

A. *Minto*, I clipei funerari etruschi e il problema sulle origini dell'imago clipeata funeraria, in: St. Etr. xxɪ (1950–1) p. 25 ff.

A. *Cederna*, Teste votive di Carsoli, in: Arch. Class. v (1953) p. 187 ff.

E. H. *Richardson*, The Etruscan Origins of Early Roman Sculpture, in: Mem. Am. Acc. Rom. xxɪ (1953) p. 77 ff.

L. *Homo*, L'Italie primitive et les débuts de l'impérialisme romain. Paris, 1953.

E. *Gjerstad*, Early Rome ɪ–ɪɪɪ. Lund 1953–1960.

H. A. *Stützer*, Die Kunst der Etrusker und der römischen Republik. Munich, 1955.

P. C. *Sestieri*, Tombe dipinte di Paestum, in: Riv. Ist. Archeol. St. Arte. Rome N.S. v–vɪ (1956–7) p. 65 ff.

A. *Adriani*, Sculture in tufo. Rome, 1959.

G. A. *Mansuelli*, Italico-romane popolaresche correnti, in: Enciclopedia universale dell'arte. Rome xxɪ (1953) p. 77 ff.

M. *Pallottino*, Le origini di Roma, in: Arch. Class. xɪɪ (1960) p. 1 ff.

SCULPTURE, BRONZES AND TERRACOTTA PLASTIC ART

H. *Brunn–G. Körte*, I rilievi delle urne etrusche (3 vols.), Rome, 1870–1916.

E. *Petersen*, Bronzen von Perugia, in: Römische Mitteilungen, ɪx (1894) p. 253 ff.

C. H. *Chase*, Three Bronze Tripods belonging to J. Loeb, in: Amer. Journ. Arch. xɪɪ (1908) p. 312 ff.

P. *Ducati*, Le pietre funerarie felsinee, in: Monumenti Antichi Lincei, xx (1911) p. 357 ff.

C. *Albizzati*, Ritratti etruschi arcaici, in: Atti Pont. Acc. xɪv (1920) p. 149 ff.

C. *Anti*, L'Apollo che cammina, in: Bollettino d'Arte, (1920) p. 73 ff.

G. *Libertini*, Decorazione fittile di un tempio sul colle di Telamonaccio, in: Dissert. Pont. Acc. ɪɪ, xv (1921) p. 137 ff.

E. *Douglas v. Buren*, Figurative Terracotta Revetments in Etruria and Latium. London, 1921.

K. *Neugebauer*, Bronze-Industrie von Vulci, in: Archäologischer Anzeiger, xxxvɪɪɪ–xxxɪx (1923–4) p. 302 ff.

R. *Bianchi Bandinelli*, I caratteri della scultura etr. a Chiusi, in: Dedalo vɪ (1925) p. 5 ff.

J. *Carcopino*, Influences puniques sur les sarcophages étrusques de Tarquinia, in: Mem. Pont. Acc. ɪ (1925) p. 109 ff.

R. *Bianchi Bandinelli*, Il Bruto Capitolino, scultura etrusca, in: Dedalo, vɪɪɪ (1927) p. 5 ff.

L. *Laurenzi*, Frontone e fregio di Civita Alba, in: Boll. d'Arte (1927) p. 259 ff.

H. *Sauer*, Die archaisch. etr. Terrakottasarkophage aus Caere. Dissertation. Leipzig, 1930.

D. *Levi*, La tomba della Pellegrina a Chiusi, in: Riv. Ist. Arch. St. Arte ɪv (1932–3) pp. 7 ff., p. 101 ff.

F. *Poulsen*, Altetr. Grossplastik in Terrakotta, in: Die Antike vɪɪɪ (1932) p. 90 ff.

F. *Magi*, Stele e cippi fiesolani, in: Studi Etr. vɪ (1932).

G. M. A. *Hanfmann*, Daidalos in Etruria, in: American Journal of Archeology xxxɪx (1935) p. 189 ff.

D. *Levi*, I canopi di Chiusi, in: La Critica d'Arte ɪ (1935–6) pp. 18 ff., p. 82 ff.

G. M. A. *Hanfmann*, Altetruskische Plastik, Berlin, 1936.

G. M. A. *Hanfmann*, The Origin of Etr. Sculpture, in: La Critica d'Arte ɪɪ (1937) p. 458 ff.

A. *Minto*, Le stele arcaiche volterrane, in: Scritti in onore di B. Nogara, Città del Vaticano, 1937 p. 305 ff.

G. M. A. *Hanfmann*, Studies in Etr. Bronze Reliefs, in: The Art Bulletin xɪx (1937) p. 463 ff.

E. *Paribeni*, I rilievi chiusini arcaici, in: St. Etr. xɪ–xɪɪɪ (1938) p. 9.

A. *Andrén*, Architectural Terracottas from Etrusco-Italic Temples. Lund–Leipzig, 1939–40.

P. *Riis*, Tyrrhenika, An Archaeological Study of the Etruscan Sculpture. Copenhagen, 1941.

P. *Riis*, Notes of Etr. Archit. Terracotta, in: Acta Archaeologica xɪɪ (1941).

P. *Ducati*, La scultura etrusca. Novara, 1941.

L. *Goldscheider*, Etruscan Sculpture. London, 1941.

K. A. *Neugebauer*, Archaische Vulcenter Bronzen, in: Jahrbuch Inst. lvɪɪɪ (1943) p. 206 ff.

M. *Pallottino*, La scuola di Vulca, Rome, 1945.

G. *Maetzke*, Terrecotte architettoniche etr. scoperte ad Arezzo, in: Bollettino d'Arte xxxv (1949) p. 251 ff.

M. *Cagiano de Azevedo*, Sulla autenticità di alcune

terrecotte del Metropolitan Museum, in: Boll. Ist. Centr. Restauro (1950) p. 44 ff.

M. *Pallottino*, Il grande acroterio femminile di Veio, in: Arch. Class. II (1950) p. 122 ff.

R. *Herbig*, Die jüngeren etruskischen Steinsarkophage. Berlin, 1952.

A. *Åkerström*, Untersuchungen über die figürlichen Terrakottafriese aus Etrurien und Latium, in: Opuscula Romana I (1954).

S. *Ferri*, Divinatio in fastigium Veiens, in: Arch. Class. VI (1954) p. 115 ff.

U. *Scerrato*, Considerazioni sul carro di Monteleone di Spoleto, in: Arch. Class. VII (1956) p. 163 ff.

L. *Banti*, I Tripodi Loeb, in: Tyrrhenika a. O.

M. *Zuffa*, I frontoni e il fregio di Civita Alba, in: Studi Paribeni-Calderini III, Milano 1956, p. 287 ff.

D. *Thimme*, Chiusinische Aschenkisten und Sarkophage der hellenistischen Zeit, in: St. Etr. XXIII (1954-55) p. 25 ff.; XXV (1957) p. 87 ff.

T. *Dohrn*, Zwei etruskische Kandelaber, in: Römische Mitteilungen LXVI (1959) p. 45 ff.

Hus, La sculpture étrusque. Paris, 1962.

TOPOGRAPHY, MEMORIAL MONUMENTS
AND INSCRIPTIONS

G. *Dennis*, The Cities and Cemeteries of Etruria (2 vols.). London, 1883.

A. *Solari*, Topografia storica dell'Etruria (3 vols.). Pisa, 1915-20.

F. v. *Duhn* and F. *Messerschmidt*, Italische Gräberkunde (2 vols.). Heidelberg, 1924-39.

P. *Ducati*, Le necropoli etrusche, in: Romania III (1939) p. 673 ff.

J. *Bradford*, Etruria from the Air, in: Antiquity, XXI (1947) p. 74 ff.

G. B. *Pellegrini* and G. *Fogolari*, Iscrizioni etrusche e venetiche di Adria, in: St. Etr. XXVI (1958).

H. *Koch*, E. v. *Merklin* and C. *Weickert*, Bieda, in: Röm. Mitteil. XXX (1915) p. 161 ff.

A. *Grenier*, Bologne villanovienne et étrusque. Paris, 1912.

G. A. *Mansuelli*, La terza Bologna, in: St. Etr. XXV (1957) p. 13 ff.

A. *Minto*, Marsiliana d'Albegna, Florence, 1921.

P. *Ducati*, Storia di Bologna, I, I tempi antichi. Bologna, 1928.

J. *Heurgon*, Recherches sur l'histoire, la religion et la civilisation de Capoue préromaine, Paris, 1942.

R. *Vighi*, G. *Ricci* and M. *Moretti*, Caere, in: Mon. Ant. Lincei XLII (1955).

R. *Bianchi Bandinelli*, Clusium, in: Mon. Ant. Lincei XLII (1925).

A. *Neppi Modona*, Cortona etrusca e romana. Florence, 1925.

E. F. *Brown*, Cosa, I, History and Topography, in: Mem. Amer. Acad. Rome XX (1951) p. 7 ff.

R. *Bianchi Bandinelli*, Materiali archeologici della Val d'Elsa, in: La Balzana (Siena) II (1928).

L'Etruria padana e la città di Spina, Catalogo della Mostra (con i contributi di G. A. Mansuelli, P. E. Arias, N. Alfieri, M. Zuffa, R. Pincelli, B. Forlati, G. dei Fogolari, G. B. Pellegrini, F. Rittatore, G. Bermond). Bologna, 1960.

F. *Magi*, Contributi alla conoscenza di Fiesole etrusca, in: Atene e Roma I (1930) p. 83 ff.

L. *Banti*, Luni. Florence, 1937.

A. *Minto*, Marsiliana d'Albegna, Florence, 1921.

E. *Brizio*, Mon. Ant. Lincei I (1899), p. 249 ff.

P. E. *Arias*, Considerazioni sulla città etrusca a Pian di Misano, in: Atti e Memorie della Deputazione di Storia patria per le Provincie di Romagna, N.S. III (1953) p. 225 ff.

G. A. *Mansuelli*, La Cité étrusque de Marzabotto, in: Comptes-rendus de l'Acad. des Inscript. et des B.L., Paris, 1962.

G. A. *Mansuelli*, La città etrusca di Pian di Misano, in: Arte antica e moderna. Bologna, 1962.

D. *Levi*, La necropoli etrusca dell'Accesa nel territorio di Massa Marittima, in: Mon. Ant. Lincei XXXV (1933) p. 5 ff.

S. *Puglisi*, Studi e ricerche su Orvieto etrusca. Catania, 1932.

L. *Banti*, Contributo alla storia e alla topografia del territorio perugino, in: St. Etr. X (1936) p. 97 ff.

L. *Banti*, Pisae, in: Mem. Pontif. Accad. S. III, IV, I (1943) p. 97 ff.

A. *Boëthius*, Gli Etruschi in Pompei, in: Symbolae O. A. Danielsson, dic. Uppsala, 1932.

A. *Maiuri*, Greci ed Etruschi in Pompei, in: Memorie Accad. d'Italia IV (1943) p. 161 ff.

A. *Minto*, Populonia, La necropoli arcaica, Florence 1922. Id. Populonia, Florence, 1943.

S. I. *Ryberg*, An Archaelogical Survey of Rome from the VI to the VII Century B.C. Philadelphia, 1940.

R. *Bianchi Bandinelli*, Rusellæ, in: Atene e Roma VI (1925) p. 35 ff.

R. *Naumann*, Unters. in der etruskischen Stadt Rusellae, Neue Ausgrabungen im Mittelmeergebiet, Berlin, 1959.

C. *Laviosa*, Rusellæ, in: St. Etr. XXVII (1959) p. 3 ff.

A. *Minto*, Saturnia etrusca e romana, in: Mon. Ant. Lincei XXX (1925).

R. *Bianchi Bandinelli*, Sovana. Florence, 1929.

S. *Aurigemma*, Il r. Museo di Spina in Ferrara, (2nd ed.), Ferrara, 1936.

N. *Alfieri*, P. E. *Arias* and M. *Hirmer*, Spina, Florence–Munich, 1958.

Spina e l'Etruria padana, special number of St. Etr. XXV, Florence, 1959.

P. E. Arias, N. Alfieri, Il Museo Archeologico di Ferrara (2nd ed.). Florence, 1961.

G. Matteucig, Poggio Buco, The Necropolis of Statonia. Berkeley–Los Angeles, 1951.

M. Pallottino, Tarquinia, in: Mon. ant. Lincei xxxvi (1937).

R. Bloch, Volsinies étrusques, in: Mél. Arch. Hist. 1947 p. 99 ff.

R. Bloch, Volsinii étrusque et romaine, in: Mél. Arch. Hist. (1950) p. 119 ff.

S. Gsell, Fouilles de Vulci. Paris, 1891.

G. Caputo–G. Maetzke, Presentazione del rilievo di Fiesole antica, St. Etr. xxvii (1959) p. 41 ff.

M. Santangelo, Musei e monumenti etruschi. Novara 1960.

San Giovenale, Etruskerna landet och folket; Svenske forskning i Etrurien. Allhems Förlag Malmö, 1960.

G. A. Mansuelli–R. Scarani, L'Emilia prima dei Romani. Milan, 1961.

INDEX